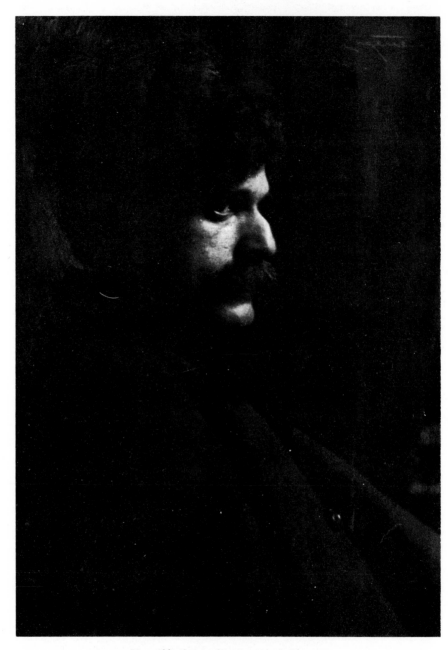

Mr. Alfred Stieglitz, by Frank Eugene.

Camera Work

A PICTORIAL GUIDE

With Reproductions of All 559 Illustrations
and Plates, Fully Indexed

ALFRED STIEGLITZ

Edited by Marianne Fulton Margolis

DOVER PUBLICATIONS, INC., NEW YORK

and The International Museum of Photography
at George Eastman House, Rochester

ACKNOWLEDGMENTS

I wish to thank the following people at the International Museum of Photography: Robert Doherty, Director, Andrew Eskind, Assistant Director, and Robert Sobieszek, Associate Curator, for their support; Gretchen Van Ness, Susan Stromei, Deborah K. Barsel and Jeff Wolin for their assistance; Christina Clarke and, in particular, James C. A. Kaufmann for patience and good humor in dealing with me and the computer; and W. Paul Rayner, co-editor of *Image,* and José Orraca, former Conservator, for their advice. I especially want to thank Martha E. Jenks, Director of the Archives, for her help and encouragement.

David Vance, President of the Museum Computer Network, selected the appropriate data classification for use in the computerization of the work. Alan Klotz and his graduate class provided the initial impetus for this project. Thaddeus Bukowski designed the original information forms and John Frater worked with Mr. Vance on the special problems of computerizing a manuscript.

I also appreciate the cooperation and assistance of Dorothy Norman and Jonathan Green.

For generous and valuable advice, I wish to thank Clarence Strowbridge and Thomas Baker of Dover Publications. Also, scholar, poet, writer, critic, Dr. Deba P. Patnaik always knew which of his talents to apply in times of need.

I am most grateful to my husband, Richard Margolis, without whose knowledge of photography and unceasing confidence in me this work could not have been completed.

Published in Canada by General Publishing Company, Ltd., 30 Lesmill Road, Don Mills, Toronto, Ontario.

Published in the United Kingdom by Constable and Company, Ltd., 10 Orange Street, London WC2H 7EG.

"Camera Work": A Pictorial Guide is a new work, first published by Dover Publications, Inc., in 1978.

International Standard Book Number: 0-486-23591-2
Library of Congress Catalog Card Number: 77-85410

Manufactured in the United States of America
Dover Publications, Inc.
180 Varick Street
New York, N.Y. 10014

CONTENTS

INTRODUCTION

In the fifty numbers of *Camera Work,* published between the years 1903 and 1917, there appeared some of the finest examples of photography and modernist art. *Camera Work* chronicled the introduction of modern European art into America—three years before the Armory show, it published plates of Rodin's and Matisse's drawings. It recorded public and journalistic reaction to this modern art by reprinting reviews from the newspapers. In addition, as a forum for the discussion and criticism of new work, it acted as a catalyst in the fight to have photography accepted as a medium of artistic expression. The editorial staff stated in issue number 1:

> The time appearing ripe for the publication of an independent American photographic magazine devoted largely to the interests of pictorial photography, "Camera Work" makes its appearance as the logical outcome of the evolution of the photographic art.[1]

During this evolution of photographic art, one primary question had always been whether a machine could indeed produce a work of art. Various views were expounded, and while most people felt that photography could not rival the combination of creativity and hand work found in painting, they appreciated its ability to preserve people and places and the freedom it gave painting to explore new areas.

Lady Elizabeth Eastlake (1809-1893) wrote that photography's legitimate business was "to give evidence of facts, as minutely and as impartially as, to our shame, only an unreasoning machine can give."[2] She stated the crux of the argument against photography as a fine art in 1857:

> The power of selection and rejection, the living application of the language which lies dead in his paint-box, the marriage of his own mind with the object before him, and the offspring, half stamped with his own features, half with those of Nature, which is born of the union—whatever appertains to the free-will of the intelligent being, as opposed to the obedience of the machine,—this, and much more than this, constitutes

that mystery called Art, in the elucidation of which photography can give valuable help, simply by showing what it is not.[3]

In an article written in 1859, Baudelaire declared that it was time for photography "to return to its true duty, which is to be the servant of the sciences and arts—but the very humble servant, like printing or shorthand, which have neither created nor supplemented literature."[4] Baudelaire feared that by imitating the extreme accuracy of photography, art would fall away from its reliance on creative imagination and concern itself only with superficial reality.

But pictorial photography sought to break away from its designation as a mindless purveyor of facts and achieve control over its subject matter and mechanical shortcomings. Thus, through obvious manipulation, photographers hoped to show that they were part of the art tradition. Their first consideration was the choice of subject matter. "High Art" photography of the 1850s concerned itself with depicting scenes from literature, as in William Lake Price's *Don Quixote in his Study,* the Bible, in *Head of St. John the Baptist* by O. G. Rejlander, and allegory, such as Rejlander's *Two Ways of Life.* In these productions, models were dressed or undressed in accordance with the theme, with props and backgrounds also lending themselves to the illusion. Decisions about placing, draping and focusing all were made before the picture was taken. After the negative was developed, the photographer could retouch the negative to add or delete details, and could even combine negatives or paste-up prints and rephotograph them to form a new image.

Henry Peach Robinson (1830-1901) argued that to "admit that photographers had no control over their subjects would be to deny that the works of one photographer were better than another, which would be untrue."[5] The method he proposed and taught was combination printing. This technique of printing several negatives by means of masks to produce one unified print allowed the photographer to arrange and select only those portions which added to the overall effect. By "building" an image in the

darkroom not only could a photographer compensate for the film's inability to record true tones for both sky and land simultaneously, but he could construct idealized scenes by, for instance, introducing posed studio models into a pastoral background. Natural detail was of major importance; Robinson stressed the use of "proper focus" for each portion of the composite picture, and taught that pictorial effect was achieved in photography with the same principles of composition used in academic painting. The photographer was instructed to learn the laws which governed the arrangement of the picture so that he would be capable of producing "an agreeable presentation of forms and tones, to tell the story which is to be elucidated, and to embody the spirit of what it is intended the picture shall represent or suggest."[6]

In the 1880s, Peter Henry Emerson (1856-1936) passionately rebuked any kind of constructed picture, in part because the separate portions of the picture printed with separate negatives failed to allow for a center of interest. Having everything in focus tended to diffuse the power of the subject: "This 'sharp' ideal is the childish view taken of nature by the uneducated in art matters and they call their productions true, whereas, they are just about as artistically false as can be."[7] Not only did Emerson feel that this was not art, but he also felt that it was not natural. He believed that when one looked at a scene the subject was clear, and that other sections fell away and were thus less defined.[8] He therefore suggested a procedure called "differential focusing," also known as soft focusing (although he was careful to advise students not to abuse the technique by overdoing it). Robinson had also taught that detail was an inherent quality of photography and should be preserved. He advocated a dramatic approach to the staging of a photograph which resulted in a rather artificial look at life. R. Child Bayley later condemned mid-Victorian photography for these tendencies, claiming that "able workers lost themselves in morasses of false sentiment, and swamps of elaborate theatrical unrealities."[9] Emerson, however, whose theory of composition was based on the ability to see and choose a beautiful subject, deplored the manipulation of the negative. He wanted the photograph to be true to the way he supposed man saw. His approach was based on the scientific discoveries of Hermann von Helmholtz's *Physiological Optics,* and not on a desire to make painterly photographs.

Late Victorian photographers such as Emerson had the advantage of commercially made dry plates; these enabled the photographer to develop negatives at his convenience rather than only while the emulsion was still wet. The increased sensitivity of both paper and negatives brought new aesthetic possibilities, such as a wider tonal range,

and along with the faster film hand cameras were developed. The photographer was finally freed from the studio as well as the posed subject and painted backdrop. But even though photographers now had new tools that provided sharp, vibrant prints, many pictorialists who felt they were following Emerson's advice produced out-of-focus, "impressionistic" images. Llewellen Morgan in *The Amateur Photographer* reported that "little details are interesting to the scientist, but of no value to the artist."[10] For all pictorialists, the primary interest lay in artistic expression of a non-documentary nature. In other words, the pictorialist used the photographic subject as a means to an end: to achieve a satisfactory result, he might emphasize a certain feature of the composition to alter its significance and meaning.

To sum up the situation when *Camera Work* appeared on the scene, "pictorialism" was synonymous with "artistic" and applied to a wide variety of styles; and unlike today, when the distinctions between documentary and art photography have blurred, documentary work was seen as an objective method of recording or reporting facts which did not imitate painting, and consequently could not be aesthetic.

> In the early stages of photography man's interest was captured by the camera's ability to record facts; today, the artist's aim is to make it record his impressions of the fact, and to express in the print his personal feeling.[11]

Some groups of pictorial workers formed large camera clubs which sponsored photographic exhibitions. These organizations provided a place for photographers to meet and share their work. Sometimes darkrooms were provided on the premises, lectures given on various processes and theories, and small journals published showing the club's activities. And, of course, for these amateur photographers social functions were an important part of the appeal.

Over the years the largest of these groups dedicated to the advancement of photography became lax in their standards of achievement. Perhaps it was a question of becoming more democratic: rules regarding admission to shows were loosened, allowing for a greater cross section of work to be shown. Those photographers genuinely committed to photography as a means of personal expression became increasingly disgruntled with the large, conservative photographic establishments and began to break away.

The first important exhibit sponsored by a new group was the Viennese Photographic Salon of 1891 sponsored by the Vienna Camera Club, which included in its mem-

bership Heinrich Kühn (1866-1944), Dr. Hugo Henneberg (1863-1918) and Hans Watzek (1849-1905). In 1892, fifteen members of the Royal Photographic Society withdrew from the club and formed the Linked Ring. The Photo-Club de Paris was organized in 1894 and included Robert Demachy (d. 1937) and Commandant Puyo. A group show at the National Arts Club in New York City in 1902 marked the founding of the Photo-Secession by Alfred Stieglitz.

By 1902, Stieglitz (1864-1946) was an internationally famous photographer. As a student in Berlin he had studied photochemistry with Professor Vogel and had won over a hundred medals in photography competitions. After returning to the United States in 1890 he became a partner in the Heliochrome Company (later the Photochrome Engraving Company), a photoengraving business. He also served as editor of the *American Amateur Photographer* from 1893 to 1896. When the Society of Amateur Photographers merged with the New York Camera Club, he became vice-president of the new Camera Club of New York and created the quarterly *Camera Notes*.

Stieglitz had encountered difficulties during his management of the *American Amateur Photographer* because of his staunch insistence on a high standard of pictorial work. The same objection developed within the Camera Club of New York—it should be kept in mind that the group had given serious thought to becoming a bicycle club before Stieglitz became vice-president. Stieglitz tried to strengthen the club's interest in photography by reorganizing the Publications Committee and converting the club publication, a small journal of activities and meetings, into the full-scale commercial periodical *Camera Notes*. The magazine was successful in attracting those seriously interested in photography, but in doing so it created factions within the club. It became apparent that Stieglitz could not operate *Camera Notes* the way he felt he must, nor could he change the views of his opponents. So in 1901, when the opportunity presented itself to hang a "select" exhibition of photographs in New York City at the National Arts Club, Stieglitz accepted. He called it "An Exhibition of Photography Arranged by the Photo-Secession."

The term "Secession" was borrowed from a group of modern painters in Austria and Germany. Eduard Steichen (1879-1973) explained:

Secessionists of Munich . . . gave, as the reason of their movement, the fact that they could no longer tolerate the set convictions of the body from which they detached themselves, a body which exists on conventions and stereotyped formulae, that checked all spirits of originality instead of encouraging them, that refused its ear to any new doctrine—such groups gave birth to secession.[12]

In 1902 Stieglitz resigned as editor of *Camera Notes* and prepared a new, independent quarterly, *Camera Work*. The quarterly was the "mouthpiece" of the Photo-Secession, and as such Stieglitz pledged:

Only examples of such work as gives evidence of individuality and artistic worth, regardless of school, or contains some exceptional feature of technical merit, or such as exemplifies some treatment worthy of consideration, will find recognition in these pages.[13]

The printing was of primary importance. In forty-eight of the fifty numbers published, a page was devoted to describing the printing methods of the illustrations. Stieglitz was particularly careful to point out which images were made from the original negatives; these were considered original prints. In a special insert in number 12, Stieglitz pointed out that the gravures were thought to be so fine that they were chosen to hang in the 1904 exhibition of the Société L'Effort in Brussels when the photographic prints from the Photo-Secession failed to arrive. Most of the gravures were printed on Japan tissue, which held the delicate tones of the original. These hand-pulled plates were then tipped into each copy by the small *Camera Work* staff. A. Radclyffe Dugmore's gravure *A Study in Natural History* (Jan. 1903, 1:55) is a good example of the time taken to create a beautiful magazine. The photogravure picture of young birds was printed on Japan tissue, which was mounted in the center of a heavy gray page over a cream-colored mount, all in order to enhance the soft white feathers of the birds' breasts.

The illustration page often included a reference to the printer, a compliment if a difficult subject was well done and, in one case, a castigation. In number 4, Frederick H. Evans (1853-1943) was allowed to use an English printer to avoid sending his original prints to America. The result was completely unsatisfactory to Stieglitz, who wrote:

Imagine our consternation upon the arrival of the edition to find that the work was uneven, not up to proof, and in most cases far below that standard which we had every reason to expect. It was then too late to do aught than make the best of a bad job, feeling that we have only ourselves to blame for having broken our rule. . . .

For our own sakes, who have striven to make the illustrations of Camera Work as perfect as possible, having spared no expense or pains, we feel disappointed that this number should leave our hands and we not satisfied with it. It shall never happen again.[14]

But perhaps *Camera Work's* greatest contribution was as a forum for debate, both on the questions of what in photography could be admissible as art and on the theories of modern art in general. A solid basis for modern criticism was formed in articles written by such people as R. Child Bayley, Charles H. Caffin, Robert Demachy, Frederick H. Evans, Sadakichi Hartmann, Joseph T. Keiley, George Bernard Shaw and Eduard Steichen. Although most pieces were written especially for use in *Camera Work,* reviews and controversial articles from other magazines and newspapers were reprinted.

The photographic honesty vs. manipulation controversy, for instance, was a recurring theme in *Camera Work's* pages. In 1907 Robert Demachy, famous for his gum and oil prints, restated Lady Eastlake's objection to photography as being too mechanical to be art, but offered a way out—the manipulated print:

> The photographic character is, and always has been, an anti-artistic character, and the mechanically-produced print from an unretouched negative will always have in the eyes of a true artist faults in values and absence of accents against which the special qualities so loudly proclaimed will not count for much.[15]

George Bernard Shaw then replied that the photographer who uses painterly methods "fails in respect for his art. He is a traitor in the photographic camp."[16] Frederick Evans pointed out that the basis of pure, straight photography was the perfect negative; how many "gummists," he wondered, could say that and also maintain that the gum print produced the ideal rendering of that perfect negative?[17] Steichen, in an earlier article, had come out in favor of manipulation by maintaining that, due to latitudes in exposure and development, all photography was manipulated to a certain degree. Each piece, Steichen claimed, should be regarded as an "original."

Stieglitz's position evolved slowly during the *Camera Work* years. During a talk at the National Arts Club in 1902, Stieglitz reportedly had taken the view that "the result was the only fair basis for judgment and that it was justifiable to use any means upon negative or paper to attain the desired end."[18] However, the next year in *Camera Work* editorial opinion endorsed Gertrude Käsebier's work as "absolutely straight photography, being in no way faked, doctored or retouched."[19] The critical language grew stronger, and in the last number of *Camera Work* Stieglitz wrote of Paul Strand's pictures: "The work is brutally direct. Devoid of all flim-flam; devoid of trickery and of any 'ism;' devoid of any attempt to mystify an ignorant public, including the photographers themselves."[20]

Thus over the years the story-telling aspect of pictorialism was dropped. In Stieglitz's work especially there appeared a de-emphasis of artificial subject matter, manipulation, and any sort of "impressionism," and in their place a concern for pattern and design relationships became apparent. With pictures like *The Steerage (1907)* (Oct. 1911, 36:37) and *The Pool—Deal (1910)* (Oct. 1911, 36:43) he broke away from the noble thought or the beautifully rendered scene and began to experiment with the inherent qualities of the medium. In 1923 he wrote, "My photographs look like photographs—and (in the eyes of the 'pictorial photographers') they therefore can't be art."[21]

Stieglitz's growing impatience with painterly techniques was made evident in two ways: he began to exhibit modern European paintings and sculpture, and in 1910 he organized a grand finale to the fine-art fight of pictorialism—the International Exhibition of Pictorial Photography at the Albright Art Gallery in Buffalo.

The Little Galleries of the Photo-Secession had opened in 1905 with an exhibition of work by the members. The practice of two-week-long photographic exhibitions between November and May was broken in 1907 when Stieglitz put up a show of drawings by Pamela Coleman Smith. After 1908, when the galleries were moved across the hall and renamed "291," a variety of American and European avant-garde work was presented. In the next ten years, between 1908 and the gallery's closing in 1917, only ten more photographic shows were hung. In response to those who protested the showing of drawings at 291, *Camera Work* reminded its readers that the idea of "secession" did not belong to the photographic medium alone, but was the spirit of the "too often discarded lamp of honesty; honesty of aim, honesty of self-expression, honesty of revolt against the autocracy of convention."[22]

The gigantic exhibition at the Albright Art Gallery in 1910 consisted of 584 prints and filled eight galleries. The foreword to the catalogue read:

> The aim of this exhibition is to sum up the development and progress of photography as a means of pictorial expression. The Invitation Section consists largely of the work of photographers of international reputation American and foreign, whose work has been the chief factor in bringing photography to the position to which it has now attained.[23]

The work was submitted by Secessionists and non-Secessionists from Europe and America and was hung as a series of one-man shows. The crowds were large, the press enthusiastic. Paradoxically, perhaps, even though the exhibition was a huge success and gave the photo-

graphic art movement the attention it desired, many photographers (including Stieglitz) had already grown impatient with Victorian aesthetic. The Photo-Secession as a group essentially disbanded due to differing opinions and a fragmenting of goals.

Stieglitz had expressed his feelings about the importance of this seminal group earlier in *Camera Work:*

> Though the individual American photographer was subordinated to the success of the cause, yet, in its success, the individual was enabled to achieve, and did achieve, a far greater distinction than could ever have been his portion if he had been compelled to rely on his unaided effort. . . .[24]

Camera Work continued publication until 1917. During these last seven years, Stieglitz steered the magazine towards a more modern sensibility, both literary and visual. In the April/July 1911 issue, collotype reproductions of Rodin's drawings were published. The August 1912 issue, the first "special" issue since the earlier Steichen Supplement, presented the work of Matisse and Picasso along with the first published piece by Gertrude Stein. Also during this period *Camera Work* encouraged a rediscovery of the early masters, David Octavius Hill and Robert Adamson, and Julia Margaret Cameron. Their pictures reinforced the movement towards the unmanipulated, "straight" approach, culminating in the work of Paul Strand, whose bold surface design and urban-oriented pictures expressed perfectly the ideals of *Camera Work,* Stieglitz and modern photography.

Strand himself stated in 1917 that "the whole development of photography has been given to the world through CAMERA WORK. . . ." He concluded:

> The existence of a medium, after all, is its absolute justification, if as so many seem to think, it needs one and all, comparison of potentialities is useless and irrelevant. Whether a watercolor is inferior to an oil, or whether a drawing, an etching, or a photograph is not as important as either, is inconsequent. To have to despise something in order to respect something else is a sign of impotence. Let us rather accept joyously and with gratitude everything through which the spirit of man seeks to an ever fuller and more intense self-realization.[25]

NOTES

1. Alfred Stieglitz, "An Apology," *Camera Work,* Jan. 1903, 1:15.
2. Lady Elizabeth Eastlake, "Photography," in Beaumont Newhall, ed., *On Photography: A Source Book of Photo History in Facsimile* (Watkins Glen, N.Y.: Century House, 1956), p. 102.
3. Ibid., p. 106.
4. Charles Baudelaire, "The Modern and Photography," in Newhall, p. 106.
5. Henry Peach Robinson, *Pictorial Effect in Photography* (1869; reprint ed., Pawlet, Vt.: Helios, 1971), p. 13.
6. Ibid., p. 21.
7. Peter Henry Emerson, *Naturalistic Photography* (London: Sampson Low, Marston, Searle & Rivington, 1889), p. 151.
8. Ibid., p. 150.
9. R. Child Bayley, "Pictorial Photography," *Camera Work,* Apr. 1907, 18:23.
10. Llewellen Morgan, "Aids to Picture Making by Photography, for Beginners," *The Amateur Photographer,* 5 Apr. 1901, 33:283.
11. Charles H. Caffin, *Photography as a Fine Art* (1901; reprint ed., Hastings-on-Hudson, N.Y.: Morgan & Morgan, 1971), p. 95.
12. Eduard Steichen, "The American School," *Camera Notes,* 6:1:22.
13. Stieglitz, loc. cit.
14. "Our Illustrations," *Camera Work,* Oct. 1903, 4:25.
15. Robert Demachy, in "Monsieur Demachy and English Photographic Art," *Camera Work,* Apr. 1907, 18:44.
16. George Bernard Shaw, in ibid., p. 45.
17. Frederick H. Evans, in ibid., p. 46.
18. John Francis Strauss, "The 'Photo-Secession' at the Arts Club," *Camera Notes,* 6:1:34.
19. "The Pictures in this Number," *Camera Work,* Jan. 1903, 1:63.
20. "Our Illustrations," *Camera Work,* June 1917, 49/50:36.
21. Dorothy Norman, "From the Writings and Conversations of Alfred Stieglitz," *Twice A Year,* Fall-Winter 1938, 1:98.
22. "The Editors' Page," *Camera Work,* Apr. 1907, 18:37.
23. Quoted in "The Exhibition at the Albright Gallery— Some Facts, Figures, and Notes," *Camera Work,* Jan. 1911, 33:61.
24. Quoted in Bayley, pp. 26-27.
25. Paul Strand, "Photography," *Camera Work,* June 1917, 49/50:3.

BIBLIOGRAPHY

Anderson, Paul L. *Pictorial Photography: Its Principles and Practice.* Philadelphia: J. B. Lippincott, 1917.

Borcoman, James. *An Inquiry into the Aesthetics of Photography.* Toronto: Society for Art Publications, 1975.

Bry, Doris. *Alfred Stieglitz: Photographer.* Boston: Museum of Fine Arts, 1965.

Caffin, Charles H. *Photography as a Fine Art.* 1901. Reprint. Hastings-on-Hudson, N.Y.: Morgan & Morgan, 1971.

Camera Notes. New York: The Camera Club of New York, 1897-1903.

Camera Work. New York: Alfred Stieglitz, 1903-1917.

Camera Work. 1903-1917. Reprint. Nendeln, Liechtenstein: Kraus, 1969.

Coke, Van Deren. *The Painter and the Photograph.* Rev. ed. Albuquerque: University of New Mexico Press, 1972.

Dijkstra, Bram. *The Hieroglyphics of a New Speech: Cubism, Stieglitz, and the Early Poetry of William Carlos Williams.* Princeton: Princeton University Press, 1969.

Doty, Robert. *Photo-Secession.* 1960. Reprint. New York. Dover Publications, 1978.

Ehrlich, George. "Technology and the Artist: A Study of the Interaction of Technological Growth and Nineteenth Century American Pictorial Art." Ph.D. dissertation, University of Illinois, 1960.

Emerson, Peter Henry. *Naturalistic Photography.* London: Sampson Low, Marston, Searle & Rivington, 1889.

Frank, Waldo et al., ed. *America and Alfred Stieglitz: A Collective Portrait.* Garden City, N.Y.: Doubleday, Doran & Co., 1934.

Gernsheim, Helmut and Gernsheim, Alison. *The History of Photography from the Camera Obscura to the Beginning of the Modern Era.* 2d ed. New York: McGraw-Hill, 1969.

Green, Jonathan, ed. *Camera Work: A Critical Anthology.* Millerton, N.Y.: Aperture, 1973.

Hartmann, Sadakichi. *A History of American Art.* 2 vols. Boston: L. C. Page & Co., 1902.

Hartmann, Sadakichi. *Japanese Art.* Boston: L. C. Page & Co., 1904.

Hearn, Charles W. "Carbon Printing." *Photo Era,* Oct. 1901, 7:147-151.

Heyman, Therese Thau. *Anne Brigman: Pictorial Photographer/Pagan/Member of the Photo-Secession.* Oakland: The Oakland Museum, 1974.

Horgan, Stephen H. *Horgan's Half-Tone and Photomechanical Processes.* Chicago: Inland Printer Co., 1913.

Hutchins, C. C. "The Platinum Process." *The American Amateur Photographer,* Feb. 1893, 5:55-57.

Jones, Bernard E., ed., *Encyclopedia of Photography.* 1911 (*Cassell's Cyclopedia of Photography,* London). Reprint. New York: Arno Press, 1974.

Keiley, Joseph T. "Concerning the Photo-Secession." *Photo Era,* July 1903, 11:314-315.

Lyons, Nathan, ed. *Photographers on Photography: A Critical Anthology.* Englewood Cliffs, N.J.: Prentice-Hall, 1966.

Maclean, Hector. "The Two Chief Photographic Exhibitions of the Year." *The Photographic Times,* Feb. 1897, 29:74.

Miller, Henry. "Stieglitz and John Marin." *Twice A Year,* Spring-Summer/Fall-Winter 1942, 89:146-155.

Morgan, Llewellyn. "Aids to Picture Making by Photography, for Beginners." *The Amateur Photographer,* 5 Apr. 1901, 33:281-283.

Newhall, Beaumont. *Frederick H. Evans.* Millerton, N.Y.: Aperture, 1975.

Newhall, Beaumont. *The History of Photography, from 1839 to the Present Day.* Rev. ed. Garden City, N.Y.: Doubleday, 1964.

Newhall, Beaumont. *On Photography: A Source Book of Photo History in Facsimile.* Watkins Glen, N.Y.: Century House, 1956.

Newhall, Nancy. *P. H. Emerson: The Fight for Photography as a Fine Art.* Millerton, N.Y.: Aperture, 1975.

Newhall, Nancy. *A Portfolio of Sixteen Photographs by Alvin Langdon Coburn.* Rochester: George Eastman House, 1962.

Norman, Dorothy. *Alfred Stieglitz: An American Seer.* New York: Random House, 1973.

Norman, Dorothy. "From the Writings and Conversations of Alfred Stieglitz." *Twice A Year,* Fall-Winter 1938, 1:77-110.

Poore, Henry R. *Pictorial Composition.* New York: Baker & Taylor, 1903.

Robinson, Henry Peach. *Pictorial Effect in Photography.* 1869. Reprint. Pawlet, Vt.: Helios, 1971.

Rosenfeld, Paul. *Port of New York.* New York: Harcourt Brace & Co., 1924.

Satterlee, Edward. "Is Photography a Fine Art?" *The Philadelphia Photographer,* 6:326-328.

Stieglitz, Alfred. "Correspondence (Stieglitz Replies to 'Officialdom')." *Twice A Year,* Spring-Summer/Fall-Winter 1942, 8-9:172-178.

Stieglitz, Alfred. "Four Happenings." *Twice A Year,* Spring-Summer/Fall-Winter 1942, 8-9:105-136.

Stieglitz, Alfred. "Four Marin Stories." *Twice A Year,* Spring-Summer/Fall-Winter 1942, 8-9:156-162.

Stieglitz, Alfred. "Points on Developing Cold Bath Platinotypes." *The American Amateur Photographer,* May 1893, 5:209.

Stieglitz, Alfred. "Three Parables and a Happening." *Twice A Year,* Spring-Summer/Fall-Winter 1942, 8-9:163-171.

Strasser, Alexander. *Immortal Portraits.* New York: Focal Press, 1941.

Strasser, Alexander. *Victorian Photography.* London: Focal Press, 1942.

Zigrosser, Carl. "Alfred Stieglitz." *Twice A Year,* Spring-Summer/Fall-Winter 1942, 8-9:137-145.

NOTE ON THE CONTENTS
AND GLOSSARY OF TERMS

This book is, in essence, made up of four indexes. The first (pp. 1-140) is a complete, illustrated chronological inventory of all photographs and other illustrations appearing in *Camera Work,* advertisements excepted. The second index (pp. 141-146) lists the illustrations alphabetically by artist, the third (pp. 147-153) by title, and the fourth (pp. 155-157), which applies to portraits only, by the name of the sitter.

The first index is the most complete. It lists for each illustration the artist's name exactly as it appeared with the picture; the title, if any was given; the month, volume and page of the issue (including the actual publication month in the case of delayed issues); the photographic process (both the printing method used in *Camera Work* and, where applicable, the process used in the original print); and the dimensions of the illustration as it appeared in the magazine. The artist and title indexes suppress the extra bibliographical information about the dates, the process and the dimensions; the artist index however, attempts to give more complete forms of names. The sitter index lists only the full name of the sitter, as determined by the editor, and the page location.

Camera Work usually grouped its illustrations into sections that stood apart from the text portions of the magazine, and Roman numbers were frequently assigned to the pictures in each group. These numbers have been retained in these indexes as integral parts of the titles, primarily to help distinguish different photographs with the same name.

Camera Work pagination has been determined from the original issues and not from the Kraus reprint edition found in most libraries. The abbreviation "SS" denotes the special, unnumbered Steichen Supplement (Apr. 1906) and "SN" refers to a "Special Number." It should also be noted that no illustrations appeared in number 47 (July 1914, published Jan. 1915).

Throughout each index, material in parentheses represents alternate spellings or other discrepancies that appeared in *Camera Work* from time to time; bracketed material represents this editor's additions, such as the identification of an illustration with no title or the presentation of a more complete form of an artist's name.

GLOSSARY OF PHOTOGRAPHIC PROCESSES

In the main chronological index (pp. 1-140) the photographic processes related to each photograph are listed. Where one process only is given, this is the method of reproduction used to produce the print published in *Camera Work;* where two are listed, the second is this *Camera Work* process and the first is the process used to make the original print which *Camera Work* reproduced from. In this glossary the entries are thus arranged with printing processes grouped at the beginning and reproduction processes nearer to the end.

CARBON PROCESS

In this process unsensitized paper was coated with either gelatin containing carbon black or pigment color or with commercially made carbon tissue. The paper was then sensitized in a bichromate bath and allowed to dry. During contact printing in daylight, areas of the carbon tissue hardened in proportion to the amount of light the negative permitted. After exposure the print was developed in water, washing away those areas of carbon not hardened by the light.

The top of the carbon tissue formed a tough "skin" during exposure so that the underside next to the paper was still soluble. Because of this property, the carbon tissue had to be transferred to another sheet of paper; this differentiated the carbon process from other light-hardened emulsions. The transferred image was reversed left to right and could be transferred a second time onto a third piece of paper (the double transfer was also known as an autotype).

GUM

This popular process is most often associated with the Europeans Robert Demachy and Heinrich Kühn but was

also widely used in this country at the turn of the century.

Paper was coated with a sensitized gum arabic and allowed to dry in a dark room. As in the carbon process, the photograph was contact-printed, developed in water and dried. However, in the gum process the photographer had the option of adding layers of other color by recoating the paper and proceeding as in the first layer.

Because the paper was hand-coated, areas of the negative could simply be left out by not applying gum to that portion of the paper. Manipulation of the surface could also be accomplished during development by rubbing or brushing the soft emulsion.

OZOTYPE

The ozotype process was similar to both carbon and gum processes because unsensitized paper could be coated with either gum or a commercially made sensitized gelatin. Also as with carbon and gum, the gelatin or gum emulsion hardened with exposure to light and the soluble portions were washed away during development.

A pigment plaster (paper coated with pigment gelatin) was soaked in acid and applied to the image surface. The color of the plaster was picked up by the surface of the original print and the paper backing on the plaster was pulled away. While the photograph was still damp the surface could be manipulated with a soft brush. No transfer of image was required.

PLATINUM/PLATINOTYPE

These synonymous terms described a process in which paper was coated with a solution of iron salts and a platinum compound. A difficult chemical process, most photographers of the time bought ready-made platinum paper, which was then available.

The paper, much admired for its permanency and wide range of tones, was contact-printed until the image was lightly visible ("printed out") and then developed to the desired intensity.

GLYCERINE/GLYCERINE PLATINOTYPE

A glycerine print was a manipulated platinum print. A combination of glycerine and developer was brushed on desired areas of a normally developed platinotype to alter the appearance of the print.

AUTOCHROME

Perfected during the years 1904–1907 by the Lumière brothers, the autochrome was the first commercially successful color transparency. Grains of starch dyed red-orange, green and blue-violet were dusted over a piece of glass which had been coated with adhesive varnish to form a single layer. The grains were then crushed against the glass to form a mosaic pattern. Any remaining openings between grains were filled with finely ground carbon black to ensure that light would only pass through the dyed grains. The plate was then varnished and coated with panchromatic-sensitive emulsion.

Because the plate was placed in the camera with the glass side toward the lens, the light passed through the dyed starch grains, which served as selective, microscopic color filters, before it reached the color-sensitive emulsion. Thus, when red light reflected off an apple, it passed through only the red-orange starch grains and exposed only that section of the emulsion. After the plate was developed, a pattern of exposed red-orange, green and blue-violet points emerged. These were so miniscule that when the plate was held up to the light, a positive color picture could be seen.

PHOTOGRAVURE

In photogravure a carbon negative was attached to the surface of a specially treated copper plate. During a series of acid baths the plate was etched to different depths, depending on the thickness of the carbon. The depth of the etched area determined the relative darkness of the printed image when the desired printing paper was pressed against the cleaned and inked intaglio plate.

DUOGRAVURE

An image made by double printing on a gravure press, duogravure was used to deepen tones or to add color.

COLLOTYPE

Collotype was an ink printing process in which a glass printing plate was coated with bichromated gelatin that reticulated during the drying process. The plate was contact-printed with a negative and then washed, leaving a positive image formed by the light-hardened gelatin.

A dilution of glycerine and water was then applied to the surface and absorbed into the areas of less hardened gelatin. As in lithographic printing, the ink was repelled from those areas where water had been absorbed, leaving a positive ink image on the hardened gelatin.

HALFTONE

A commercial reproduction process that prepared a continuous tone image for printing by a process of reducing the image to a dot pattern. The dots varied in size,

the largest carrying more ink and therefore printing the darkest areas, the middle sizes printing the half or middle tones and the smallest printing highlights.

A high-contrast negative was made of the desired photograph by placing the grated screen between the film and the photograph. This caused the screen to be super-imposed onto the original image. The halftone image was transferred to a treated printing plate used for offset reproduction.

DUOTONE

By using a double printing on a halftone press from the same monochrome original, duotone achieved a two-color effect.

MEZZOTINT PHOTOGRAVURE

In this process a special screen pattern was used to produce a screened image on a gravure press for a hand-drawn effect.

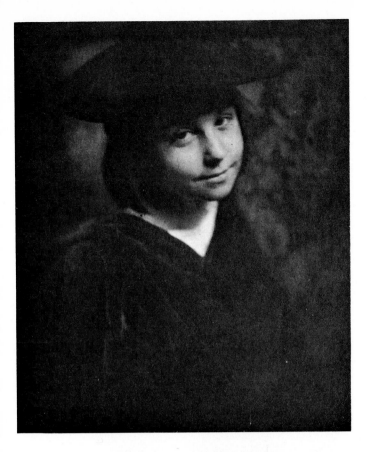

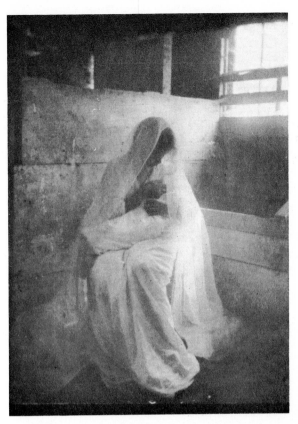

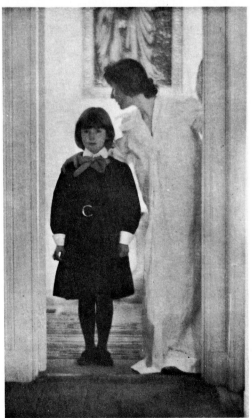

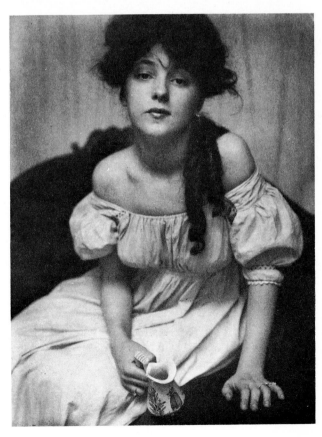

UPPER LEFT: *I. Dorothy*, by Gertrude Käsebier. Jan. 1903, 1:5. Original negative; photogravure. 19.9 x 16.1 cm. UPPER RIGHT: *II. The Manger*, by Gertrude Käsebier. Jan. 1903, 1:7. Original negative; photogravure. 21.1 x 14.8 cm. LOWER LEFT: *III.*

Blessed Art Thou Among Women, by Gertrude Käsebier. Jan. 1903, 1:9. Original negative; photogravure. 23.6 x 14.0 cm. LOWER RIGHT: *IV. Portrait (Miss N.)*, by Gertrude Käsebier. Jan. 1903, 1:11. Original negative; photogravure. 19.5 x 14.7 cm.

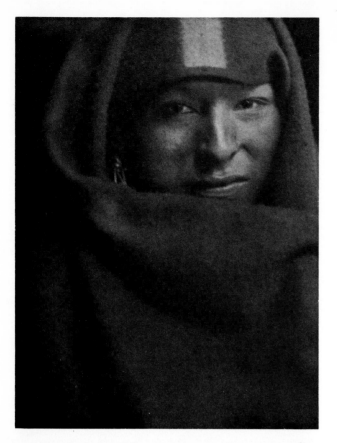

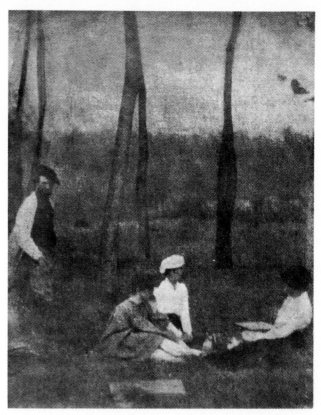

UPPER LEFT: *V. The Red Man*, by Gertrude Käsebier. Jan. 1903, 1:14. Original negative; photogravure. 18.2 x 13.6 cm. UPPER RIGHT: *Serbonne*, by Gertrude Käsebier. Jan. 1903, 1:27. Gum; halftone. 18.0 x 13.8 cm. LOWER LEFT: *Landscape*, by D. W. Tryon. Jan. 1903, 1:31. Halftone. 5.9 x 12.8 cm. LOWER RIGHT: *L'Hiver*, by Puvis de Chavannes. Jan. 1903, 1:31. Halftone. 8.2 x 12.8 cm.

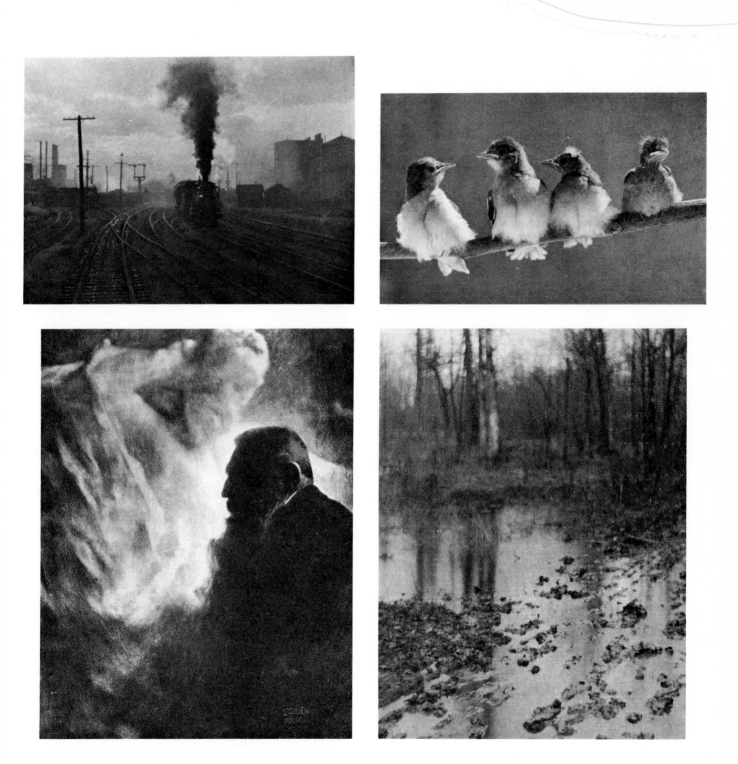

UPPER LEFT: *The Hand of Man*, by Alfred Stieglitz. Jan. 1903, 1:47. Original negative; photogravure. 15.6 x 21.3 cm. UPPER RIGHT: *A Study in Natural History*, by A. Radclyffe Dugmore. Jan. 1903, 1:55. Original negative; photogravure. 11.2 x 17.2 cm. LOWER LEFT: *I. Rodin*, by Eduard J. Steichen. Apr. 1903, 2:5. Gum; photogravure. 21.1 x 16.0 cm. LOWER RIGHT: *II. The Pool*, by Eduard J. Steichen. Apr. 1903, 2:7. Original negative; photogravure. 20.3 x 15.3 cm.

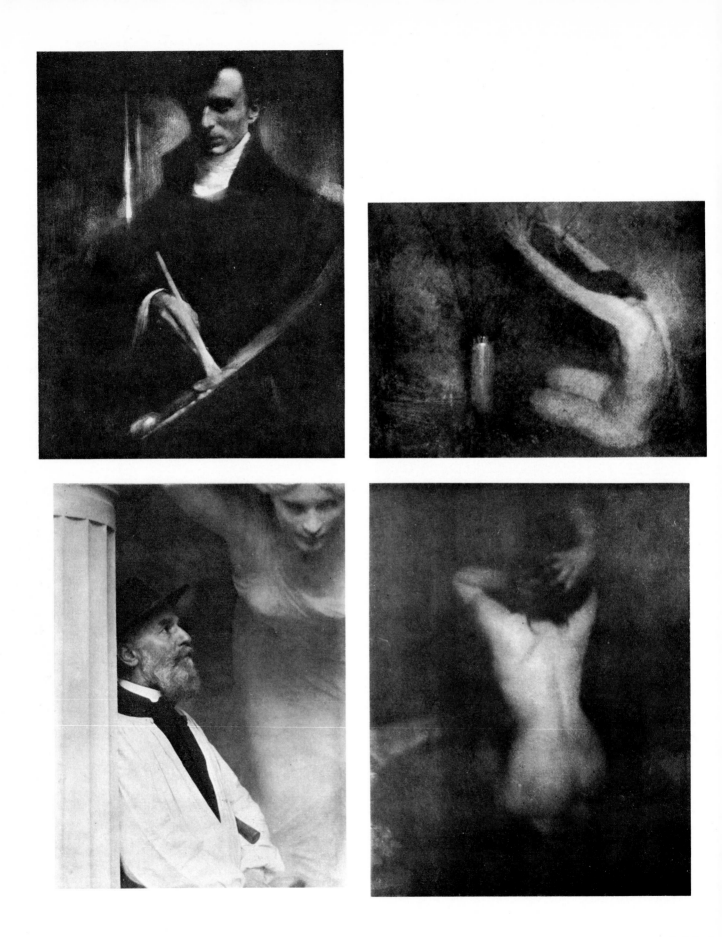

UPPER LEFT: *III. Self-portrait*, by Eduard J. Steichen. Apr. 1903, 2:9. Gum, photogravure. 21.3 x 16.1 cm. UPPER RIGHT: *IV. Dawn-flowers*, by Eduard J. Steichen. Apr. 1903, 2:11. Original negative; photogravure. 14.8 x 19.5 cm. LOWER LEFT: *V.*

Bartholomé, by Eduard J. Steichen. Apr. 1903, 2:13. Original negative; photogravure. 20.8 x 15.1 cm. LOWER RIGHT: *VI. Dolor*, by Eduard J. Steichen. Apr. 1903, 2:15. Original negative; photogravure. 19.2 x 14.8 cm.

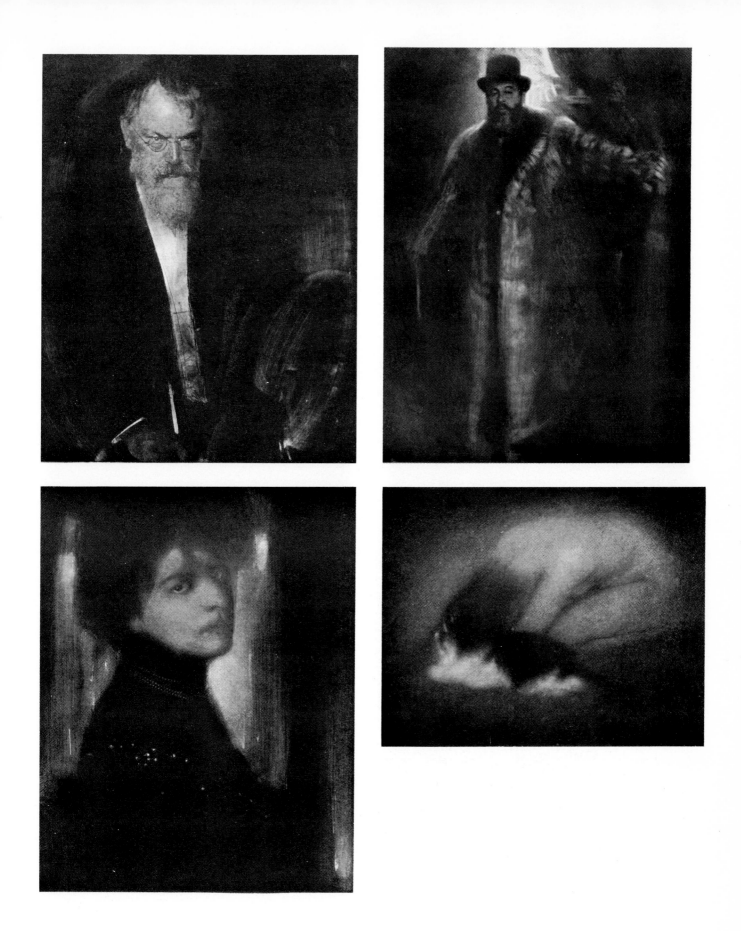

UPPER LEFT: *VII. Lenbach*, by Eduard J. Steichen. Apr. 1903, 2:17. Gum; photogravure. 20.3 x 15.8 cm. UPPER RIGHT: *VIII. Besnard*, by Eduard J. Steichen. Apr. 1903, 2:20. Gum; halftone. 17.4 x 13.1 cm. LOWER LEFT: *IX. Portrait*, by Eduard J. Steichen. Apr. 1903, 2:37. Gum; halftone. 16.8 x 13.1 cm. LOWER RIGHT: *X. Nude with Cat*, by Eduard J. Steichen. Apr. 1903, 2:39. Gum; halftone. 11.0 x 13.7 cm.

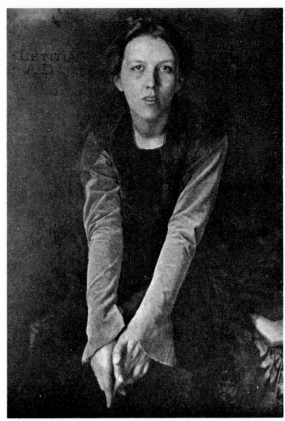

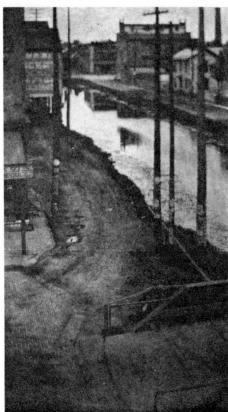

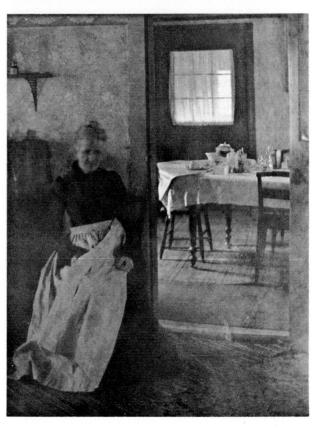

UPPER LEFT: *XI. Judgment of Paris—A Landscape Arrangement*, by Eduard J. Steichen. Apr. 1903, 2:41. Platinum; halftone. 15.2 x 11.5 cm. UPPER RIGHT: *I. Letitia Felix*, by Clarence H. White. July 1903, 3:7. Original negative; photogravure. 21.0 x 14.3 cm. LOWER LEFT: *II. Telegraph Poles*, by Clarence H. White. July 1903, 3:9. Original negative; photogravure. 18.7 x 10.3 cm. LOWER RIGHT: *III. Illustration to "Eben Holden,"* by Clarence H. White. July 1903, 3:11. Original negative; photogravure. 19.5 x 14.9 cm.

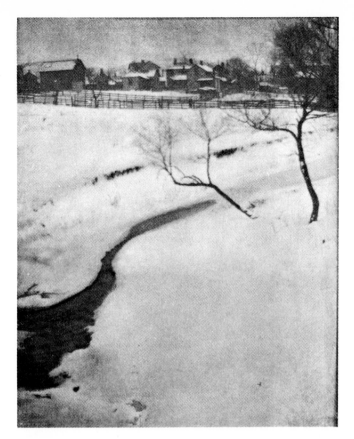

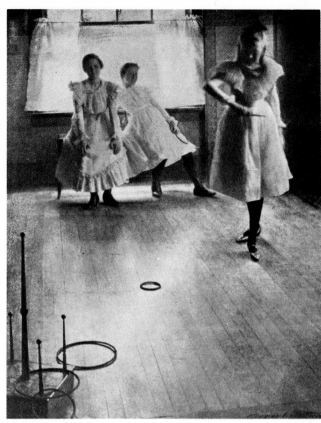

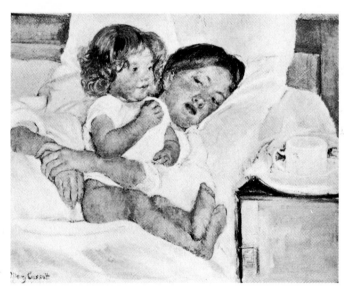

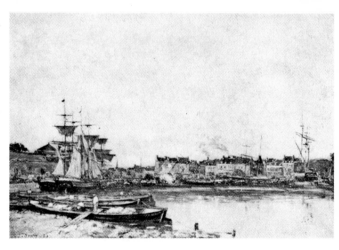

UPPER LEFT: *IV. Winter Landscape,* by Clarence H. White. July 1903, 3:13. Platinum; halftone. 17.7 x 13.6 cm. UPPER RIGHT: *V. Ring Toss,* by Clarence H. White. July 1903, 3:14. Gum; color halftone. 17.5 x 13.7 cm. LOWER LEFT: *The Break-* *fast in Bed,* by Mary Cassatt. July 1903, 3:19. Halftone. 9.2 x 11.2 cm. LOWER RIGHT: *The Old Basin of Dunkirk,* by E. Boudin. July 1903, 3:19. Halftone. 7.7 x 11.3 cm.

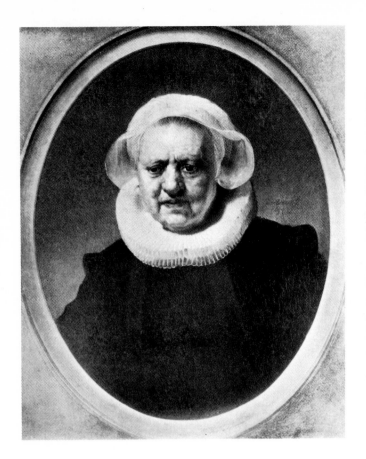

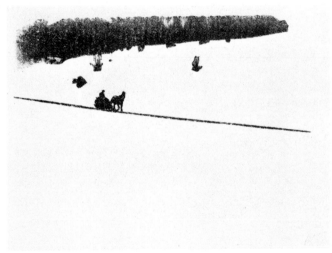

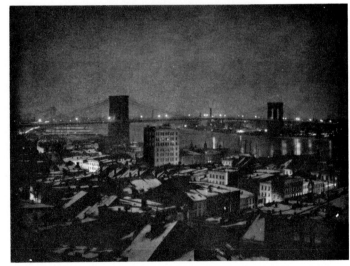

UPPER LEFT: *The Admiral's Wife*, by Rembrandt. July 1903, 3:29. Halftone. 15.8 x 12.6 cm. UPPER RIGHT: Untitled [silhouette photograph], by Ward Muir. July 1903, 3:35. Halftone. 11.4 x 8.5 cm. LOWER LEFT: Untitled [silhouette photograph], by Ward Muir. July 1903, 3:37. Halftone. 6.4 x 8.6 cm. LOWER RIGHT: *I. The Bridge*, by John Francis Strauss. July 1903, 3:43. Original negative; photogravure. 15.8 x 20.7 cm.

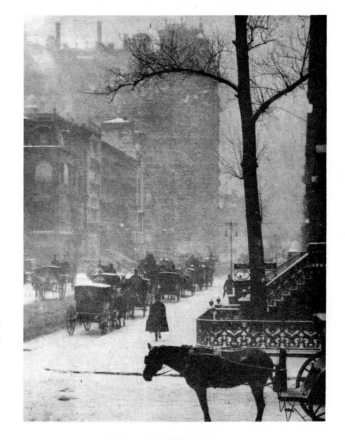

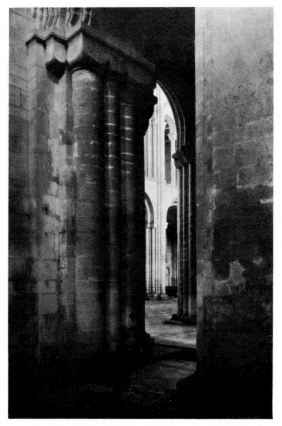

UPPER LEFT: *II. The Last Hour*, by Joseph T. Keiley. July 1903, 3:45. Platinum; halftone. 11.6 x 19.2 cm. UPPER RIGHT: *III. The Street—Design for a Poster*, by Alfred Stieglitz. July 1903, 3:47. Original negative; photogravure. 17.5 x 13.2 cm. LOWER LEFT:

IV. Winter Shadows, by Alvin Langdon Coburn. July 1903, 3:49. Original negative; photogravure. 14.4 x 19.1 cm. LOWER RIGHT: *I. Ely Cathedral: A Memory of the Normans*, by Frederick H. Evans. Oct. 1903, 4:5. Photogravure. 19.9 x 13.0 cm.

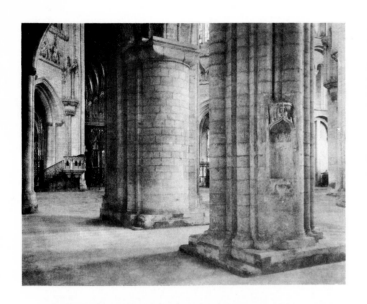

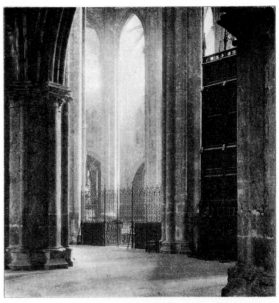

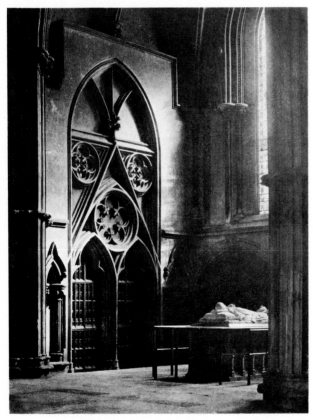

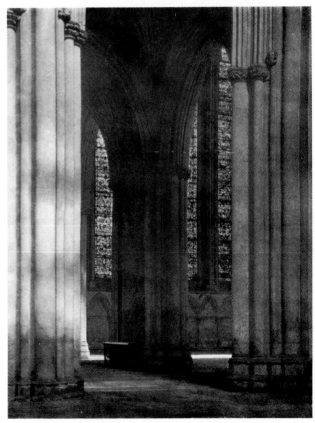

UPPER LEFT: *II. Ely Cathedral: Across Nave and Octagon,* by Frederick H. Evans. Oct. 1903, 4:7. Photogravure. 14.5 x 18.4 cm. UPPER RIGHT: *III. Height and Light in Bourges Cathedral,* by Frederick H. Evans. Oct. 1903, 4:9. Photogravure. 7.0 x 7.0 cm. LOWER LEFT: *IV. York Minster: "In Sure and Certain Hope,"* by Frederick H. Evans. Oct. 1903, 4:12. Photogravure. 20.0 x 14.8 cm. LOWER RIGHT: *V. York Minster: Into the North Transept,* by Frederick H. Evans. Oct. 1903, 4:29. Halftone. 20.2 x 15.0 cm.

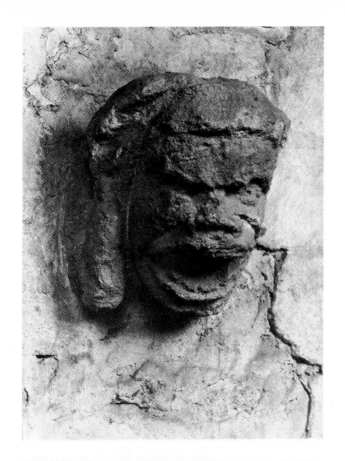

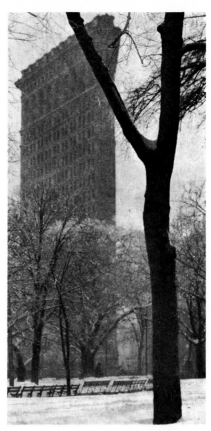

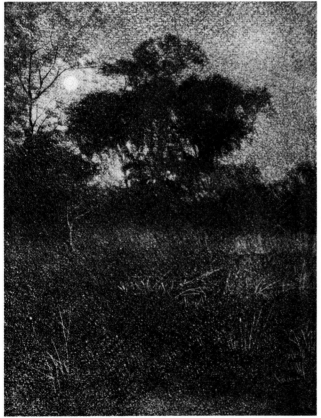

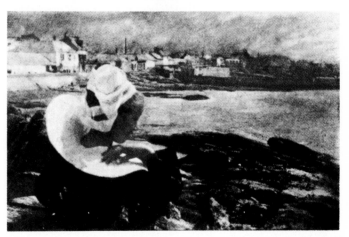

UPPER LEFT: *VI. Ely Cathedral: A Grotesque*, by Frederick H. Evans. Oct. 1903, 4:31. Halftone. 20.7 x 15.0 cm. UPPER RIGHT: *I. The "Flat-iron,"* by Alfred Stieglitz. Oct. 1903, 4:49. Original negative; photogravure. 16.8 x 8.2 cm. LOWER LEFT: *II. Moon-light*, by Arthur E. Becher. Oct. 1903, 4:51. Gum; colored halftone. 17.0 x 12.9 cm. LOWER RIGHT: *I. In Brittany*, by Robert Demachy. Jan. 1904, 5:5. Gum; photogravure. 13.1 x 20.1 cm.

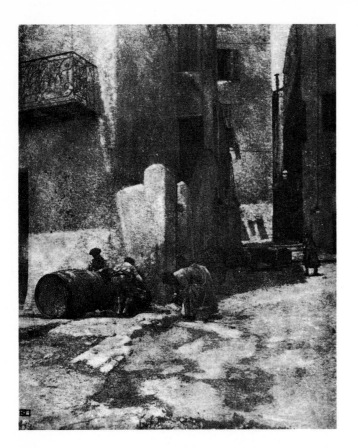

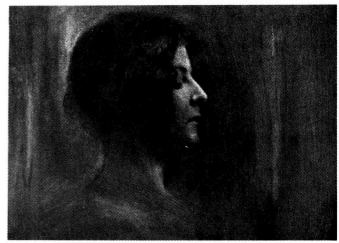

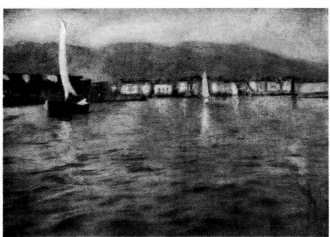

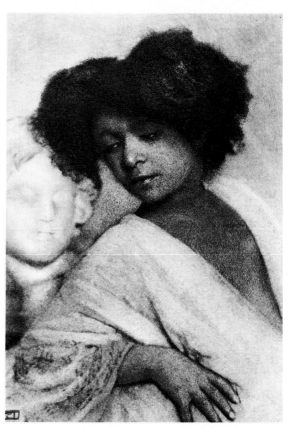

UPPER LEFT: *II. Street in Mentone*, by Robert Demachy. Jan. 1904, 5:7. Gum; photogravure. 16.3 x 12.7 cm. UPPER RIGHT: *III. Severity*, by Robert Demachy. Jan. 1904, 5:9. Gum; halftone. 11.4 x 15.8 cm. LOWER LEFT: *IV. On the Lake*, by Robert Demachy. Jan. 1904, 5:11. Gum; halftone. 11.8 x 17.0 cm. LOWER RIGHT: *V. Contrasts*, by Robert Demachy. Jan. 1904, 5:13. Gum; photogravure. 16.6 x 11.5 cm.

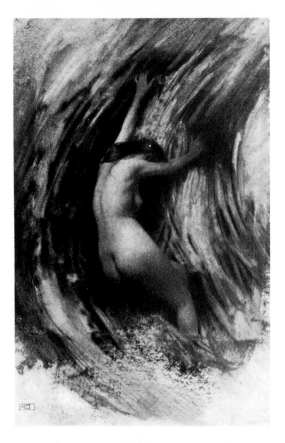

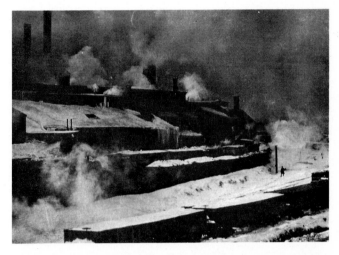

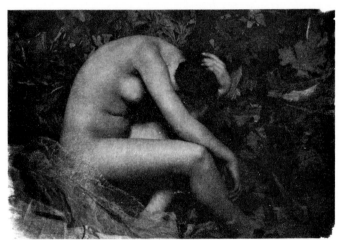

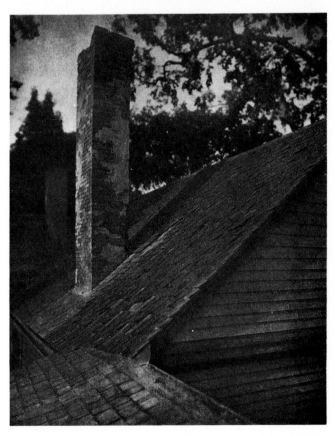

UPPER LEFT: *VI. Struggle,* by Robert Demachy. Jan. 1904, 5:16. Gum; halftone. 19.4 x 12.1 cm. UPPER RIGHT: *I. 'Midst Steam and Smoke,* by Prescott Adamson. Jan. 1904, 5:37. Original negative; photogravure. 13.1 x 18.4 cm. LOWER LEFT: *II. La Cigale,* by

Frank Eugene. Jan. 1904, 5:39. Original negative; photogravure. 12.1 x 17.0 cm. LOWER RIGHT: *I. Gables,* by Alvin Langdon Coburn. Apr. 1904, 6:5. Photogravure. 18.7 x 14.8 cm.

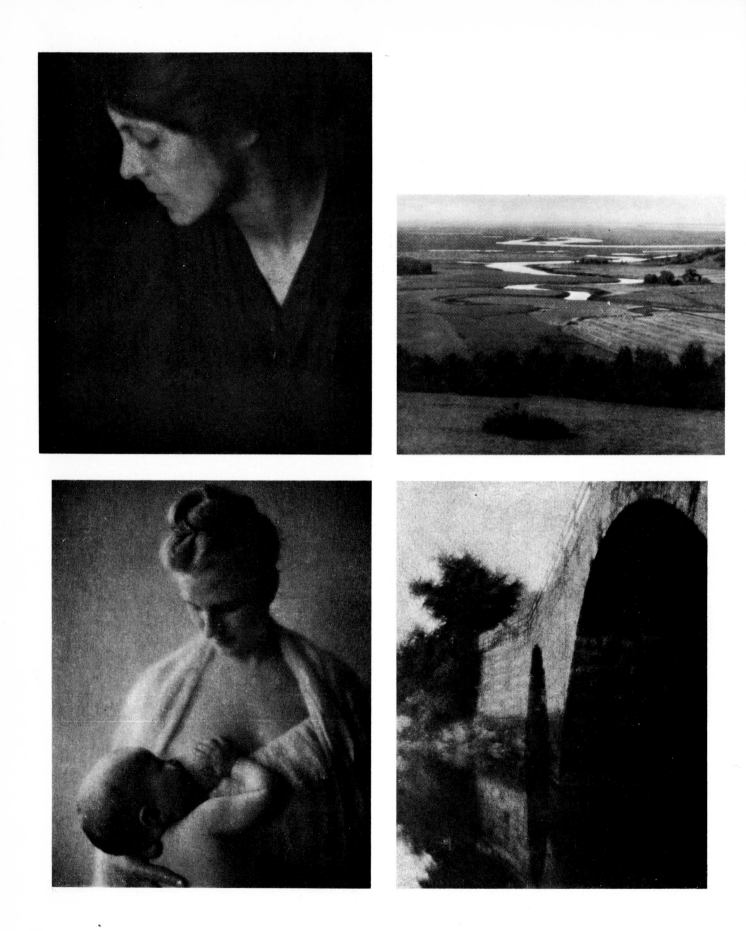

UPPER LEFT: *II. A Portrait Study*, by Alvin Langdon Coburn. Apr. 1904, 6:7. Photogravure. 17.7 x 14.8 cm. UPPER RIGHT: *III. The Dragon*, by Alvin Langdon Coburn. Apr. 1904, 6:9. Duotone. 13.7 x 17.7 cm. LOWER LEFT: *IV. Mother and Child— A Study*, by Alvin Langdon Coburn. Apr. 1904, 6:11. Photogravure. 18.0 x 14.6 cm. LOWER RIGHT: *V. The Bridge—Ipswich*, by Alvin Langdon Coburn. Apr. 1904, 6:13. Photogravure. 19.2 x 14.9 cm.

UPPER LEFT: *VI. House on the Hill*, by Alvin Langdon Coburn. Apr. 1904, 6:16. Photogravure. 14.8 x 18.7 cm. UPPER RIGHT: *I. Under the Pines*, by Will A. Cadby. Apr. 1904, 6:29. Halftone. 18.3 x 12.9 cm. LOWER LEFT: *II. Storm Light*, by Will A. Cadby. Apr. 1904, 6:31. Halftone. 9.6 x 13.0 cm. LOWER RIGHT: *Wintry Weather*, by W. B. Post. Apr. 1904, 6:43. Photogravure. 14.9 x 16.2 cm.

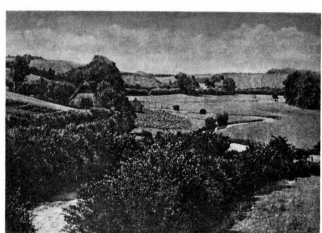

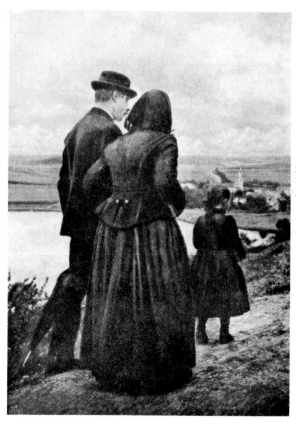

UPPER LEFT: *I. The Solitary Horseman*, by Theodor and Oscar Hofmeister. July 1904, 7:5. Gum; photogravure. 12.1 x 17.7 cm.
UPPER RIGHT: *II. Dachau*, by Theodor and Oscar Hofmeister. July 1904, 7:7. Gum; photogravure. 17.8 x 12.5 cm. LOWER

LEFT: *III. Meadow-brook*, by Theodor and Oscar Hofmeister. July 1904, 7:9. Gum; photogravure. 12.3 x 17.7 cm. LOWER RIGHT: *IV. The Churchgoers*, by Theodor and Oscar Hofmeister. July 1904, 7:11. Gum; halftone. 17.7 x 12.3 cm.

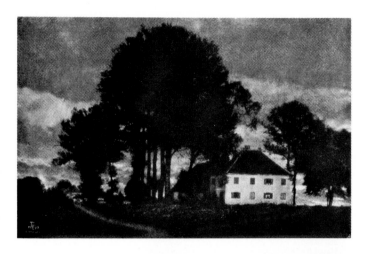

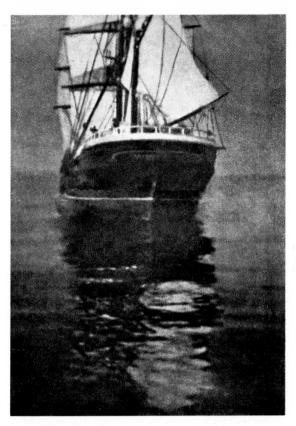

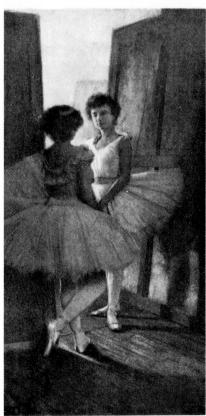

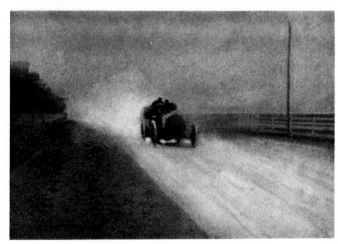

UPPER LEFT: *V. A Village Corner*, by Theodor and Oscar Hofmeister. July 1904, 7:13. Gum; halftone. 12.0 x 17.6 cm. UPPER RIGHT: *VI. Sea Calm*, by Theodor and Oscar Hofmeister. July 1904, 7:16. Gum; halftone. 17.7 x 12.1 cm. LOWER LEFT: *I. Behind the Scenes*, by Robert Demachy. July 1904, 7:29. Gum; halftone. 19.2 x 9.5 cm. LOWER RIGHT: *II. Speed*, by Robert Demachy. July 1904, 7:31. Gum; halftone. 12.4 x 17.9 cm.

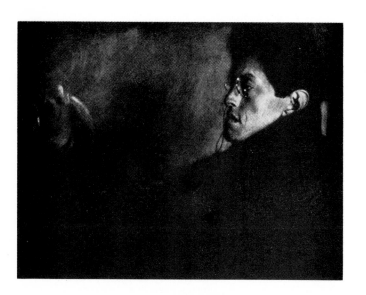

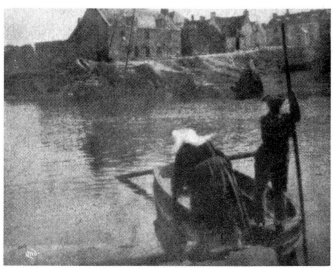

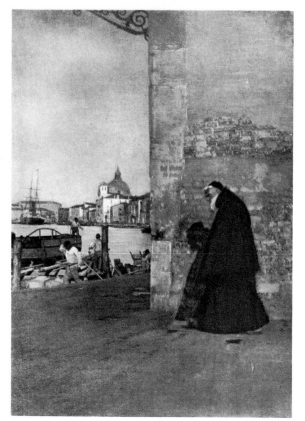

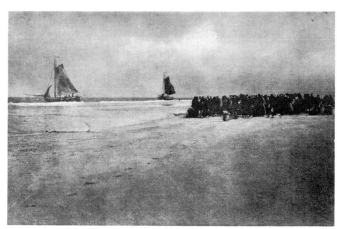

UPPER LEFT: *I. Sadakichi Hartmann*, by Eduard J. Steichen. July 1904, 7:49. Gum; halftone. 11.9 x 15.1 cm. UPPER RIGHT: *II. The Ferry, Concarneau*, by Mary Devens. July 1904, 7:51. Ozotype; halftone. 12.2 x 15.5 cm. LOWER LEFT: *I. A Franciscan, Venice*, by J. Craig Annan. Oct. 1904, 8:5. Photogravure. 19.6 x 13.8 cm. LOWER RIGHT: *II. On a Dutch Shore*, by J. Craig Annan. Oct. 1904, 8:7. Photogravure. 15.0 x 23.0 cm.

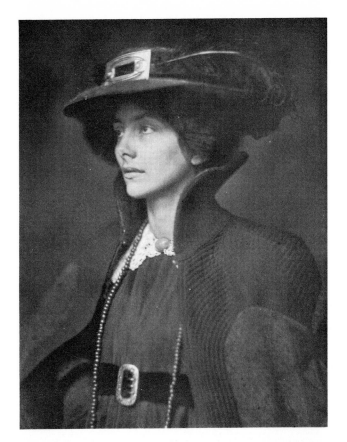

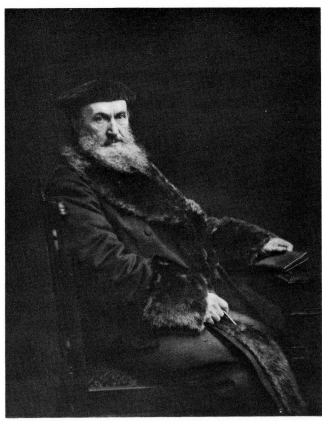

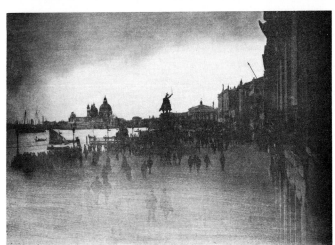

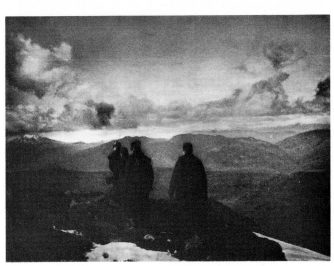

UPPER LEFT: *III. Frau Mathasius*, by J. Craig Annan. Oct. 1904, 8:9. Photogravure. 20.6 x 15.5 cm. UPPER RIGHT: *IV. Prof. John Young, of Glasgow University*, by J. Craig Annan. Oct. 1904, 8:11. Photogravure. 19.8 x 15.3 cm. LOWER LEFT: *V. The Riva Schiavoni, Venice*, by J. Craig Annan. Oct. 1904, 8:13. Photogravure. 14.2 x 19.9 cm. LOWER RIGHT: *VI. The Dark Mountains*, by J. Craig Annan. Oct. 1904, 8:15. Photogravure. 14.9 x 20.1 cm.

UPPER LEFT: Untitled [inkblot], by J. B. Kerfoot. Oct. 1904, 8:29. Letterpress. 3.3 x 1.8 cm. (approx.). UPPER RIGHT: Untitled [silhouette of Stieglitz], by J. B. Kerfoot. Oct. 1904, 8:29. Letterpress. 5.2 x 3.2 cm. (approx.). LOWER LEFT: Untitled [silhouette of Steichen], by J. B. Kerfoot. Oct. 1904, 8:30. Letterpress. 4.5 x 2.8 cm. (approx.). LOWER RIGHT: Untitled [silhouette of Coburn], by J. B. Kerfoot. Oct. 1904, 8:30. Letterpress. 5.5 x 3.8 cm. (approx.).

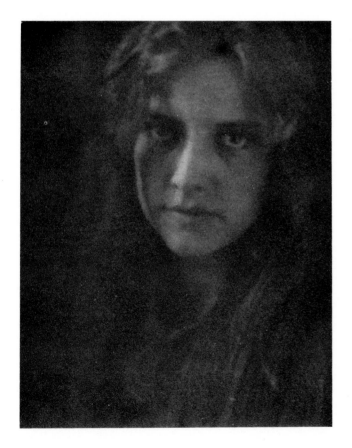

UPPER LEFT: Untitled [silhouette of Coburn], by J. B. Kerfoot. Oct. 1904, 8:31. Letterpress. 5.0 x 6.5 cm. (approx.). UPPER RIGHT: Untitled [silhouette of Käsebier], by J. B. Kerfoot. Oct. 1904, 8:31. Letterpress. 4.2 x 7.2 cm. (approx.). LOWER LEFT:

Study—Miss R., by Alvin Langdon Coburn. Oct. 1904, 8:33. Photogravure. 21.0 x 16.2 cm. LOWER RIGHT: *In Sure and Certain Hope*, by Frederick H. Evans. Oct. 1904, 8:47. Photogravure. 19.8 x 14.6 cm.

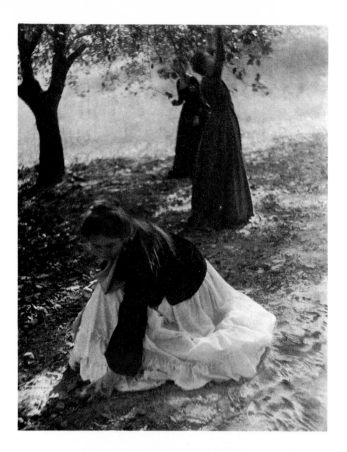

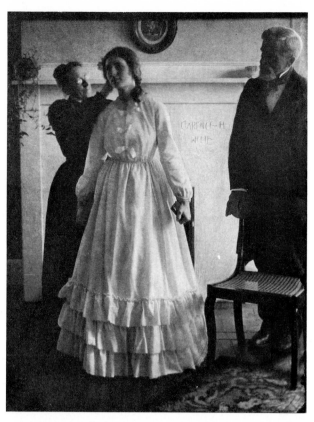

UPPER LEFT: *I. The Orchard*, by Clarence H. White. Jan. 1905, 9:5. Original negative; photogravure. 20.5 x 15.6 cm. UPPER RIGHT: *II. Illustration to "Beneath the Wrinkle,"* by Clarence H. White. Jan. 1905, 9:7. Original negative; photogravure. 20.1 x 15.5 cm. LOWER LEFT: *III. Illustration to "Eben Holden,"* by Clarence H. White. Jan. 1905, 9:9. Original negative; photogravure. 19.6 x 13.9 cm. LOWER RIGHT: *IV. Boy with Camera Work*, by Clarence H. White. Jan. 1905, 9:11. Original negative; photogravure. 19.2 x 14.5 cm.

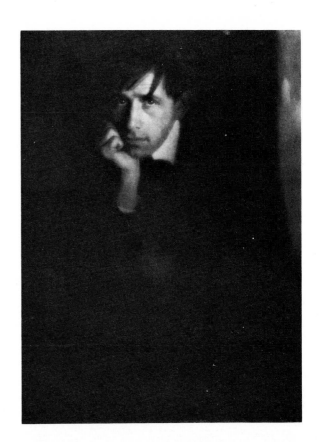

UPPER LEFT: *V. The Beatty Children*, by Clarence H. White. Jan. 1905, 9:13. Original negative; photogravure. 21.4 x 14.3 cm. UPPER RIGHT: *VI. Portrait of Clarence H. White*, by Eduard J. Steichen. Jan. 1905, 9:15. Original negative; photogravure. 21.3 x 16.1 cm. LOWER LEFT: *I. Head of a Young Girl*, by Eva Watson-Schütze. Jan. 1905, 9:29. Original negative; photogravure. 19.8 x 13.6 cm. LOWER RIGHT: *II. Portrait Study*, by Eva Watson-Schütze. Jan. 1905, 9:31. Original negative; photogravure. 21.0 x 16.3 cm.

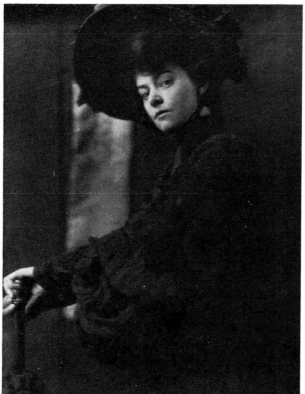

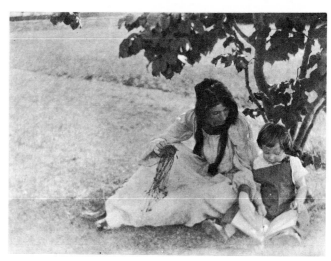

UPPER LEFT: *III. The Rose*, by Eva Watson-Schütze. Jan. 1905, 9:33. Gum; halftone. 21.3 x 7.9 cm. UPPER RIGHT: *IV. Storm*, by Eva Watson-Schütze. Jan. 1905, 9:35. Glycerine; halftone. 18.5 x 13.9 cm. LOWER LEFT: *I. Portrait—Miss Minnie Ashley*, by Gertrude Käsebier. Apr. 1905, 10:5. Original negative; photogravure. 22.3 x 17.2 cm. LOWER RIGHT: *II. The Picture-book*, by Gertrude Käsebier. Apr. 1905, 10:7. Original negative; photogravure. 21.2 x 16.5 cm.

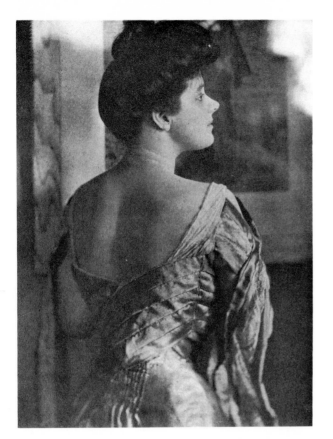

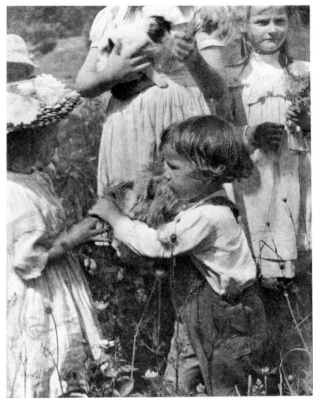

UPPER LEFT: *III. Portrait—Mrs. Philip Lydig*, by Gertrude Käsebier. Apr. 1905, 10:9. Original negative; photogravure. 20.3 x 14.7 cm. UPPER RIGHT: *IV. Happy Days*, by Gertrude Käsebier. Apr. 1905, 10:11. Original negative; photogravure. 20.5 x 16.5 cm. LOWER LEFT: *V. My Neighbors*, by Gertrude Käsebier. Apr. 1905, 10:13. Original negative; photogravure. 21.4 x 16.6 cm. LOWER RIGHT: *VI. Pastoral*, by Gertrude Käsebier. Apr. 1905, 10:15. Original negative; photogravure. 21.1 x 16.6 cm.

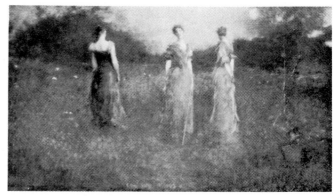

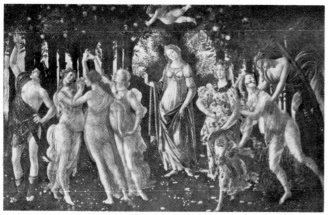

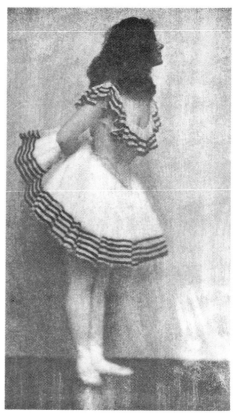

UPPER LEFT: Untitled, by Outamaro. Apr. 1905, 10:29. Half-tone. 18.7 x 11.9 cm. UPPER RIGHT: *In the Garden*, by Thomas W. Dewing. Apr. 1905, 10:31. Halftone. 7.3 x 13.0 cm. LOWER

LEFT: *Spring*, by Botticelli. Apr. 1905, 10:31. Halftone. 8.3 x 12.9 cm. LOWER RIGHT: *I. A Coryphée*, by C. Yarnall Abbott. Apr. 1905, 10:45. Halftone. 17.5 x 9.7 cm.

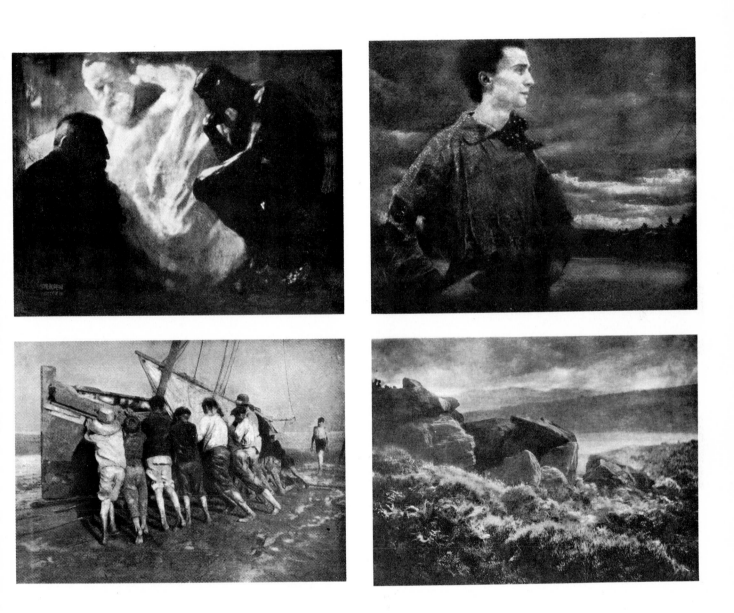

UPPER LEFT: *I. Rodin—Le Penseur*, by Eduard J. Steichen. July 1905, 11:35. Gum; halftone. 14.6 x 18.3 cm. UPPER RIGHT: *II. Portrait of a Young Man*, by Eduard J. Steichen. July 1905, 11:37. Gum; halftone. 12.0 x 14.6 cm. LOWER LEFT: *III.* *L'Effort*, by Robert Demachy. July 1905, 11:39. Gum; halftone. 20.5 x 15.0 cm. LOWER RIGHT: *I. Rain from the Hills*, by A. Horsley Hinton. July 1905, 11:53. Platinotype; photogravure. 19.7 x 14.6 cm.

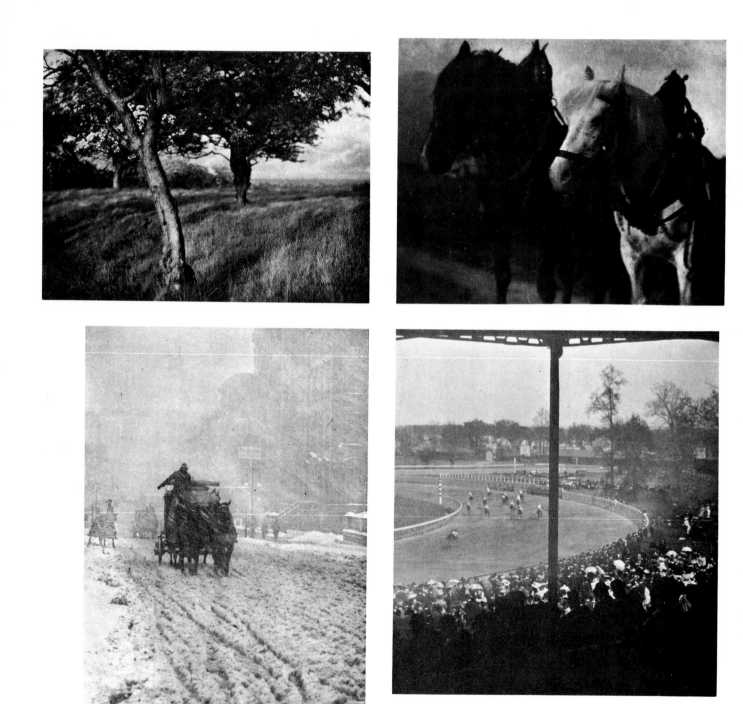

UPPER LEFT: *II. Beyond*, by A. Horsley Hinton. July 1905, 11:55. Platinotype; photogravure. 14.2 x 18.7 cm. UPPER RIGHT: *I. Horses (1904)*, by Alfred Stieglitz. Oct. 1905, 12:5. Original negative; photogravure. 22.8 x 18.2 cm. LOWER LEFT: *II. Win-ter—Fifth Avenue (1892)*, by Alfred Stieglitz. Oct. 1905, 12:7. Original negative; photogravure. 21.7 x 15.2 cm. LOWER RIGHT: *III. Going to the Start (1904)*, by Alfred Stieglitz. Oct. 1905, 12:9. Original negative; photogravure. 21.2 x 18.9 cm.

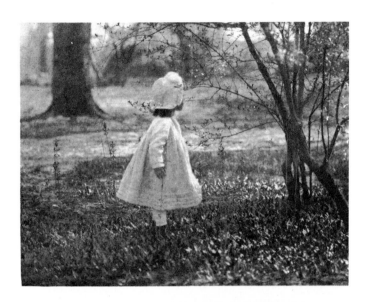

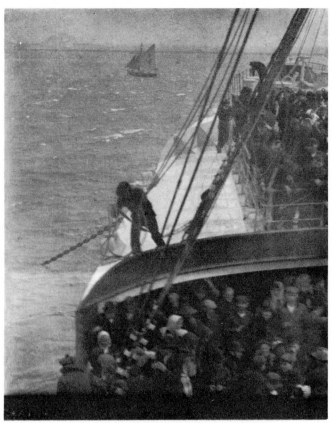

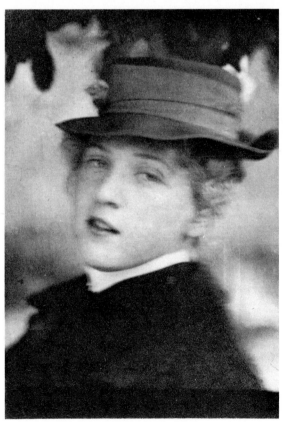

UPPER LEFT: *IV. Spring (1901)*, by Alfred Stieglitz. Oct. 1905, 12:11. Original negative; photogravure. 15.7 x 12.5 cm. UPPER RIGHT: *V. Nearing Land (1904)*, by Alfred Stieglitz. Oct. 1905, 12:13. Original negative; photogravure. 21.4 x 17.3 cm. LOWER

LEFT: *VI. Katherine (1905)*, by Alfred Stieglitz. Oct. 1905, 12:15. Original negative; photogravure. 20.7 x 16.8 cm. LOWER RIGHT: *VII. Miss S. R. (1904)*, by Alfred Stieglitz. Oct. 1905, 12:17. Original negative; photogravure. 20.4 x 14.0 cm.

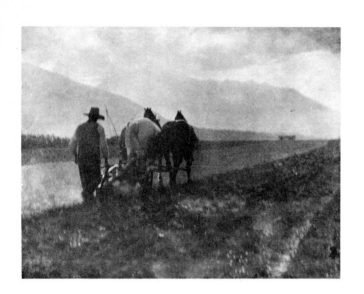

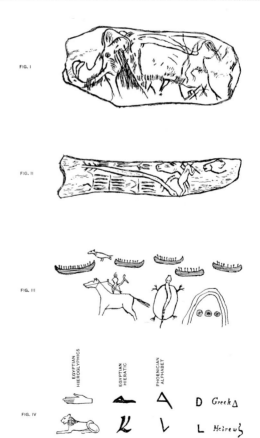

UPPER LEFT: *VIII. Ploughing (1904)*, by Alfred Stieglitz. Oct. 1905, 12:19. Original negative; photogravure. 24.2 x 18.8 cm. UPPER RIGHT: *IX. Gossip—Katwyk (1894)*, by Alfred Stieglitz. Oct. 1905, 12:21. Carbon; halftone. 20.4 x 12.6 cm. LOWER

LEFT: *X. September (1899)*, by Alfred Stieglitz. Oct. 1905, 12:23. Gum; halftone. 15.8 x 11.4 cm. LOWER RIGHT: Untitled, unidentified. Oct. 1905, 12:31. Halftone. 21.0 x 11.0 cm.

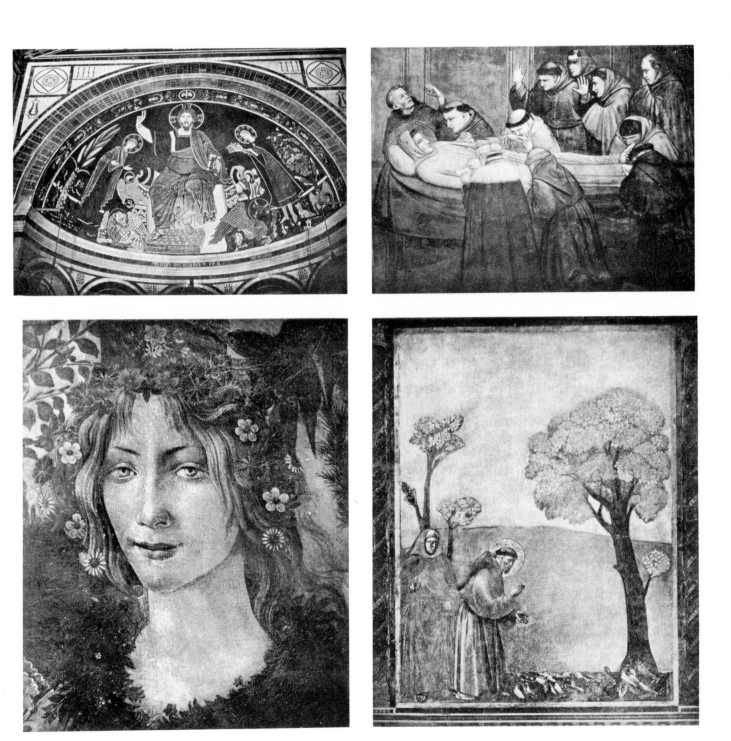

UPPER LEFT: Untitled, unidentified. Oct. 1905, 12:33. Halftone. 8.9 x 12.0 cm. UPPER RIGHT: Untitled [*Death of St. Francis*], by Giotto. Oct. 1905, 12:33. Halftone. 8.9 x 11.9 cm. LOWER LEFT: Untitled [*Primavera*: detail], by Botticelli. Oct. 1905, 12:35. Halftone. 15.1 x 11.9 cm. LOWER RIGHT: Untitled [*St. Francis Preaches to the Birds*], by Giotto. Oct. 1905, 12:37. Halftone. 14.8 x 12.0 cm.

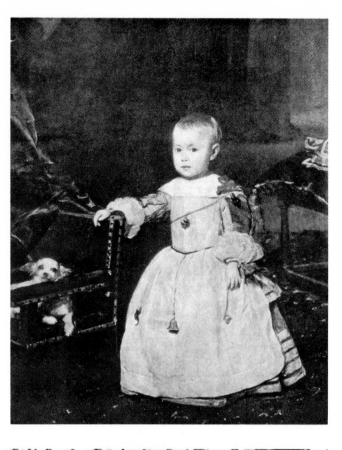

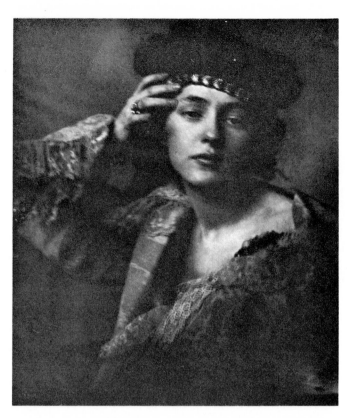

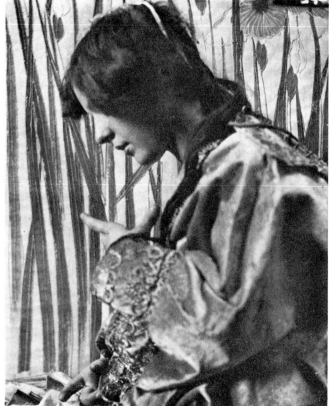

UPPER LEFT: Untitled [*Prince Felipe Prospero*], by Velasquez. Oct. 1905, 12:39. Halftone. 15.1 x 11.8 cm. UPPER RIGHT: *I. Marcella*, by F. Benedict Herzog. Oct. 1905, 12:53. Original negative; photogravure. 20.3 x 17.1 cm. LOWER LEFT: *II. Angela*, by F. Benedict Herzog. Oct. 1905, 12:55. Original negative; photogravure. 20.8 x 17.0 cm. LOWER RIGHT: *III. The Tale of Isolde*, by F. Benedict Herzog. Oct. 1905, 12:57. Photogravure. 18.9 x 18.1 cm.

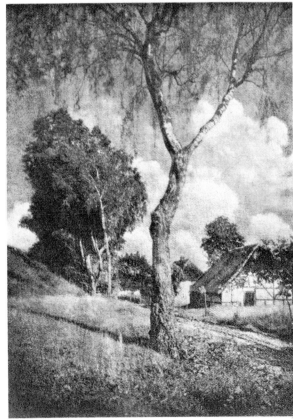

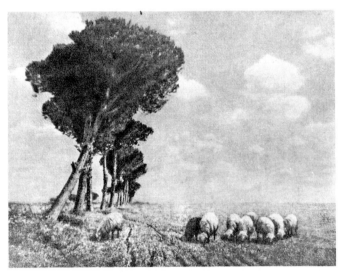

UPPER LEFT: *I. Villa Falconieri*, by Hugo Henneberg. Jan. 1906, 13:5. Photogravure. 23.8 x 12.7 cm. UPPER RIGHT: *II. Villa Torlonia*, by Hugo Henneberg. Jan. 1906, 13:7. Photogravure. 12.9 x 24.0 cm. LOWER LEFT: *III. Pomeranian Motif*, by Hugo

Henneberg. Jan. 1906, 13:9. Photogravure. 24.5 x 17.2 cm. LOWER RIGHT: *IV. Roman Campagna*, by Heinrich Kühn. Jan. 1906, 13:13. Photogravure. 17.3 x 22.7 cm.

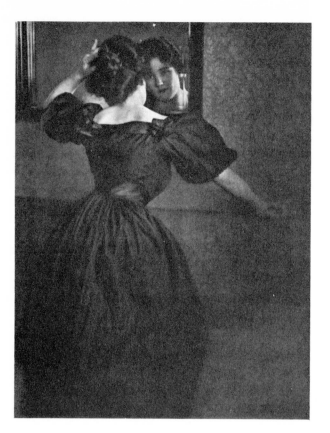

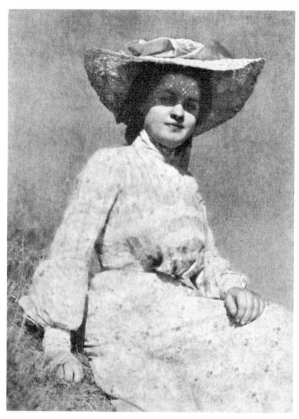

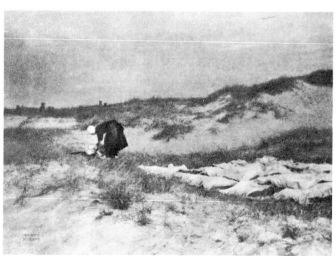

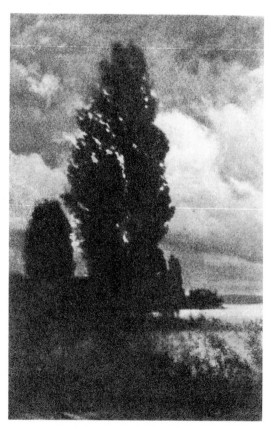

UPPER LEFT: *V. Girl with Mirror*, by Heinrich Kühn. Jan. 1906, 13:15. Photogravure. 19.6 x 14.5 cm. UPPER RIGHT: *VI. A Study in Sunlight*, by Heinrich Kühn. Jan. 1906, 13:17. Photogravure. 19.7 x 13.8 cm. LOWER LEFT: *VII. Washerwoman on the Dunes*, by Heinrich Kühn. Jan. 1906, 13:19. Photogravure. 16.8 x 22.8 cm. LOWER RIGHT: *VIII. Poplars and Clouds*, by Hans Watzek. Jan. 1906, 13:31. Photogravure. 21.1 x 13.3 cm.

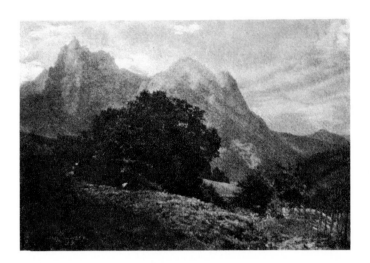

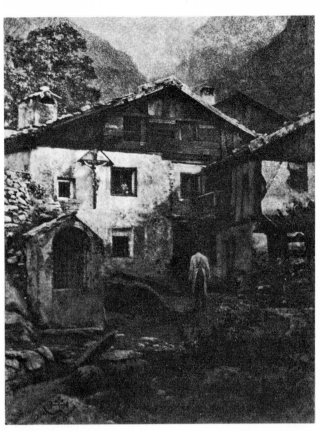

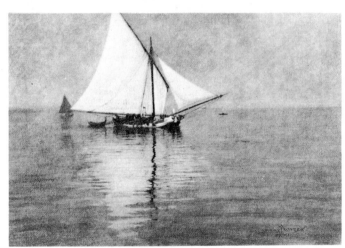

UPPER LEFT: *IX. Mountain Landscape,* by Hans Watzek. Jan. 1906, 13:33. Photogravure. 14.2 x 20.0 cm. UPPER RIGHT: *X. A Village Corner,* by Hans Watzek. Jan. 1906, 13:35. Photogravure. 19.4 x 14.9 cm. LOWER LEFT: *XI. The White Sail,* by Hans Watzek. Jan. 1906, 13:37. Photogravure. 16.0 x 22.8 cm. LOWER RIGHT: *XII. Sheep,* by Hans Watzek. Jan. 1906, 13:39. Photogravure. 16.8 x 21.9 cm.

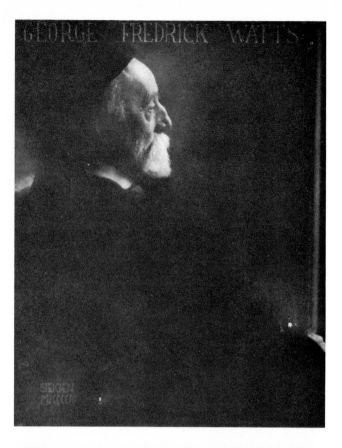

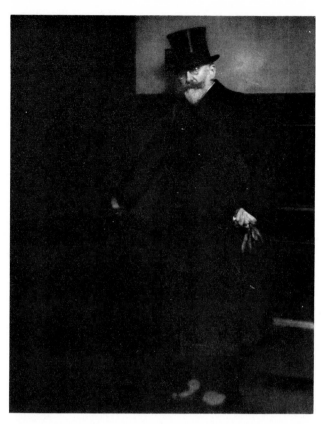

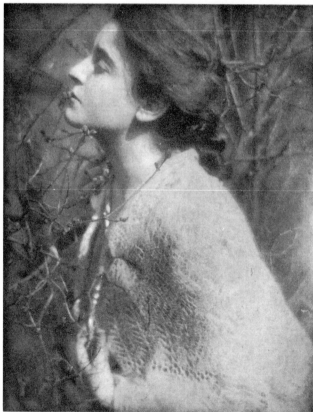

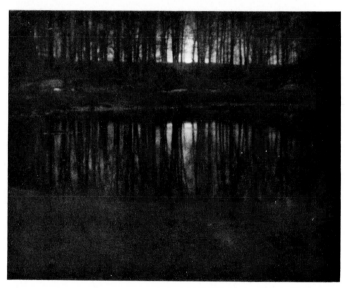

UPPER LEFT: *I. George Frederick Watts*, by Eduard J. Steichen. Apr. 1906, 14:5. Original negative; photogravure. 21.1 x .16.4 cm. UPPER RIGHT: *II. William M. Chase*, by Eduard J. Steichen. Apr. 1906, 14:7. Original negative; photogravure. 20.2 x 16.1 cm. LOWER LEFT: *III. Lilac Buds: Mrs. S.*, by Eduard J. Steichen. Apr. 1906, 14:9. Original negative; photogravure. 20.5 x 15.7 cm. LOWER RIGHT: *IV. Moonlight: The Pond*, by Eduard J. Steichen. Apr. 1906, 14:11. Original negative; photogravure. 16.1 x 20.3 cm.

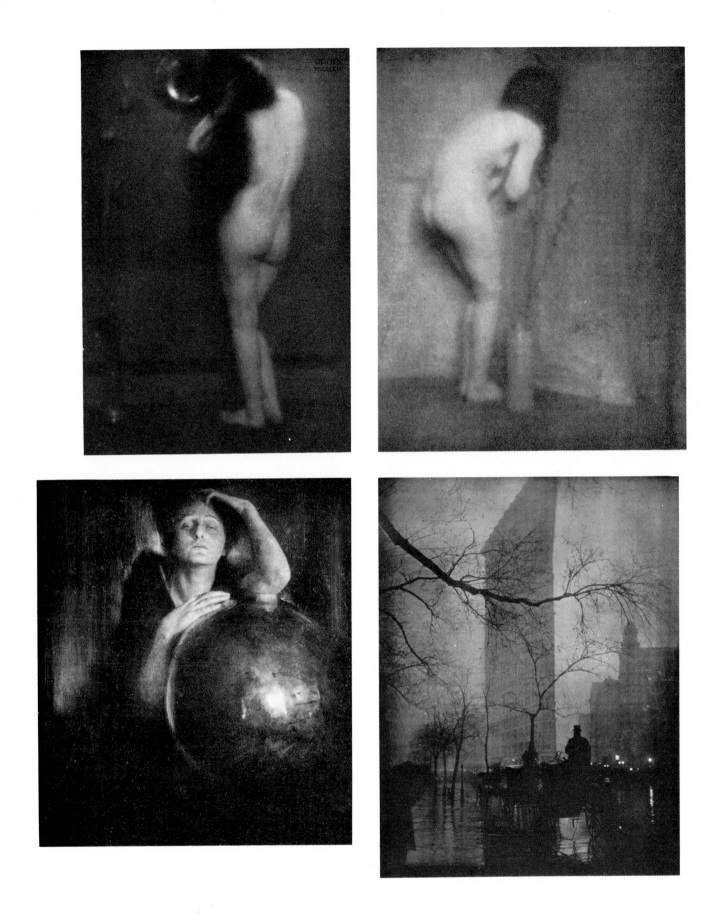

UPPER LEFT: *V. The Little Round Mirror*, by Eduard J. Steichen. Apr. 1906, 14:13. Original negative; photogravure. 21.3 x 14.2 cm. UPPER RIGHT: *VI. The Little Model*, by Eduard J. Steichen. Apr. 1906, 14:15. Original negative; photogravure. 20.8 x 16.1 cm. LOWER LEFT: *VII. The Brass Bowl*, by Eduard J. Steichen. Apr. 1906, 14:29. Halftone. 19.2 x 16.2 cm. LOWER RIGHT: *VIII. The Flatiron—Evening*, by Eduard J. Steichen. Apr. 1906, 14:31. Three-color halftone. 21.1 x 16.5 cm.

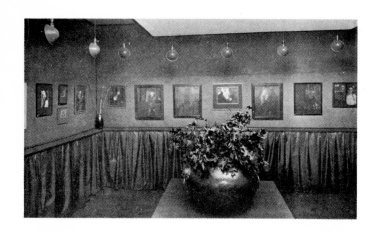

UPPER LEFT: *The Little Galleries of the Photo-Secession*, by Alfred Stieglitz. Apr. 1906, 14:42. Halftone. 7.3 x 12.3 cm.
UPPER RIGHT: *The Little Galleries of the Photo-Secession*, by Alfred Stieglitz. Apr. 1906, 14:42. Halftone. 7.4 x 12.3 cm.

LOWER LEFT: *The Little Galleries of the Photo-Secession*, by Alfred Stieglitz. Apr. 1906, 14:43. Halftone. 7.9 x 8.3 cm.
LOWER RIGHT: *The Little Galleries of the Photo-Secession*, by Alfred Stieglitz. Apr. 1906, 14:43. Halftone. 7.4 x 10.5 cm.

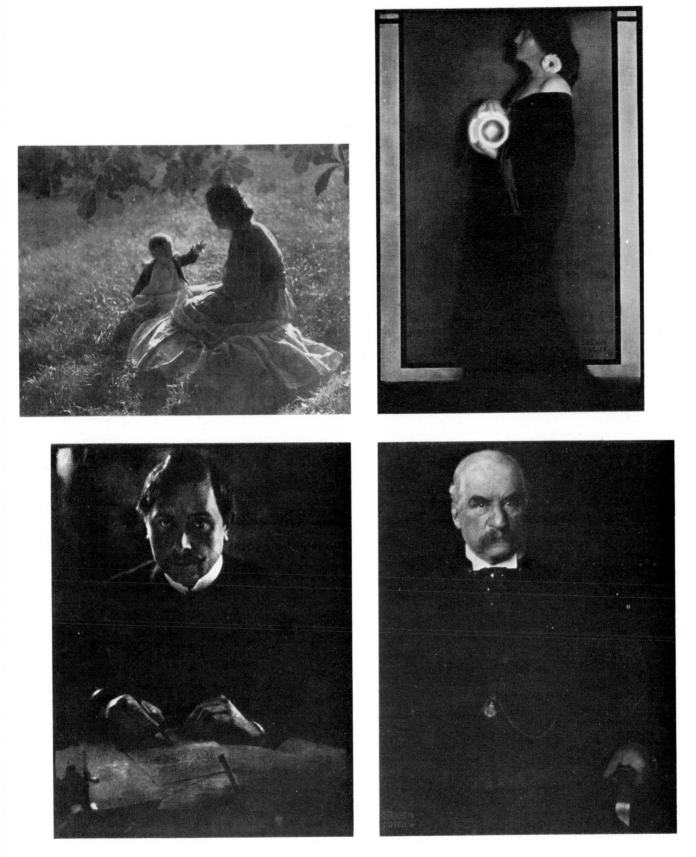

UPPER LEFT: *IX. Mother and Child—Sunlight*, by Eduard J. Steichen. Apr. 1906, 14:53. Original negative; photogravure. 12.7 x 15.7 cm. UPPER RIGHT: *X. Cover Design*, by Eduard J. Steichen. Apr. 1906, 14:55. Colored halftone. 20.1 x 13.3 cm.

LOWER LEFT: *I. Maeterlinck*, by Eduard J. Steichen. Apr. 1906, SS:7. Halftone. 21.4 x 16.2 cm. LOWER RIGHT: *II. J. Pierpont Morgan, Esq.*, by Eduard J. Steichen. Apr. 1906, SS:9. Original negative; photogravure. 20.6 x 15.5 cm.

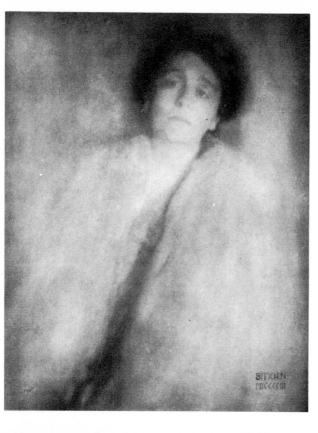

UPPER LEFT: *III. Duse*, by Eduard J. Steichen. Apr. 1906, SS:11. Original negative; photogravure. 21.5 x 16.3 cm. UPPER RIGHT: *IV. Portraits—Evening*, by Eduard J. Steichen. Apr. 1906, SS:13. Original negative; photogravure. 18.6 x 17.1 cm. LOWER LEFT:

V. Wm. M. Chase, by Eduard J. Steichen. Apr. 1906, SS:15. Original negative; photogravure. 20.7 x 16.5 cm. LOWER RIGHT: *VI. La Cigale*, by Eduard J. Steichen. Apr. 1906, SS:17. Original negative; photogravure. 16.0 x 17.9 cm.

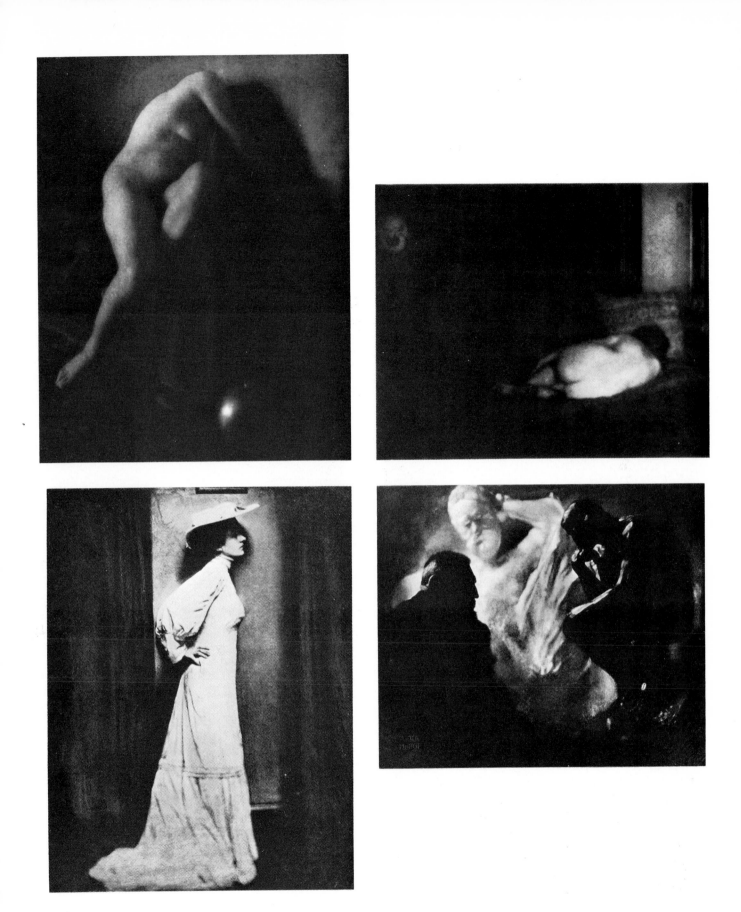

UPPER LEFT: *VII. In Memoriam*, by Eduard J. Steichen. Apr. 1906, SS:19. Original negative; photogravure. 20.7 x 15.6 cm. UPPER RIGHT: *VIII. The Model and the Mask*, by Eduard J. Steichen. Apr. 1906, SS:21. Original negative; photogravure.

16.6 x 20.6 cm. LOWER LEFT: *IX. The White Lady*, by Eduard J. Steichen. Apr. 1906, SS:23. Halftone. 20.3 x 16.3 cm. LOWER RIGHT: *X. Rodin—Le Penseur*, by Eduard J. Steichen. Apr. 1906, SS:25. Original negative; photogravure. 15.4 x 18.4 cm.

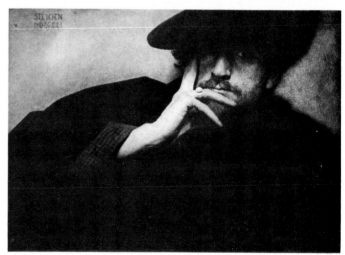

UPPER LEFT: *XI. The Big White Cloud*, by Eduard J. Steichen. Apr. 1906, SS:27. Halftone. 16.3 x 21.1 cm. UPPER RIGHT: *XII. Landscape in Two Colors*, by Eduard J. Steichen. Apr. 1906, SS:29. Two-color halftone. 16.1 x 17.7 cm. LOWER LEFT: *XIII. Profile*, by Eduard J. Steichen. Apr. 1906, SS:31. Halftone. 20.1 x 16.1 cm. LOWER RIGHT: *XIV. Solitude*, by Eduard J. Steichen. Apr. 1906, SS:33. Original negative; photogravure. 12.1 x 16.1 cm.

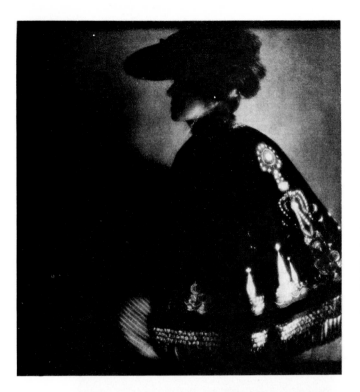

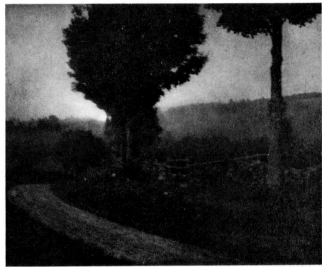

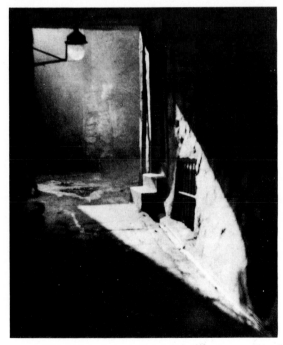

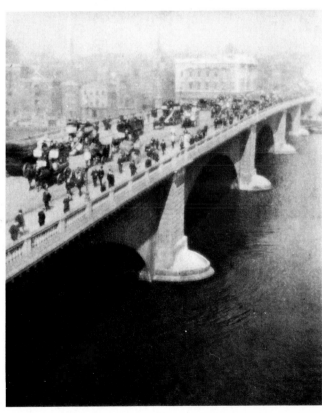

UPPER LEFT: *XV. Poster Lady*, by Eduard J. Steichen. Apr. 1906, SS:35. Original negative; photogravure. 17.1 x 15.9 cm. UPPER RIGHT: *XVI. Road into the Valley—Moonrise*, by Eduard J. Steichen. Apr. 1906, SS:37. Hand-toned photogravure. 16.3 x 20.6 cm. LOWER LEFT: *I. Wier's Close—Edinburgh*, by Alvin Langdon Coburn. July 1906, 15:5. Original negative; photogravure. 20.2 x 16.0 cm. LOWER RIGHT: *II. The Bridge—Sunlight*, by Alvin Langdon Coburn. July 1906, 15:7. Original negative; photogravure. 19.6 x 15.8 cm.

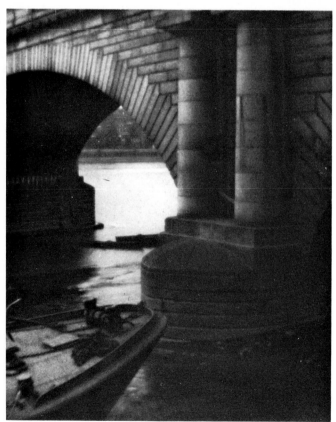

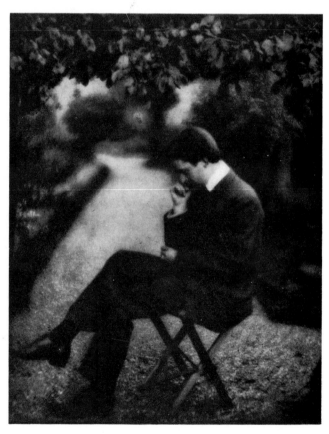

UPPER LEFT: *III. After the Blizzard,* by Alvin Langdon Coburn. July 1906, 15:9. Original negative; photogravure. 16.2 x 21.0 cm. UPPER RIGHT: *IV. Decorative Study,* by Alvin Langdon Coburn. July 1906, 15:11. Original negative; photogravure. 20.0 x 16.2 cm. LOWER LEFT: *V. The Bridge—London,* by Alvin Langdon Coburn. July 1906, 15:13. Original negative; photogravure. 20.3 x 16.1 cm. LOWER RIGHT: *VI. Portrait of Alvin Langdon Coburn,* by George Bernard Shaw. July 1906, 15:15. Original negative; photogravure. 21.2 x 16.1 cm.

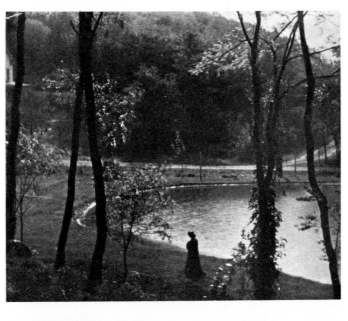

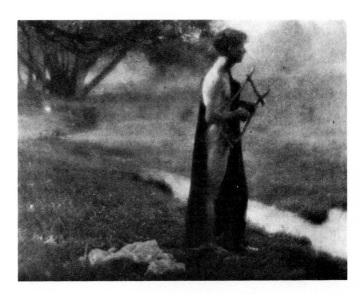

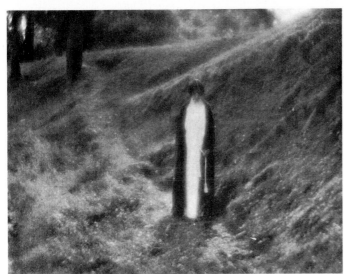

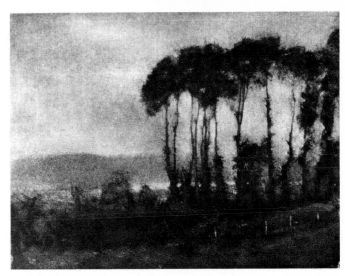

UPPER LEFT: *I. Experiment in Three-color Photography,* by Eduard J. Steichen. July 1906, 15:31. Three-color halftone. 10.3 x 12.3 cm. UPPER RIGHT: *I. No Title,* by George H. Seeley. July 1906, 15:37. Photogravure. 11.9 x 15.2 cm. LOWER LEFT: *II. No Title,* by George H. Seeley. July 1906, 15:39. Photogravure. 15.2 x 19.2 cm. LOWER RIGHT: *I. Toucques Valley,* by Robert Demachy. Oct. 1906, 16:5. Gum; photogravure. 15.5 x 20.4 cm.

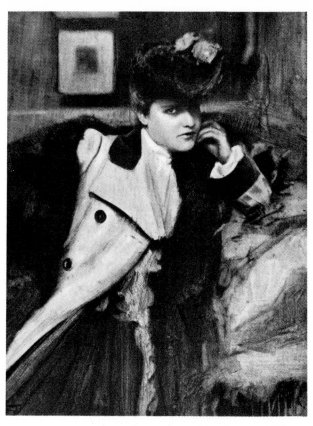

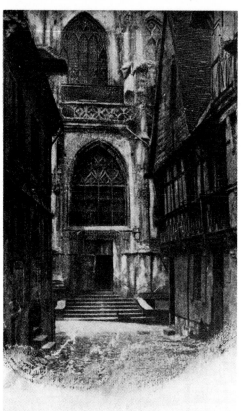

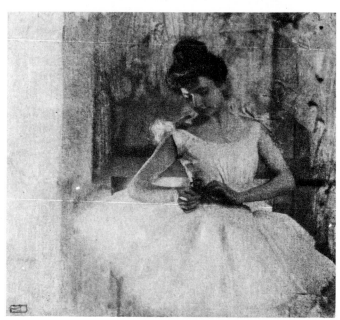

UPPER LEFT: *II. A Model*, by Robert Demachy. Oct. 1906, 16:7. Gum; photogravure. 17.4 x 15.0 cm. UPPER RIGHT: *III. Portrait—Mlle. D.*, by Robert Demachy. Oct. 1906, 16:9. Gum; halftone. 20.6 x 15.2 cm. LOWER LEFT: *IV. Street in Lisieux*, by Robert Demachy. Oct. 1906, 16:11. Gum; halftone. 20.3 x 12.2 cm. LOWER RIGHT: *V. Behind the Scenes*, by Robert Demachy. Oct. 1906, 16:13. Gum; photogravure. 13.7 x 15.1 cm.

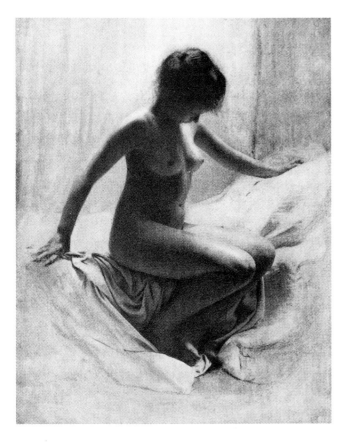

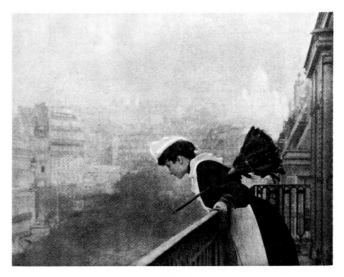

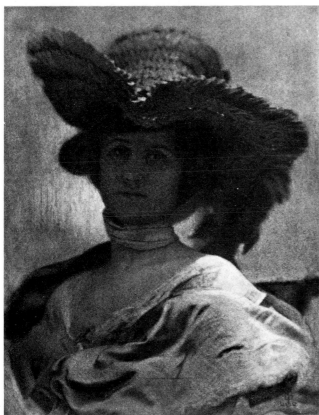

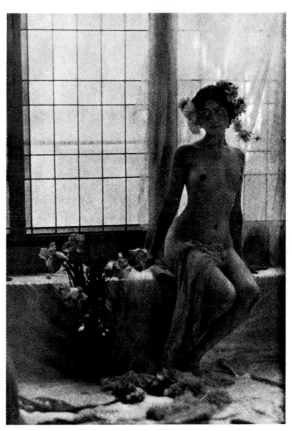

UPPER LEFT: *VI. Study*, by Robert Demachy. Oct. 1906, 16:15. Gum; halftone. 20.9 x 15.1 cm. UPPER RIGHT: *I. Montmartre*, by C. Puyo. Oct. 1906, 16:25. Gum; halftone. 16.1 x 20.8 cm. LOWER LEFT: *II. The Straw Hat*, by C. Puyo. Oct. 1906, 16:27. Gum; halftone. 21.1 x 15.7 cm. LOWER RIGHT: *Nude—Against the Light*, by C. Puyo. Oct. 1906, 16:29. Gum; halftone. 21.1 x 14.5 cm.

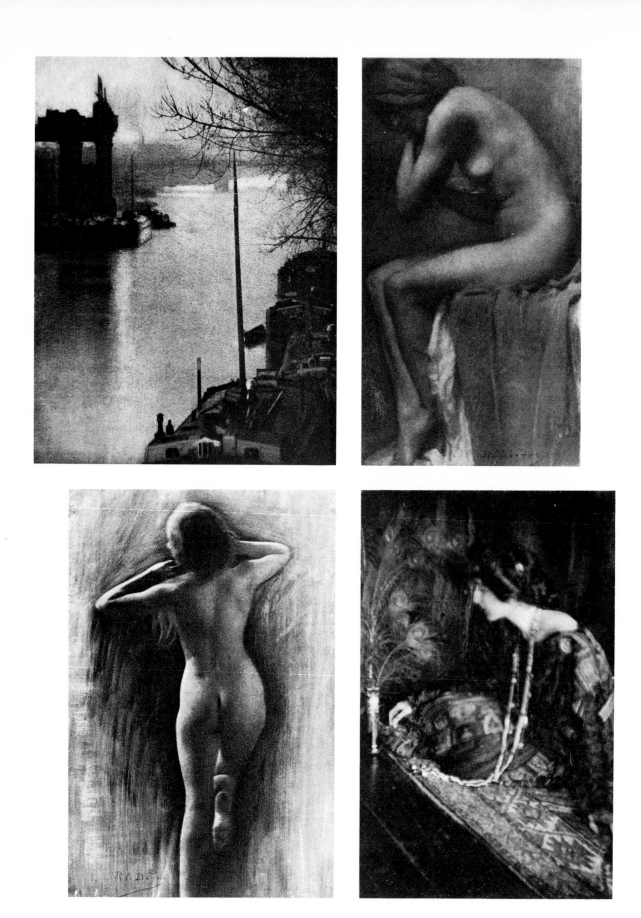

UPPER LEFT: *IV. The Seine at Clichy*, by Robert Demachy. Oct. 1906, 16:31. Gum; halftone. 20.3 x 15.0 cm. UPPER RIGHT: *I. Study*, by Renée Le Bégue. Oct. 1906, 16:41. Gum; photogravure. 21.7 x 11.5 cm. LOWER LEFT: *II. Study*, by Renée Le Bégue. Oct. 1906, 16:43. Gum; halftone. 22.5 x 14.8 cm. LOWER RIGHT: *I. Lenore*, by Joseph T. Keiley. Jan. 1907, 17:5. Original negative; photogravure. 18.8 x 11.6 cm.

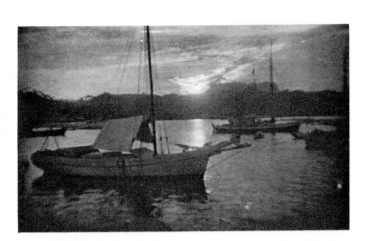

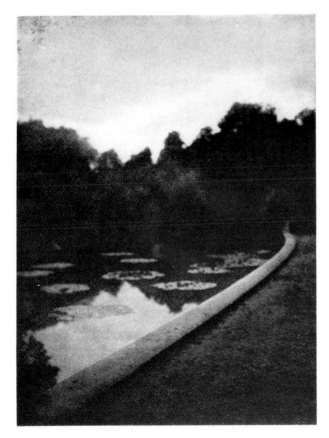

UPPER LEFT: *II. The Last Hour*, by Joseph T. Keiley. Jan. 1907, 17:7. Original negative; photogravure. 12.0 x 19.1 cm. UPPER RIGHT: *III. Portrait—Miss De C.*, by Joseph T. Keiley. Jan. 1907, 17:9. Original negative; photogravure. 12.0 x 15.9 cm.

LOWER LEFT: *IV. A Garden of Dreams*, by Joseph T. Keiley. Jan. 1907, 17:11. Glycerine platinotype; halftone. 19.1 x 13.9 cm. LOWER RIGHT: *V. Spring*, by Joseph T. Keiley. Jan. 1907, 17:13. Original negative; photogravure. 11.2 x 18.5 cm.

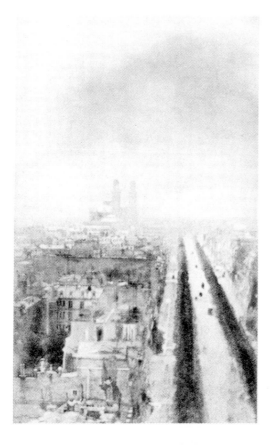

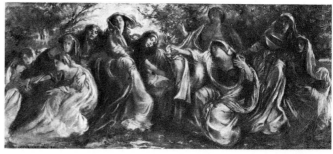

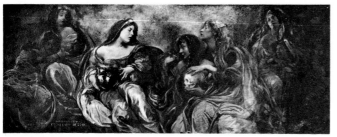

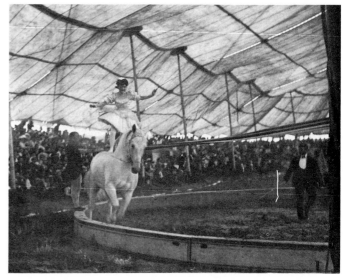

UPPER LEFT: *VI. A Bit of Paris*, by Joseph T. Keiley. Jan. 1907, 17:15. Glycerine platinotype; halftone. 19.8 x 11.8 cm. UPPER RIGHT: *I. The Banks of Lethe*, by F. Benedict Herzog. Jan. 1907, 17:25. Original negative; photogravure. 12.0 x 26.5 cm. LOWER

LEFT: *II. Twixt the Cup and the Lip*, by F. Benedict Herzog. Jan. 1907, 17:27. Original negative; photogravure. 10.4 x 26.5 cm. LOWER RIGHT: *I. In the Circus*, by Harry C. Rubincam. Jan. 1907, 17:37. Original negative; photogravure. 15.5 x 19.3 cm.

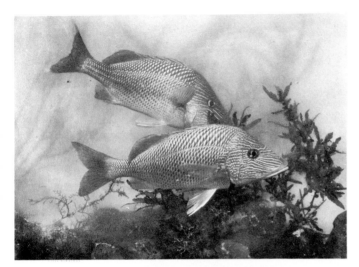

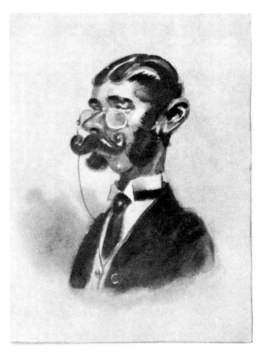

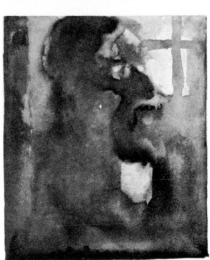

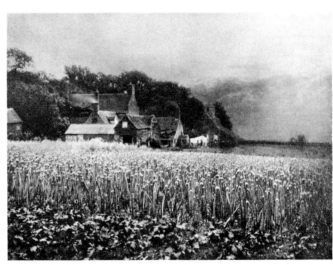

UPPER LEFT: *II. Fish*, by A. Radclyffe Dugmore. Jan. 1907, 17:39. Original negative; photogravure. 14.1 x 19.2 cm. UPPER RIGHT: *Progress in Photo-Portraiture. I. Portrait of Mr. Wotsname taken several years ago*, by J. Montgomery Flagg. Jan. 1907, 17:46. Two-color halftone. 15.0 x 9.4 cm. LOWER LEFT: *Progress in Photo-Portraiture. II. Portrait of the same gentleman taken to-day*, by J. Montgomery Flagg. Jan. 1907, 17:47. Two-color halftone. 17.3 x 15.5 cm. LOWER RIGHT: *I. The Onion Field—1890*, by George Davison. Apr. 1907, 18:5. Photogravure. 15.4 x 20.4 cm.

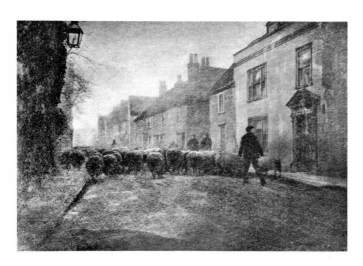

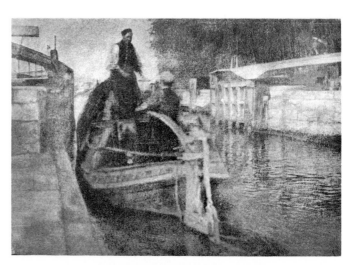

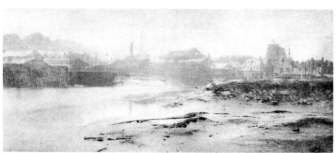

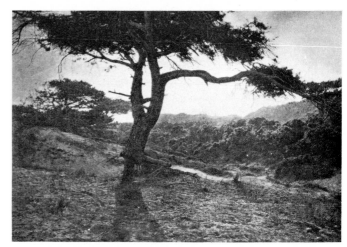

UPPER LEFT: *II. In a Village under the South Downs,* by George Davison. Apr. 1907, 18:7. Photogravure. 11.5 x 16.8 cm. UPPER RIGHT: *III. A Thames Locker,* by George Davison. Apr. 1907, 18:9. Photogravure. 11.8 x 16.6 cm. LOWER LEFT: *IV.*

Wyvenhoe on the Colne in Essex, by George Davison. Apr. 1907, 18:11. Photogravure. 7.2 x 16.7 cm. LOWER RIGHT: *V. The Long Arm,* by George Davison. Apr. 1907, 18:13. Photogravure. 11.4 x 16.3 cm.

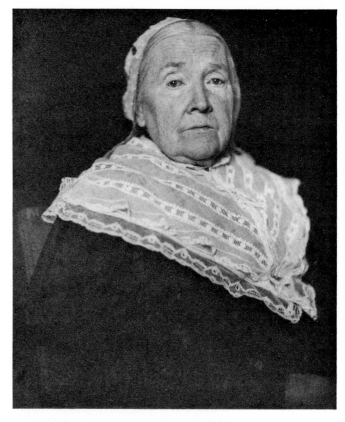

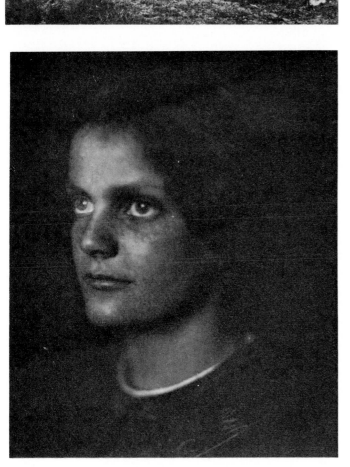

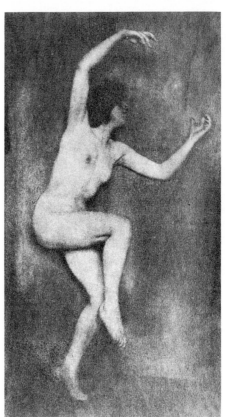

UPPER LEFT: *VI. Berkshire Teams and Teamsters,* by George Davison. Apr. 1907, 18:15. Photogravure. 10.8 x 16.8 cm. UPPER RIGHT: *I. Mrs. Julia Ward Howe,* by Sarah C. Sears. Apr. 1907, 18:33. Original negative; photogravure. 20.7 x 16.7 cm. LOWER LEFT: *II. Mary,* by Sarah C. Sears. Apr. 1907, 18:35. Original negative; photogravure. 20.6 x 16.4 cm. LOWER RIGHT: *I. The Spider,* by William B. Dyer. Apr. 1907, 18:53. Gum; photogravure. 22.1 x 11.9 cm.

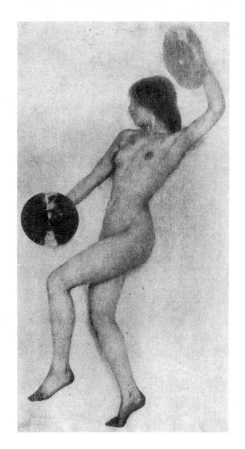

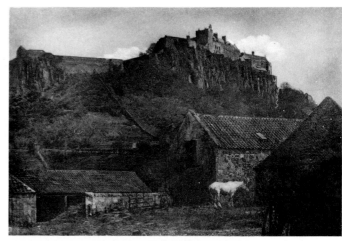

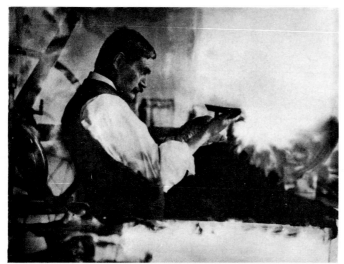

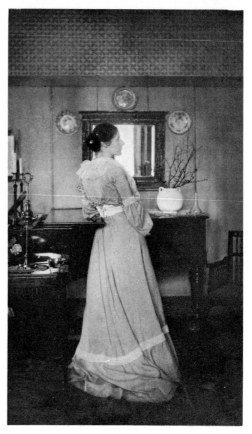

UPPER LEFT: *II. L'Allegro*, by William B. Dyer. Apr. 1907, 18:55. Gum; photogravure. 21.5 x 11.3 cm. UPPER RIGHT: *I. Stirling Castle*, by J. Craig Annan. July 1907, 19:5. Photogravure. 14.9 x 21.6 cm. LOWER LEFT: *II. The Etching Printer—* *William Strang, Esq., A. R. A.*, by J. Craig Annan. July 1907, 19:7. Photogravure. 15.0 x 19.6 cm. LOWER RIGHT: *III. Portrait of Mrs. C.*, by J. Craig Annan. July 1907, 19:9. Photogravure. 21.4 x 12.2 cm.

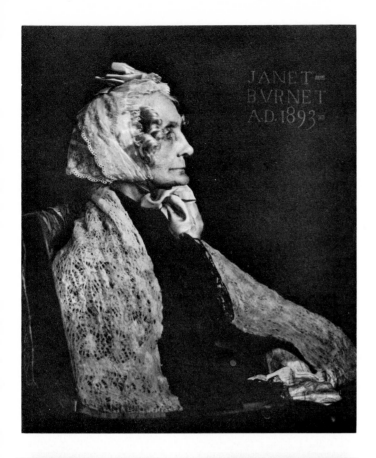

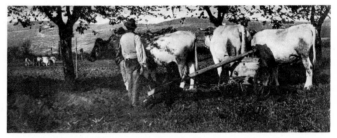

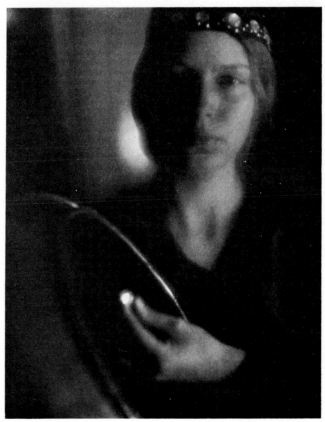

UPPER LEFT: *IV. Janet Burnet*, by J. Craig Annan. July 1907, 19:11. Photogravure. 20.3 x 16.6 cm. UPPER RIGHT: *V. Plough-ing Team*, by J. Craig Annan. July 1907, 19:13. Photogravure. 9.1 x 23.6 cm. LOWER LEFT: *I. Pastoral—Moonlight*, by Eduard J. Steichen. July 1907, 19:35. Hand-toned photogravure. 15.6 x 19.8 cm. LOWER RIGHT: *I. The Firefly*, by George H. Seeley. Oct. 1907, 20:5. Original negative; photogravure. 20.1 x 15.6 cm.

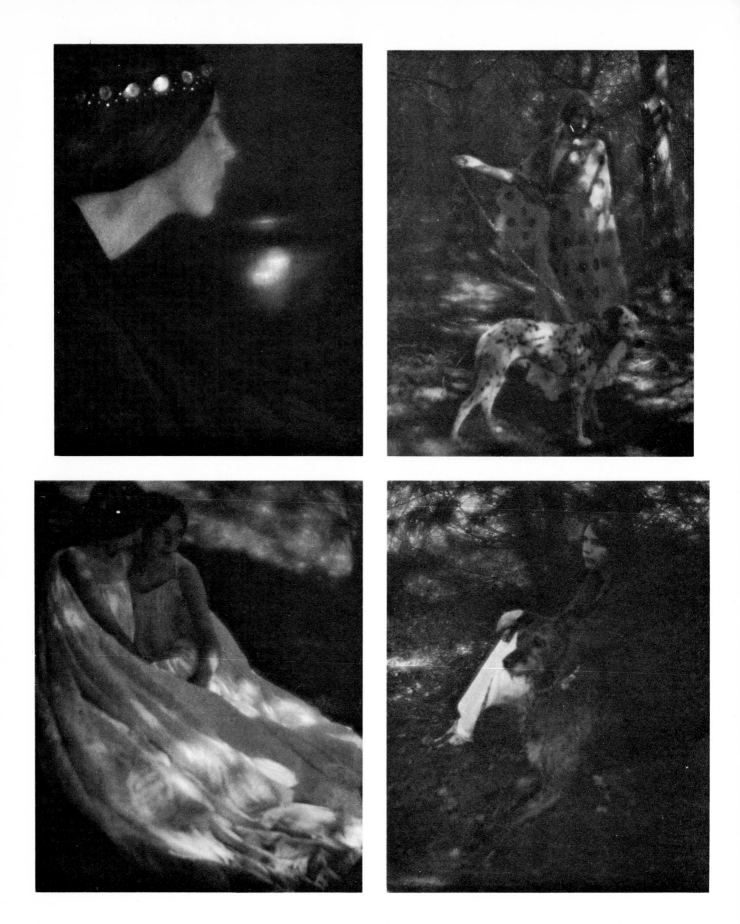

UPPER LEFT: *II. The Black Bowl*, by George H. Seeley. Oct. 1907, 20:7. Original negative; photogravure. 20.5 x 15.4 cm. UPPER RIGHT: *III. Blotches of Sunlight and Spots of Ink*, by George H. Seeley. Oct. 1907, 20:9. Original negative; photogravure. 20.6 x 15.5 cm. LOWER LEFT: *IV. The Burning of Rome*, by George H. Seeley. Oct. 1907, 20:11. Original negative; photogravure. 19.7 x 15.7 cm. LOWER RIGHT: *V. Girl with Dog*, by George H. Seeley. Oct. 1907, 20:13. Original negative; photogravure. 19.7 x 15.4 cm.

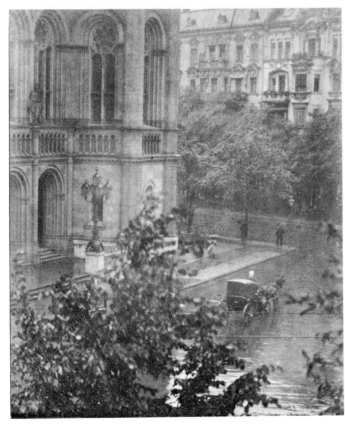

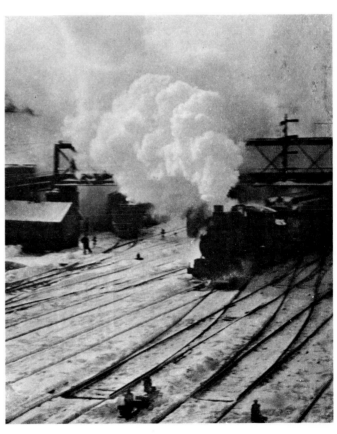

UPPER LEFT: *VI. The White Landscape*, by George H. Seeley. Oct. 1907, 20:15. Original negative; photogravure. 15.6 x 19.2 cm. UPPER RIGHT: *I. Snapshot—From my Window, New York*, by Alfred Stieglitz. Oct. 1907, 20:41. Original negative; photogravure. 18.4 x 12.8 cm. LOWER LEFT: *II. Snapshot—From my Window, Berlin*, by Alfred Stieglitz. Oct. 1907, 20:43. Original negative; photogravure. 21.0 x 17.1 cm. LOWER RIGHT: *III. Snapshot—In the New York Central Yards*, by Alfred Stieglitz. Oct. 1907, 20:45. Original negative; photogravure. 19.2 x 15.6 cm.

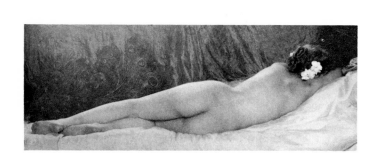

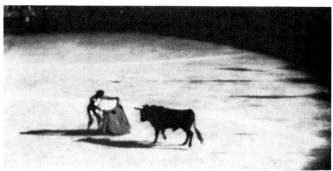

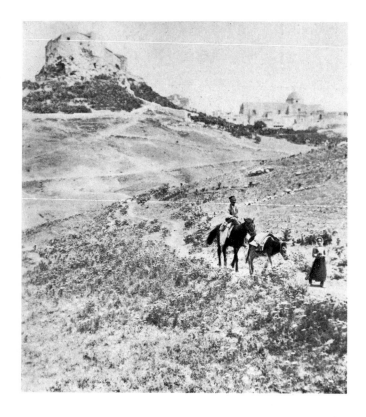

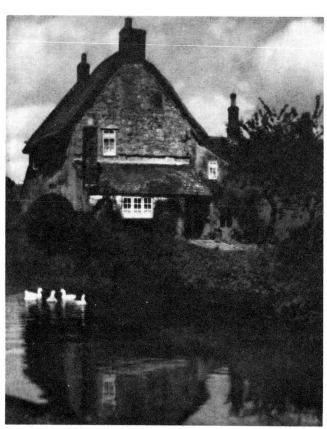

UPPER LEFT: *IV. Nude*, by W. W. Renwick. Oct. 1907, 20:47. Original negative; photogravure. 7.3 x 19.3 cm. UPPER RIGHT: *I. El Toros*, by Alvin Langdon Coburn. Jan. 1908, 21:5. Gum platinotype; photogravure. 23.8 x 12.8 cm. LOWER LEFT: *II.*

Road to Algeciras, by Alvin Langdon Coburn. Jan. 1908, 21:7. Gum platinotype; photogravure. 19.6 x 17.5 cm. LOWER RIGHT: *III. The Duck Pond*, by Alvin Langdon Coburn. Jan. 1908, 21:9. Gum platinotype; photogravure. 18.8 x 14.5 cm.

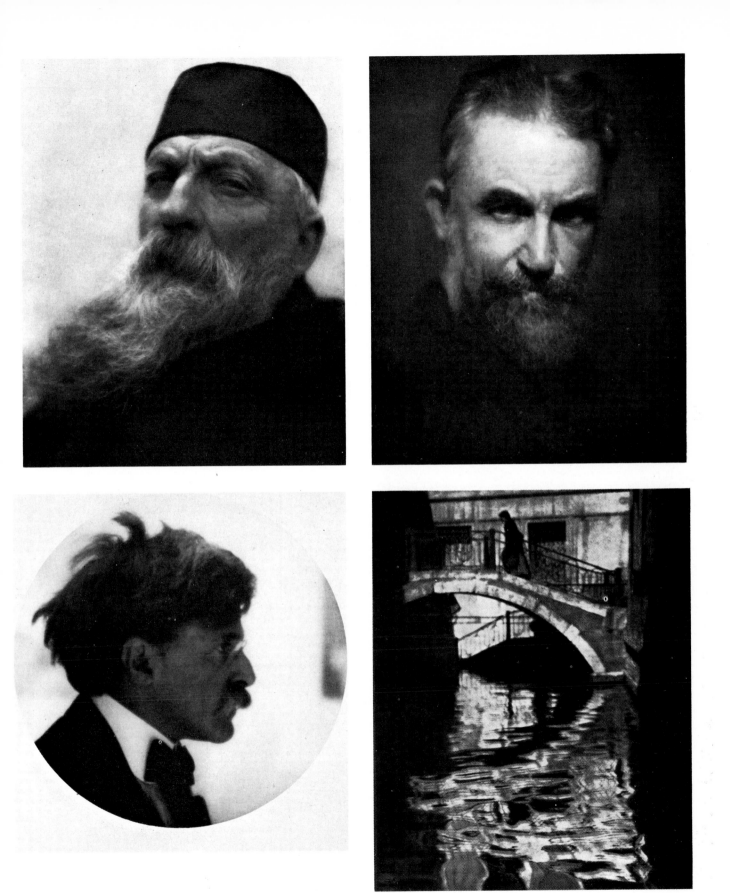

UPPER LEFT: *IV. Rodin*, by Alvin Langdon Coburn. Jan. 1908, 21:11, Gum platinotype; photogravure. 20.1 x 15.8 cm. UPPER RIGHT: *V. Bernard Shaw*, by Alvin Langdon Coburn. Jan. 1908, 21:13. Gum platinotype; photogravure. 20.9 x 16.4 cm. LOWER LEFT: *VI. Alfred Stieglitz, Esq.*, by Alvin Langdon Coburn. Jan. 1908, 21:15. Gum platinotype; photogravure. 15.7 cm. diam. LOWER RIGHT: *VII. The Bridge, Venice*, by Alvin Langdon Coburn. Jan. 1908, 21:33. Gum platinotype; halftone. 21.1 x 16.9 cm.

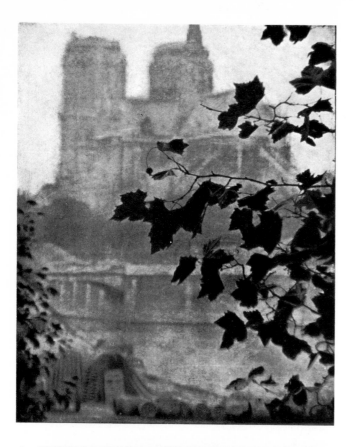

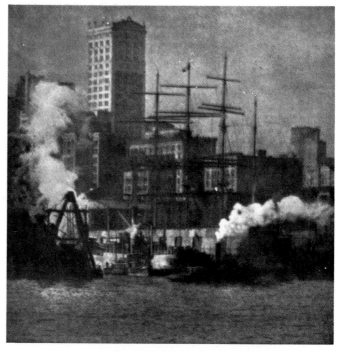

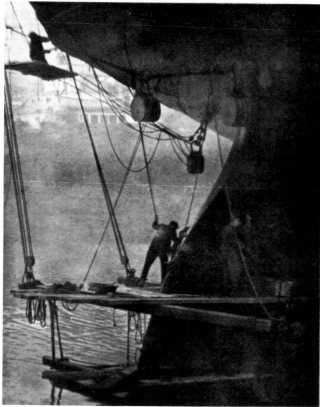

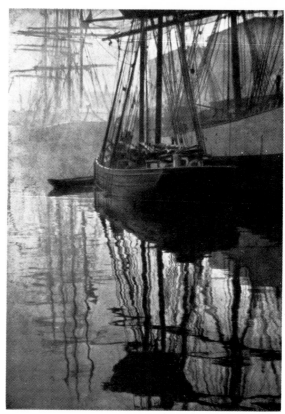

UPPER LEFT: *VIII. Notre Dame*, by Alvin Langdon Coburn. Jan. 1908, 21:35. Gum platinotype; colored halftone. 20.8 x 16.6 cm. UPPER RIGHT: *IX. New York*, by Alvin Langdon Coburn. Jan. 1908, 21:37. Gum platinotype; halftone. 16.9 x 16.5 cm.

LOWER LEFT: *X. The Rudder*, by Alvin Langdon Coburn. Jan. 1908, 21:39. Gum platinotype; halftone. 21.0 x 16.7 cm. LOWER RIGHT: *XI. Spider-webs*, by Alvin Langdon Coburn. Jan. 1908, 21:41. Gum platinotype; halftone. 24.3 x 16.9 cm.

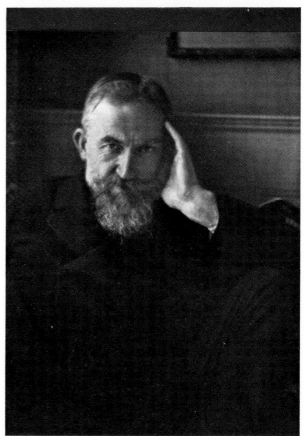

UPPER LEFT: *XII. The Fountain at Trevi*, by Alvin Langdon Coburn. Jan. 1908, 21:43. Gum platinotype; halftone. 20.7 x 16.7 cm. UPPER RIGHT: *I. G. Bernard Shaw*, by Eduard J. Steichen. Apr. 1908, 22:7. Autochrome; four-color halftone. 19.7 x 14.4 cm. LOWER LEFT: *II. On the House-boat—"The* *Log Cabin,"* by Eduard J. Steichen. Apr. 1908, 22:9. Autochrome; four-color halftone. 14.6 x 19.5 cm. LOWER RIGHT: *III. Portrait—Lady H.*, by Eduard J. Steichen. Apr. 1908, 22:11. Autochrome; four-color halftone. 19.7 x 14.5 cm.

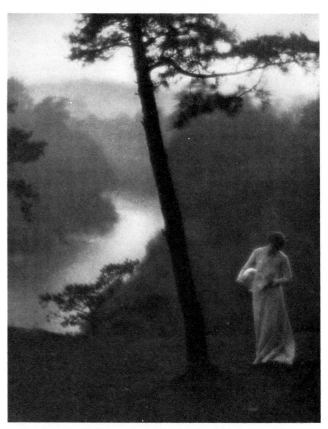

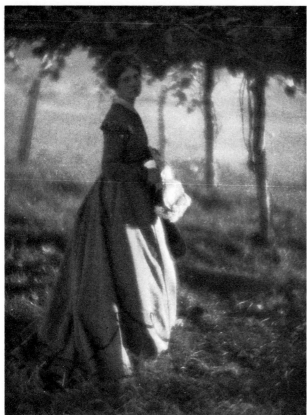

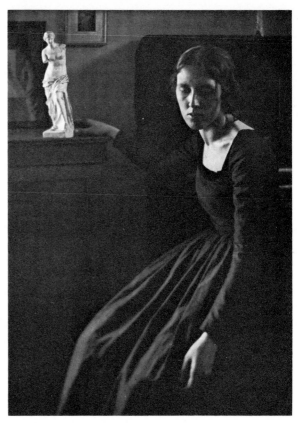

UPPER LEFT: *I. Portrait—Miss Mary Everett*, by Clarence H. White. July 1908, 23:17. Original negative; photogravure. 21.8 x 15.6 cm. UPPER RIGHT: *II. Morning*, by Clarence H. White. July 1908, 23:19. Original negative; photogravure. 20.1 x 15.8 cm. LOWER LEFT: *III. The Arbor*, by Clarence H. White. July 1908, 23:21. Original negative; photogravure. 20.6 x 15.2 cm. LOWER RIGHT: *IV. Lady in Black with Statuette*, by Clarence H. White. July 1908, 23:23. Original negative; photogravure. 19.2 x 13.5 cm.

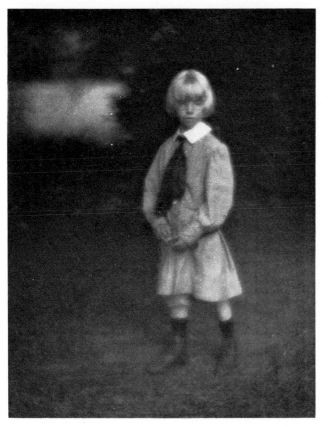

UPPER LEFT: *V. Boys Going to School*, by Clarence H. White. July 1908, 23:25. Original negative; photogravure. 20.4 x 15.5 cm. UPPER RIGHT: *VI. Landscape—Winter*, by Clarence H. White. July 1908, 23:27. Original negative; photogravure. 15.1 x 18.8 cm. LOWER LEFT: *VII. Portrait—Master Tom*, by Clarence H. White. July 1908, 23:29. Original negative; photogravure. 20.9 x 15.6 cm. LOWER RIGHT: *VIII. Boys Wrestling*, by Clarence H. White. July 1908, 23:31. Original negative; photogravure. 21.4 x 15.4 cm.

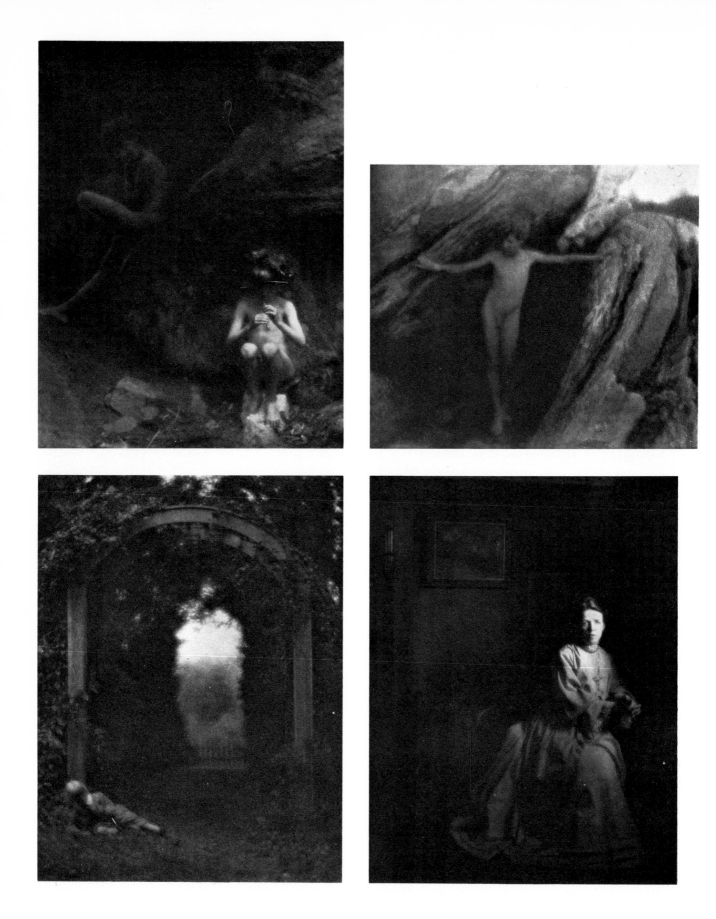

UPPER LEFT: *IX. The Pipes of Pan*, by Clarence H. White. July 1908, 23:33. Original negative; photogravure. 19.6 x 14.8 cm. UPPER RIGHT: *X. Nude*, by Clarence H. White. July 1908, 23:35. Original negative; photogravure. 15.5 x 18.0 cm. LOWER LEFT: *XI. Entrance to the Garden*, by Clarence H. White. July 1908, 23:37. Original negative; photogravure. 20.4 x 15.3 cm. LOWER RIGHT: *XII. Portrait—Mrs. Clarence H. White*, by Clarence H. White. July 1908, 23:39. Original negative; photogravure. 20.7 x 15.4 cm.

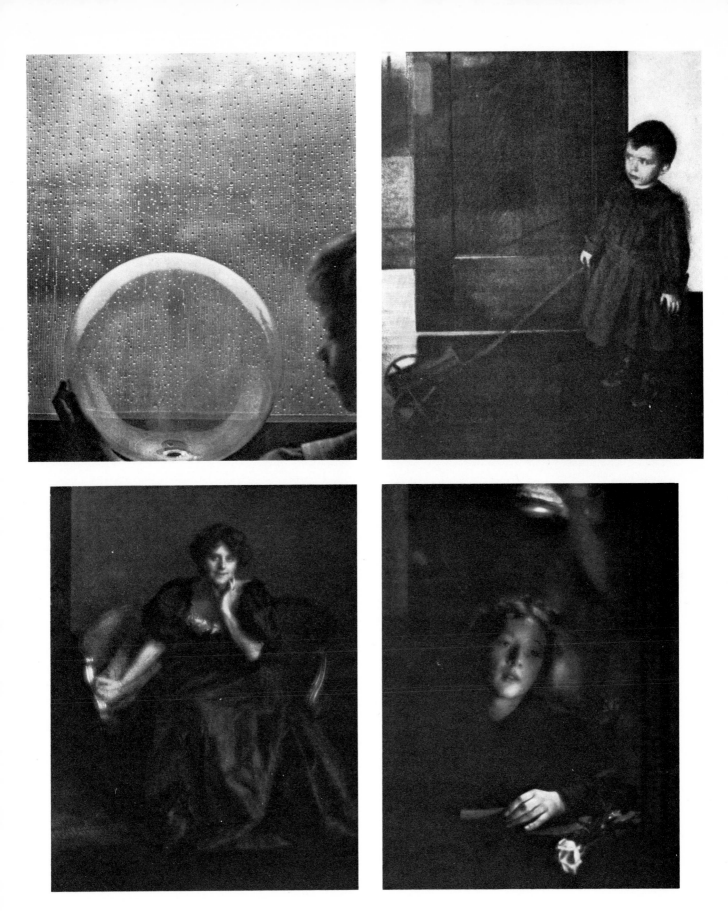

UPPER LEFT: *XIII. Drops of Rain*, by Clarence H. White. July 1908, 23:41. Original negative; photogravure. 19.3 x 15.5 cm. UPPER RIGHT: *XIV. Boy with Wagon*, by Clarence H. White. July 1908, 23:43. Original negative; photogravure. 19.7 x 15.7 cm. LOWER LEFT: *XV. Portrait—Mrs. Harrington Mann*, by Clarence H. White. July 1908, 23:45. Original negative; photogravure. 19.9 x 15.0 cm. LOWER RIGHT: *XVI. Girl with Rose*, by Clarence H. White. July 1908, 23:47. Original negative; photogravure. 19.5 x 14.5 cm.

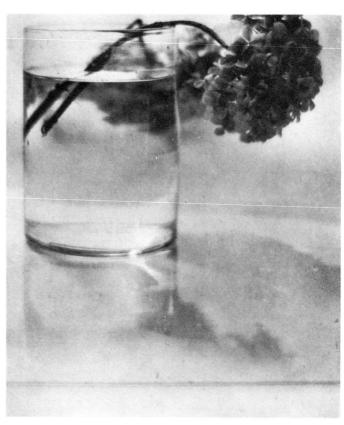

UPPER LEFT: *I. Still Life*, by Baron A. De Meyer. Oct. 1908, 24:5. Platinotype; photogravure. 21.2 x 15.2 cm. UPPER RIGHT: *II. Still Life*, by Baron A. De Meyer. Oct. 1908, 24:7. Platinotype; photogravure. 16.2 x 22.2 cm. LOWER LEFT: *III. Still Life*, by Baron A. De Meyer. Oct. 1908, 24:9. Platinotype; photogravure. 21.9 x 16.4 cm. LOWER RIGHT: *IV. Still Life*, by Baron A. De Meyer. Oct. 1908, 24:11. Platinotype; photogravure. 19.1 x 15.5 cm.

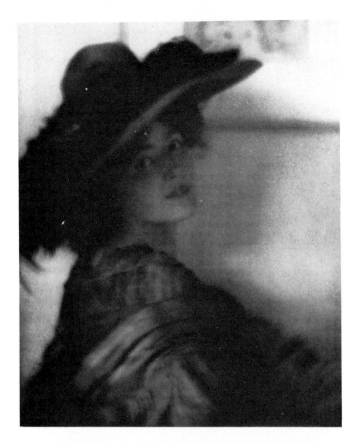

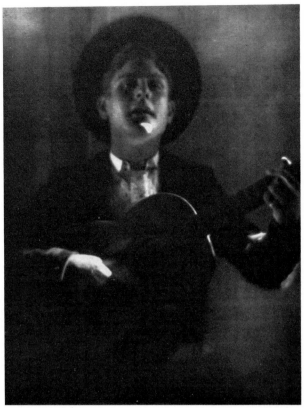

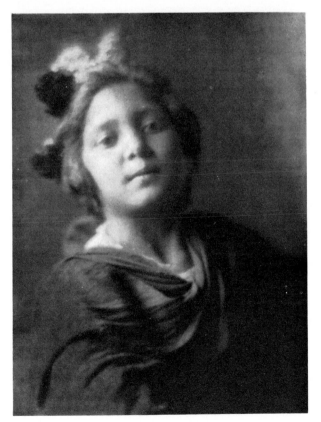

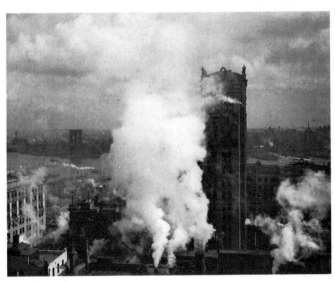

UPPER LEFT: *V. Mrs. Brown Potter,* by Baron A. De Meyer. Oct. 1908, 24:29. Platinotype; photogravure. 20.7 x 16.0 cm. UPPER RIGHT: *VI. Guitar Player of Seville,* by Baron A. De Meyer. Oct. 1908, 24:31. Platinotype; photogravure. 20.6 x 15.5 cm. LOWER LEFT: *VII. Study of a Gitana,* by Baron A. De Meyer.

Oct. 1908, 24:33. Platinotype; photogravure. 20.6 x 14.9 cm. LOWER RIGHT: *VIII. Over the House-Tops—New York,* by William E. Wilmerding. Oct. 1908, 24:35. Original negative; photogravure. 15.1 x 19.0 cm.

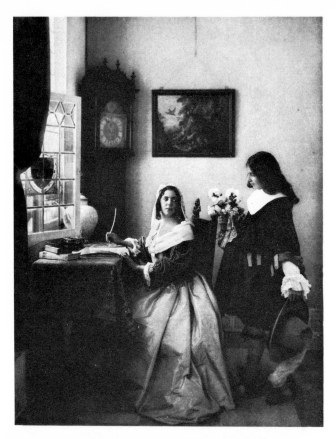

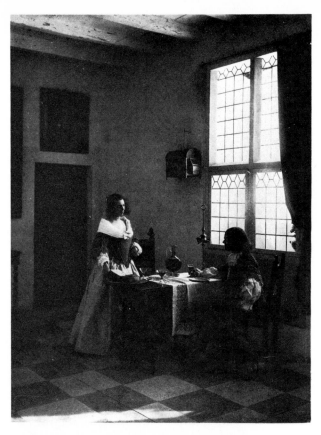

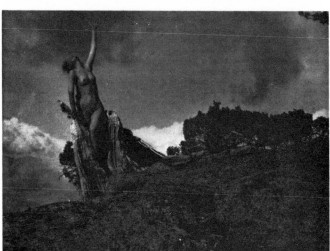

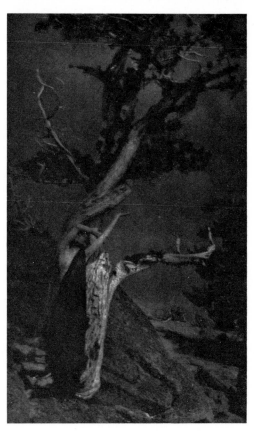

UPPER LEFT: *IX. The Letter*, by Guido Rey. Oct. 1908, 24:41. Photogravure. 20.1 x 15.2 cm. UPPER RIGHT: *X. A Flemish Interior*, by Guido Rey. Oct. 1908, 24:43. Photogravure. 21.2 x 15.5 cm. LOWER LEFT: *I. Soul of the Blasted Pine*, by Annie W. Brigman. Jan. 1909, 25:5. Original negative; photogravure. 15.4 x 20.8 cm. LOWER RIGHT: *II. The Dying Cedar*, by Annie W. Brigman. Jan. 1909, 25:7. Original negative; photogravure. 23.2 x 13.7 cm.

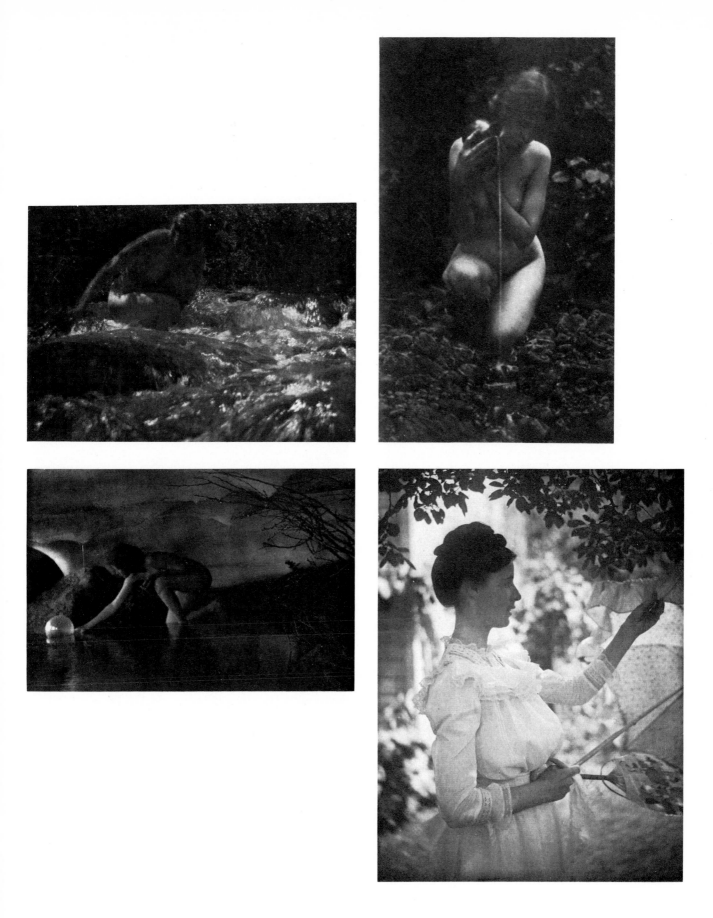

UPPER LEFT: *III. The Brook*, by Annie W. Brigman. Jan. 1909, 25:9. Photogravure. 15.6 x 21.2 cm. UPPER RIGHT: *IV. The Source*, by Annie W. Brigman. Jan. 1909, 25:11. Original negative; photogravure. 23.6 x 13.8 cm. LOWER LEFT: *V. The Bubble*, by Annie W. Brigman. Jan. 1909, 25:13. Original negative; photogravure. 16.0 x 23.4 cm. LOWER RIGHT: *I. Girl with Parasol*, by Ema Spencer. Jan. 1909, 25:25. Original negative; photogravure. 20.5 x 15.6 cm.

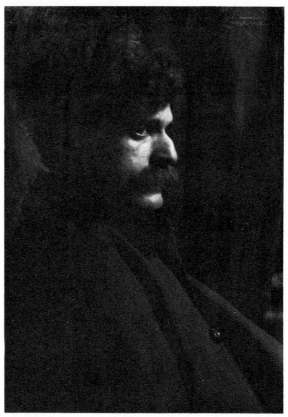

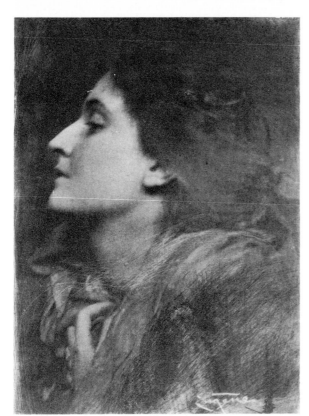

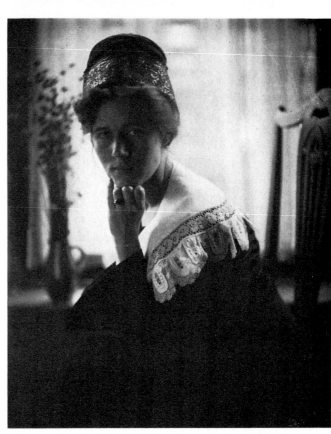

UPPER LEFT: *II. Sentinels*, by C. Yarnall Abbott. Jan. 1909, 25:27. Original negative; photogravure. 12.3 x 15.5 cm. UPPER RIGHT: *I. Mr. Alfred Stieglitz*, by Frank Eugene. Jan. 1909, 25:41. Original negative; photogravure. 16.3 x 11.1 cm. LOWER LEFT: *II. Lady of Charlotte*, by Frank Eugene. Jan. 1909, 25:43. Original negative; photogravure. 11.4 x 8.2 cm. LOWER RIGHT: *I. Danish Girl*, by Alice Boughton. Apr. 1909, 26:5. Photogravure. 20.0 x 15.8 cm.

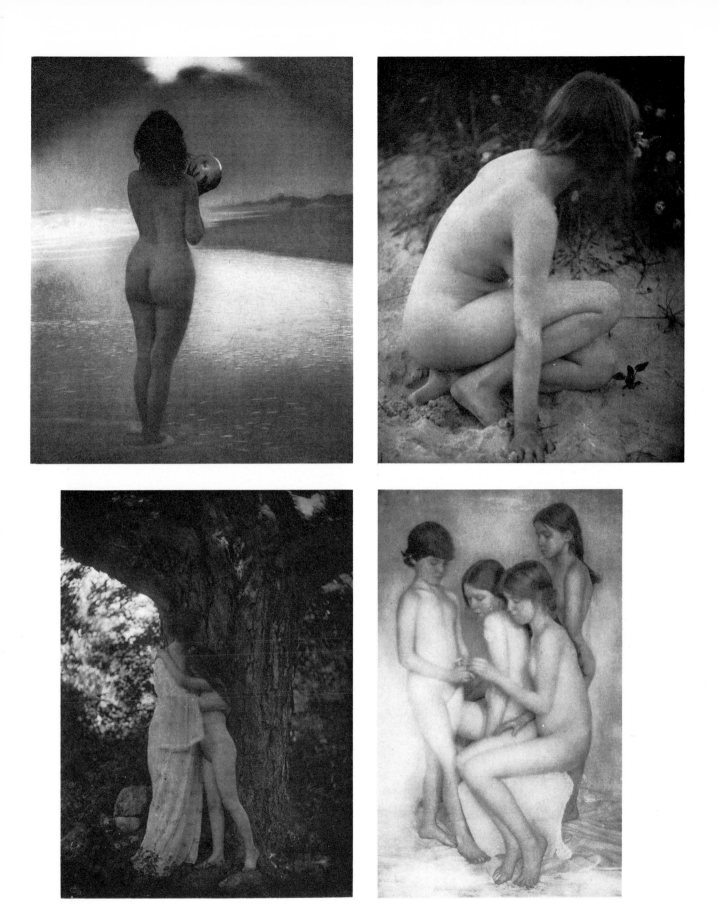

UPPER LEFT: *II. Dawn*, by Alice Boughton. Apr. 1909, 26:7. Photogravure. 19.4 x 15.3 cm. UPPER RIGHT: *III. Sand and Wild Roses*, by Alice Boughton. Apr. 1909, 26:9. Photogravure. 20.9 x 15.5 cm. LOWER LEFT: *IV. Nature*, by Alice Boughton.

Apr. 1909, 26:11. Photogravure. 22.1 x 15.9 cm. LOWER RIGHT: *V. Nude*, by Alice Boughton. Apr. 1909, 26:13. Photogravure. 21.8 x 13.2 cm.

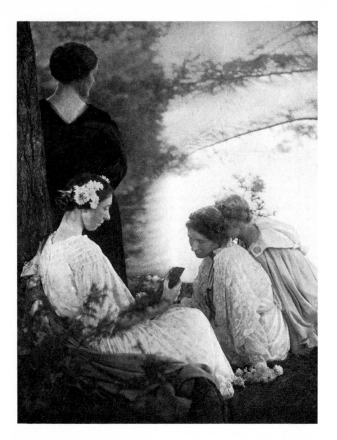

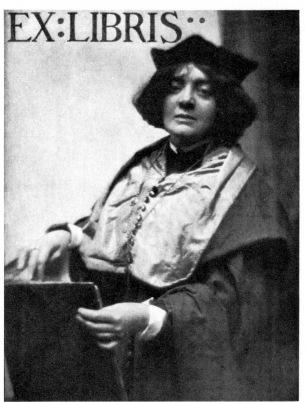

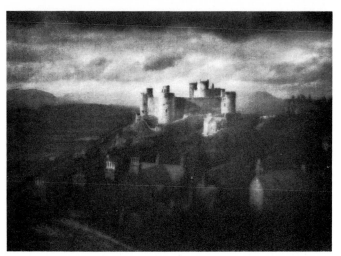

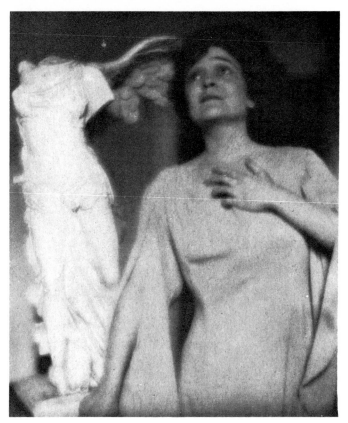

UPPER LEFT: *VI. The Seasons*, by Alice Boughton. Apr. 1909, 26:15. Photogravure. 20.7 x 15.5 cm. UPPER RIGHT: *I. Ex Libris*, by J. Craig Annan. Apr. 1909, 26:29. Photogravure. 20.2 x 15.2 cm. LOWER LEFT: *II. Harlech Castle*, by George Davison. Apr. 1909, 26:31. Photogravure. 15.4 x 21.0 cm. LOWER RIGHT: *I. Winged Victory*, by Herbert G. French. July 1909, 27:5. Original negative; photogravure. 19.6 x 16.0 cm.

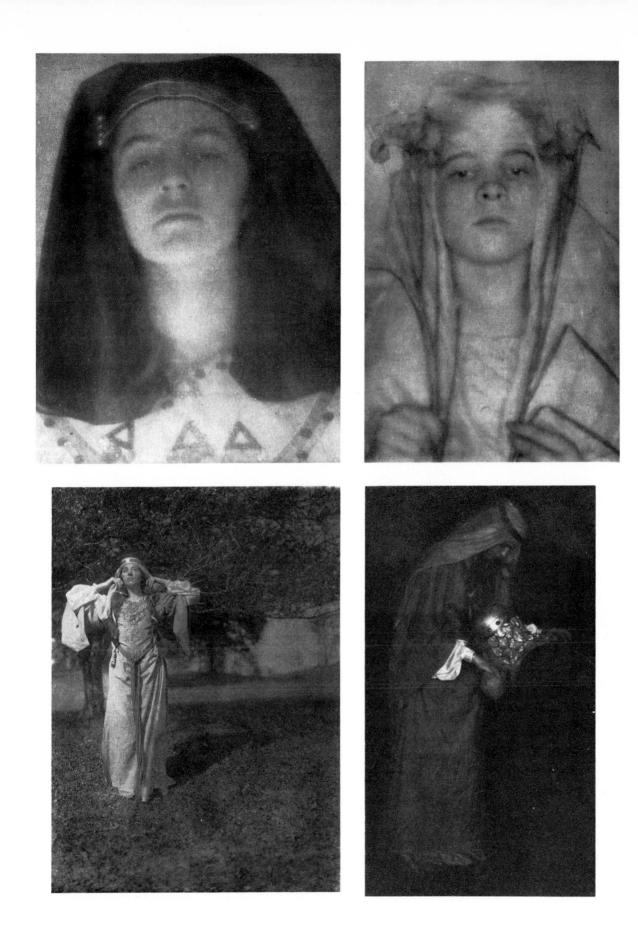

UPPER LEFT: *II. Egyptian Princess*, by Herbert G. French. July 1909, 27:7. Original negative; photogravure. 21.6 x 16.0 cm. UPPER RIGHT: *III. Iris*, by Herbert G. French. July 1909, 27:9. Original negative; photogravure. 23.4 x 15.0 cm. LOWER LEFT: *IV. Illustration, No. 18*, by Herbert G. French. July 1909, 27:11. Original negative; photogravure. 21.3 x 15.2 cm. LOWER RIGHT: *V. Illustration, No. 22*, by Herbert G. French. July 1909, 27:13. Original negative; photogravure. 17.3 x 9.8 cm.

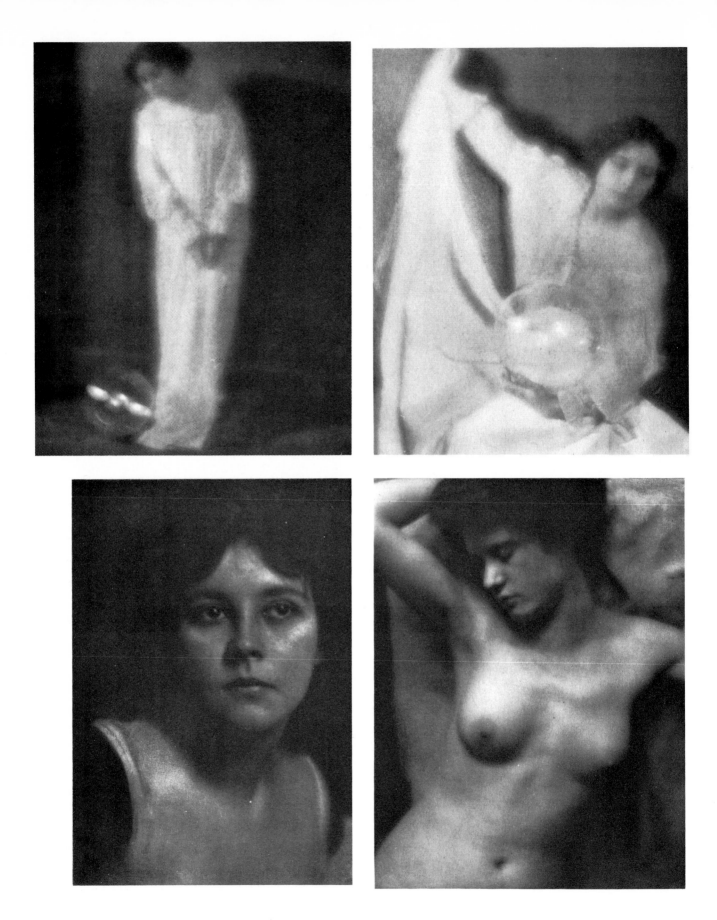

UPPER LEFT: *I. Experiment 27*, by Clarence H. White and Alfred Stieglitz. July 1909, 27:33. Original negative; photogravure. 20.4 x 15.8 cm. UPPER RIGHT: *II. Experiment 28*, by Clarence H. White and Alfred Stieglitz. July 1909, 27:35. Original negative; photogravure. 20.5 x 15.8 cm. LOWER LEFT: *III.*

Miss Mabel C., by Clarence H. White and Alfred Stieglitz. July 1909, 27:37. Original negative; photogravure. 22.5 x 15.7 cm. LOWER RIGHT: *IV. Torso*, by Clarence H. White and Alfred Stieglitz. July 1909, 27:39. Original negative; photogravure. 21.4 x 16.2 cm.

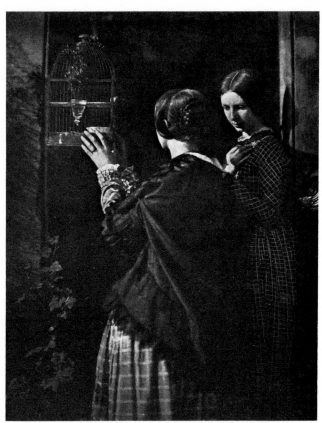

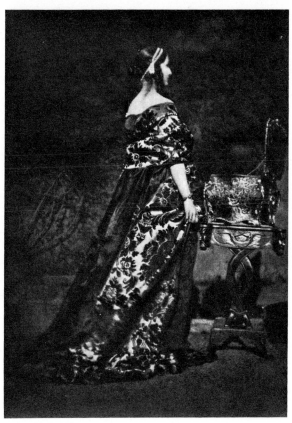

UPPER LEFT: *I. The Minnow Pool*, by David Octavius Hill [and Robert Adamson]. Oct. 1909, 28:5. Original negative; photogravure. 21.1 x 15.8 cm. UPPER RIGHT: *II. The Bird-Cage*, by David Octavius Hill [and Robert Adamson]. Oct. 1909, 28:7. Original negative; photogravure. 20.7 x 16.0 cm. LOWER LEFT:

III. Portraits—A Group, by David Octavius Hill [and Robert Adamson]. Oct. 1909, 28:9. Original negative; photogravure. 21.2 x 15.8 cm. LOWER RIGHT: *IV. Portrait—The Gown and the Casket*, by David Octavius Hill [and Robert Adamson]. Oct. 1909, 28:11. Original negative; photogravure. 20.6 x 14.5 cm.

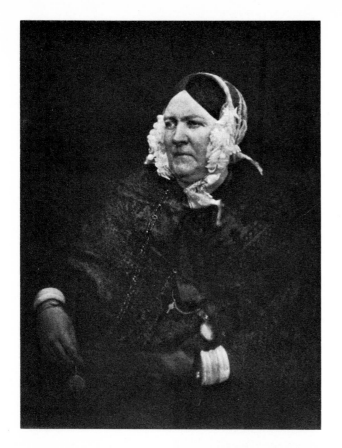

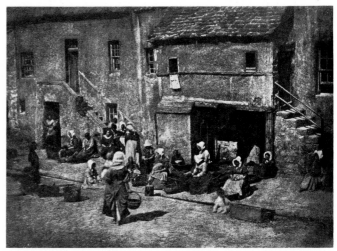

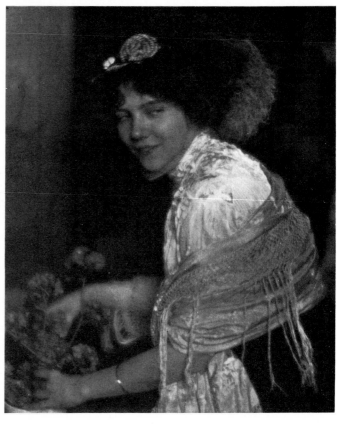

UPPER LEFT: *V. Mrs. Rigby*, by David Octavius Hill [and Robert Adamson]. Oct. 1909, 28:13. Original negative; photogravure. 20.3 x 14.9 cm. UPPER RIGHT: *VI. Newhaven Fisheries*, by David Octavius Hill [and Robert Adamson]. Oct. 1909, 28:15. Original negative; photogravure. 19.2 x 14.0 cm. LOWER LEFT: *I. House Near Aix-les-Bains*, by George Davison. Oct. 1909, 28:29. Photogravure. 19.4 x 15.2 cm. LOWER RIGHT: *I. Portrait—Miss G. G.*, by Paul E. Haviland. Oct. 1909, 28:41. Photogravure. 19.3 x 15.8 cm.

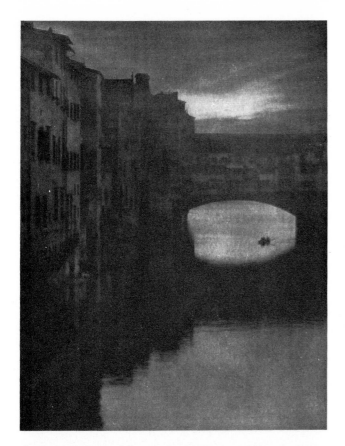

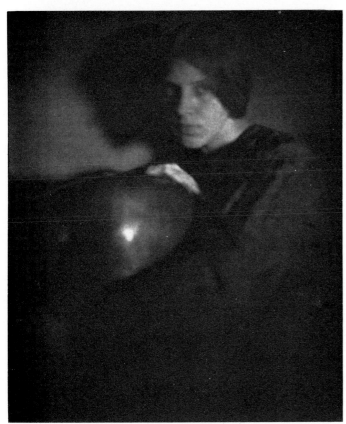

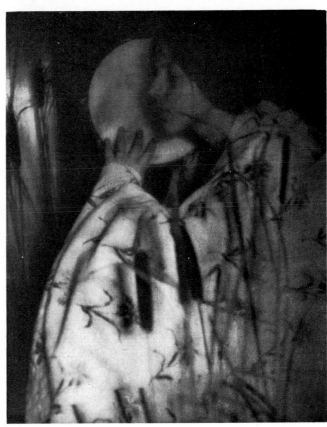

UPPER LEFT: *II. Ponte Vecchio—Florence*, by Marshall R. Kernochan. Oct. 1909, 28:43. Photogravure. 21.1 x 16.0 cm. UPPER RIGHT: *I. On the Embankment*, by Alvin Langdon Coburn. Oct. 1909, 28:55. Photogravure. 22.1 x 16.4 cm. LOWER

LEFT: *I. Girl with Bowl*, by George H. Seeley. Jan. 1910, 29:5. Original negative; photogravure. 19.9 x 16.0 cm. LOWER RIGHT: *II. Autumn*, by George H. Seeley. Jan. 1910, 29:7. Original negative; photogravure. 20.2 x 15.9 cm.

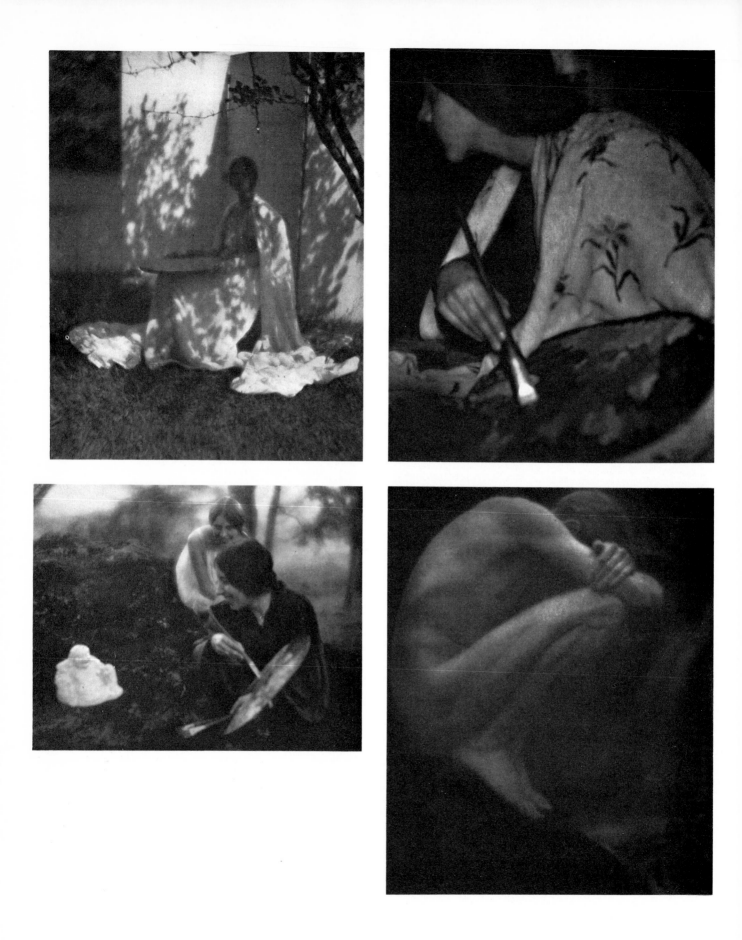

UPPER LEFT: *III. The White Screen*, by George H. Seeley. Jan. 1910, 29:9. Original negative; photogravure. 20.9 x 15.9 cm. UPPER RIGHT: *IV. The Artist*, by George H. Seeley. Jan. 1910, 29:11. Original negative; photogravure. 20.0 x 15.8 cm. LOWER LEFT: *V. Conspiracy*, by George H. Seeley. Jan. 1910, 29:13. Original negative; photogravure. 15.4 x 19.2 cm. LOWER RIGHT: *VI. Nude—The Pool*, by George H. Seeley. Jan. 1910, 29:15. Original negative; photogravure. 20.1 x 15.9 cm.

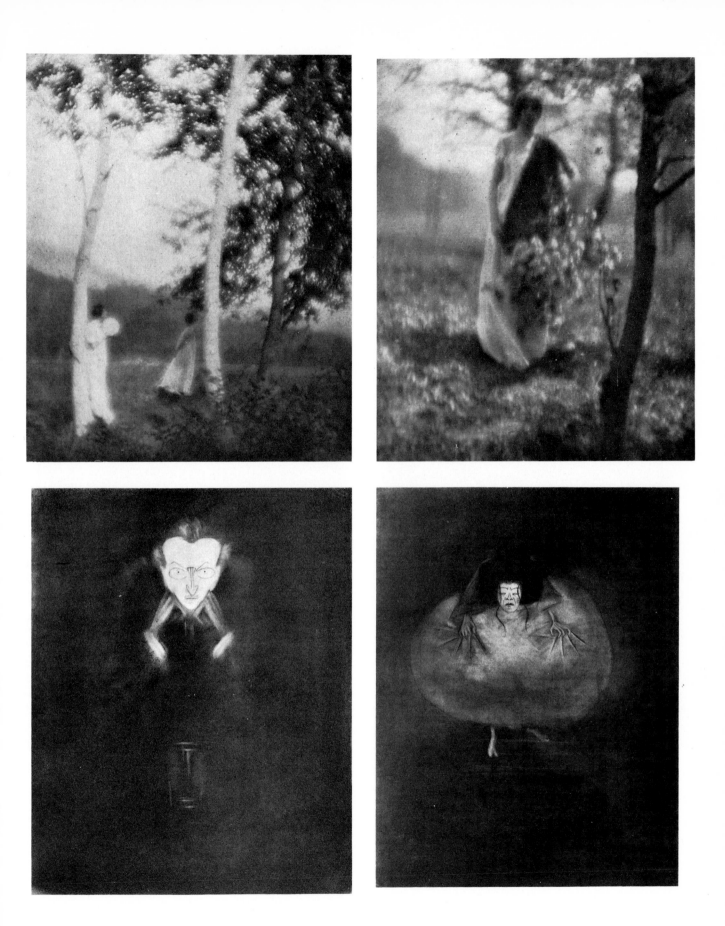

UPPER LEFT: *VII. White Trees*, by George H. Seeley. Jan. 1910, 29:25. Original negative; photogravure. 19.7 x 15.6 cm. UPPER RIGHT: *VIII. Spring*, by George H. Seeley. Jan. 1910, 29:27. Original negative; photogravure. 19.5 x 15.7 cm. LOWER LEFT:

I. Benjamin De Casseres, by Marius De Zayas. Jan. 1910, 29:41. Photogravure. 20.2 x 15.9 cm. LOWER RIGHT: *II. Madame Hanako*, by Marius De Zayas. Jan. 1910, 29:43. Photogravure. 21.3 x 16.2 cm.

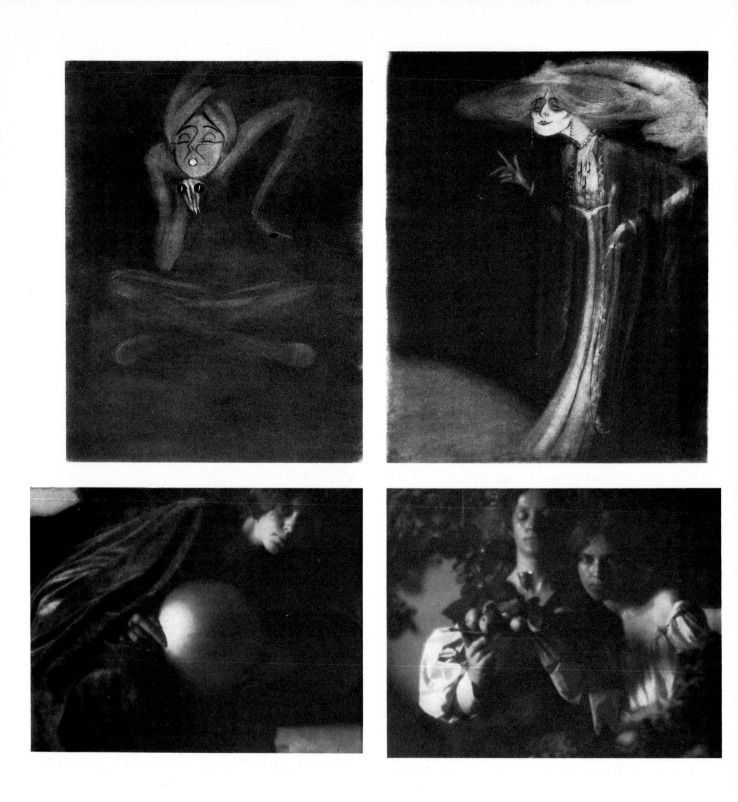

UPPER LEFT: *III. Ruth St. Denis*, by Marius De Zayas. Jan. 1910, 29:45. Photogravure. 21.9 x 16.5 cm. UPPER RIGHT: *IV. Mrs. Brown Potter*, by Marius De Zayas. Jan. 1910, 29:47. Photogravure. 20.4 x 16.0 cm. LOWER LEFT: *IX. No. 347*, by George H. Seeley. Jan. 1910, 29:57. Original negative; photogravure. 14.1 x 17.7 cm. LOWER RIGHT: *X. No. 356*, by George H. Seeley. Jan. 1910, 29:59. Original negative; photogravure. 14.4 x 17.9 cm.

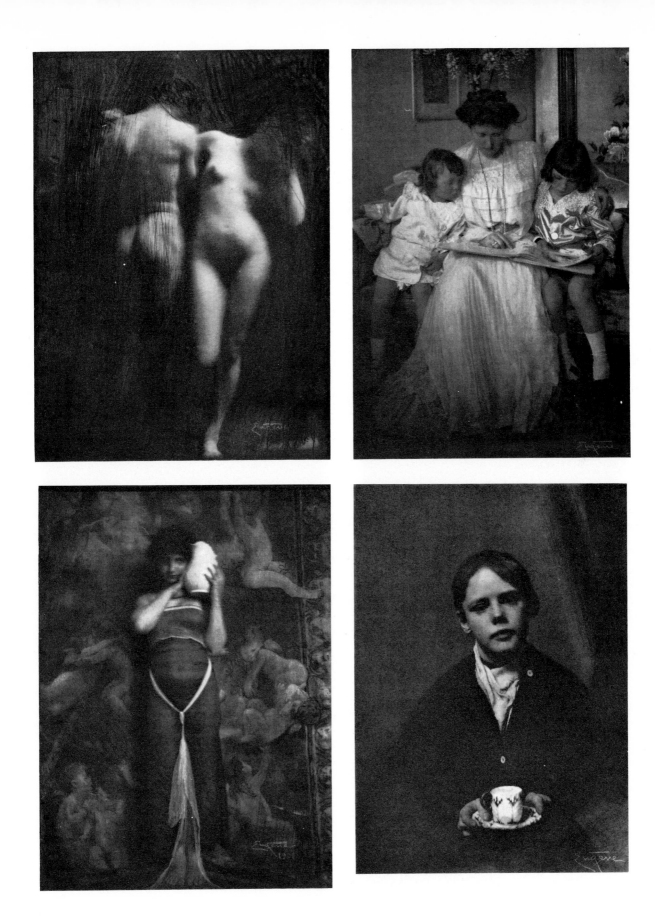

UPPER LEFT: *I. Adam and Eve,* by Frank Eugene. Apr. 1910, 30:5. Original negative; photogravure. 17.6 x 12.6 cm. UPPER RIGHT: *II. Princess Rupprecht and Her Children,* by Frank Eugene. Apr. 1910, 30:7. Original negative; photogravure. 17.5 x 12.0 cm. LOWER LEFT: *III. Rebecca,* by Frank Eugene. Apr. 1910, 30:9. Original negative; photogravure. 17.1 x 12.1 cm. LOWER RIGHT: *IV. Master Frank Jefferson,* by Frank Eugene. Apr. 1910, 30:11. Original negative; photogravure. 17.3 x 12.5 cm.

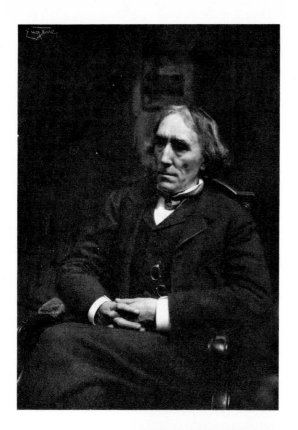

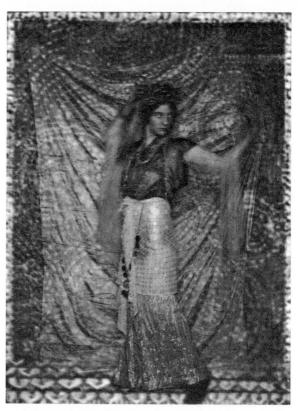

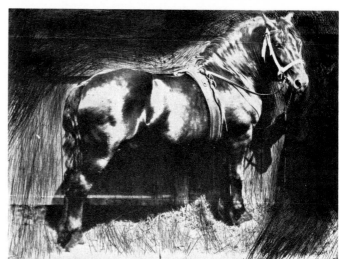

UPPER LEFT: *V. Sir Henry Irving*, by Frank Eugene. Apr. 1910, 30:13. Original negative; photogravure. 17.4 x 12.4 cm. UPPER RIGHT: *VI. Mosaic*, by Frank Eugene. Apr. 1910, 30:15. Original negative; photogravure. 18.7 x 13.8 cm. LOWER LEFT: *VII.* *Man In Armor*, by Frank Eugene. Apr. 1910, 30:29. Original negative; photogravure. 17.2 x 6.2 cm. LOWER RIGHT: *VIII. Horse*, by Frank Eugene. Apr. 1910, 30:31. Original negative; photogravure. 8.6 x 11.5 cm.

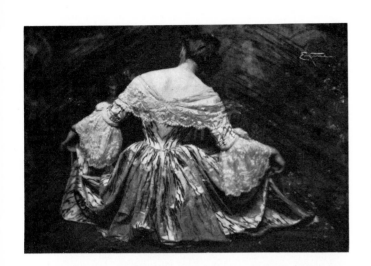

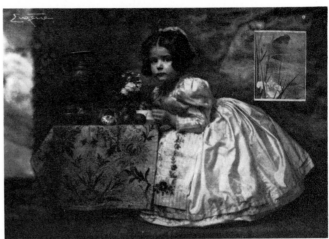

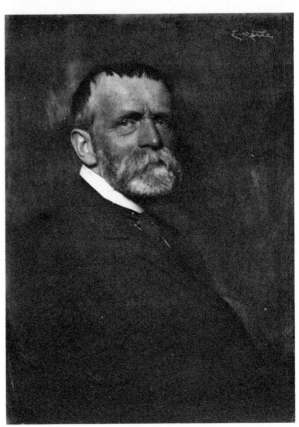

UPPER LEFT: *IX. Minuet*, by Frank Eugene. Apr. 1910, 30:59. Original negative; photogravure. 12.5 x 17.5 cm. UPPER RIGHT: *X. Brigitta*, by Frank Eugene. Apr. 1910, 30:61. Original negative; photogravure. 11.8 x 16.8 cm. LOWER LEFT: *I. H.R.H.*

Rupprecht, Prince of Bavaria, by Frank Eugene. July 1910, 31:5. Original negative; photogravure. 23.3 x 16.5 cm. LOWER RIGHT: *II. Fritz v. Uhde*, by Frank Eugene. July 1910, 31:7. Original negative; photogravure. 17.6 x 12.5 cm.

UPPER LEFT: *III. Prof. Adolf Hengeler*, by Frank Eugene. July 1910, 31:9. Original negative; photogravure. 17.0 x 12.2 cm. UPPER RIGHT: *IV. Prof. Franz v. Stuck*, by Frank Eugene. July 1910, 31:11. Original negative; photogravure. 17.0 x 12.0 cm.

LOWER LEFT: *V. Willi Geiger*, by Frank Eugene. July 1910, 31:13. Original negative; photogravure. 17.6 x 12.7 cm. LOWER RIGHT: *VI. Prof. Adolf v. Seitz*, by Frank Eugene. July 1910, 31:15. Original negative; photogravure. 16.2 x 12.1 cm.

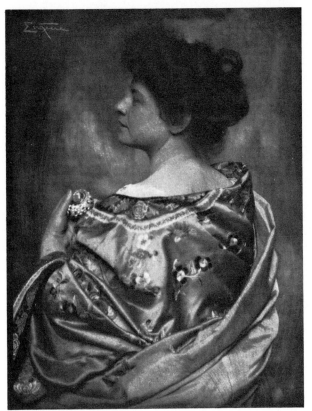

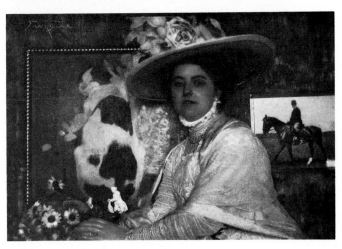

UPPER LEFT: *VIII. Dr. Georg Hirth,* by Frank Eugene. July 1910, 31:17. Original negative; photogravure. 17.0 x 12.0 cm. UPPER RIGHT: *VII. Dr. Emanuel Lasker and His Brother,* by Frank Eugene. July 1910, 31:19. Original negative; photogravure. 17.0 x 12.4 cm. LOWER LEFT: *IX. Kimono—Frl. v. S.,* by Frank Eugene. July 1910, 31:37. Original negative; photogravure. 17.3 x 12.4 cm. LOWER RIGHT: *X. Frau Ludwig von Hohlwein,* by Frank Eugene. July 1910, 31:39. Original negative; photogravure. 12.3 x 17.6 cm.

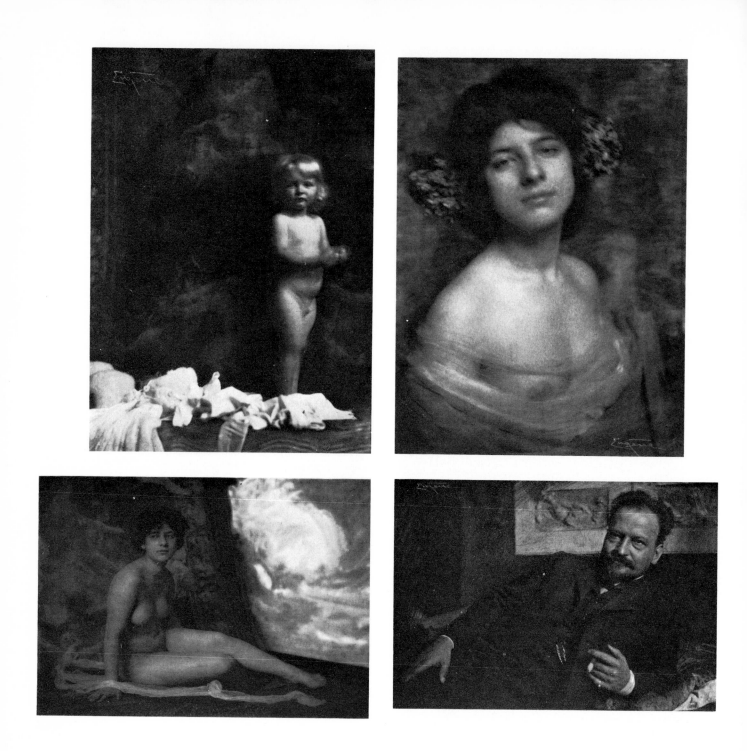

UPPER LEFT: *XI. Nude—A Child,* by Frank Eugene. July 1910, 31:57. Original negative; photogravure. 17.2 x 12.0 cm. UPPER RIGHT: *XII. "Hortensia,"* by Frank Eugene. July 1910, 31:59. Original negative; photogravure. 17.4 x 12.4 cm. LOWER LEFT:

XIII. Nude—A Study, by Frank Eugene. July 1910, 31:61. Original negative; photogravure. 12.0 x 16.8 cm. LOWER RIGHT: *XIV. Direktor F. Goetz,* by Frank Eugene. July 1910, 31:63. Original negative; photogravure. 12.5 x 17.4 cm.

UPPER LEFT: *I. East & West*, by J. Craig Annan. Oct. 1910, 32:5. Original negative; photogravure. 20.6 x 15.6 cm. UPPER RIGHT: *II. Man Sketching*, by J. Craig Annan. Oct. 1910, 32:7. Original negative; photogravure. 21.0 x 16.0 cm. LOWER LEFT: *III. Harlech Castle*, by J. Craig Annan. Oct. 1910, 32:9. Original negative; photogravure. 21.5 x 15.1 cm. LOWER RIGHT: *IV. Bolney Backwater*, by J. Craig Annan. Oct. 1910, 32:11. Original negative; photogravure. 23.3 x 14.2 cm.

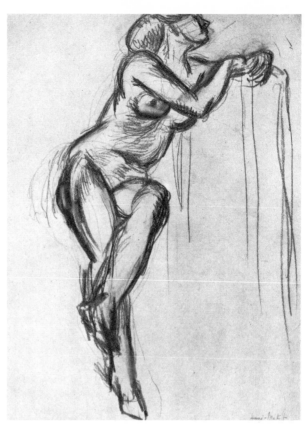

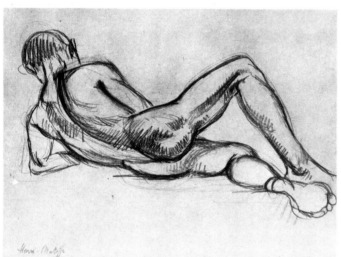

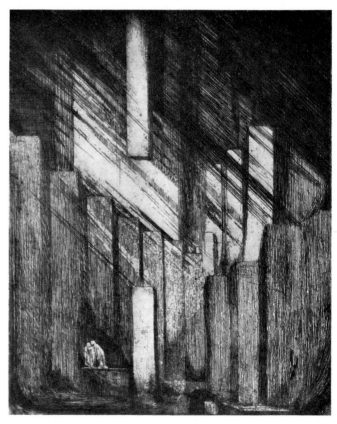

UPPER LEFT: *V. The White House*, by J. Craig Annan. Oct. 1910, 32:13. Original negative; photogravure. 19.6 x 17.4 cm. UPPER RIGHT: *I. Photogravure of Drawing*, by Henri Matisse. Oct. 1910, 32:29. Photogravure. 23.0 x 17.3 cm. LOWER LEFT:

II. Photogravure of Drawing, by Henri Matisse. Oct. 1910, 32:31. Photogravure. 17.7 x 22.8 cm. LOWER RIGHT: *I. Ninth Movement*, by Gordon Craig. Oct. 1910, 32:37. Photogravure. 19.8 x 15.7 cm.

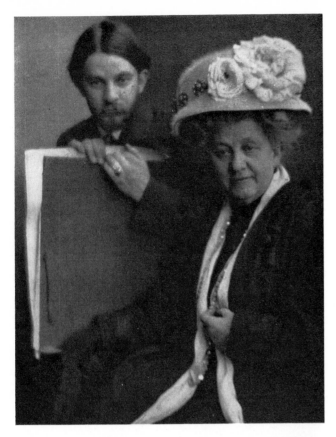

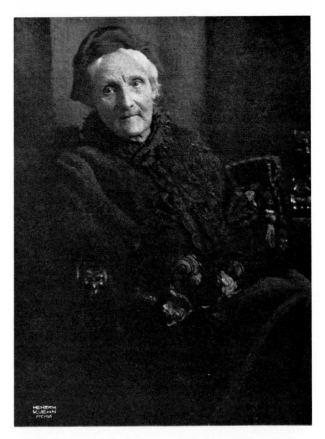

UPPER LEFT: *I. Alvin Langdon Coburn and His Mother*, by Clarence H. White. Oct. 1910, 32:45. Photogravure. 21.1 x 15.8 cm. UPPER RIGHT: *I. Portrait—Meine Mutter*, by Heinrich Kuehn. Jan. 1911, 33:5. Gum; photogravure. 19.8 x 14.7 cm.

LOWER LEFT: *II. On the Shore*, by Heinrich Kuehn. Jan. 1911, 33:7. Gum; photogravure. 21.5 x 15.4 cm. LOWER RIGHT: *III. Windblown*, by Heinrich Kuehn. Jan. 1911, 33:9. Gum; photogravure. 19.3 x 13.7 cm.

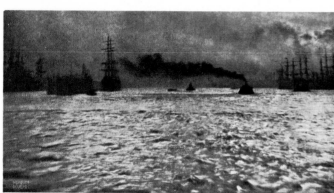

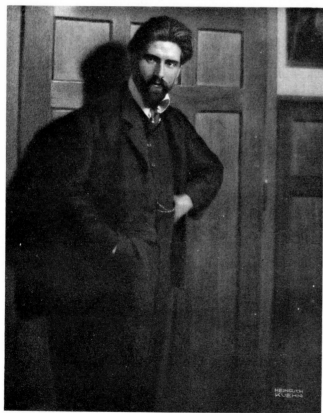

UPPER LEFT: *IV. Harbour of Hamburg*, by Heinrich Kuehn. Jan. 1911, 33:11. Gum; photogravure. 21.7 x 12.0 cm. UPPER RIGHT: *V. Portrait*, by Heinrich Kuehn. Jan. 1911, 33:13. Gum; photogravure. 17.7 x 14.2 cm. LOWER LEFT: *VI. Portrait*, by Heinrich Kuehn. Jan. 1911, 33:15. Gum; photogravure. 17.7 x 14.1 cm. LOWER RIGHT: *VII. Portrait—The Mirror,* by Heinrich Kuehn. Jan. 1911, 33:17. Gum; photogravure. 18.4 x 14.3 cm.

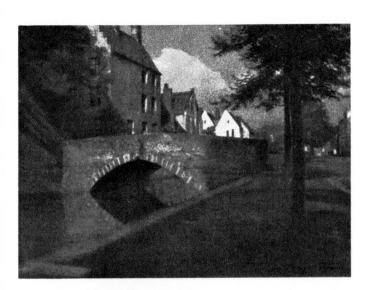

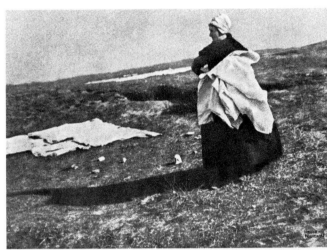

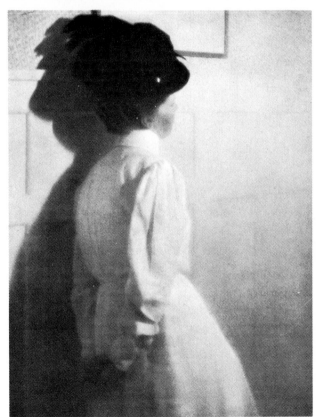

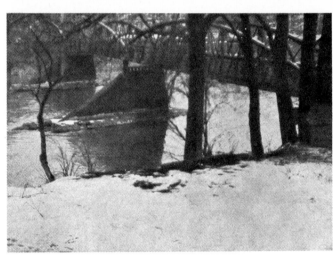

UPPER LEFT: *VIII. Landscape*, by Heinrich Kuehn. Jan. 1911, 33:37. Gum; mezzotint photogravure. 12.2 x 15.6 cm. UPPER RIGHT: *IX. On the Dunes*, by Heinrich Kuehn. Jan. 1911, 33:39. Gum; mezzotint photogravure. 11.5 x 15.7 cm. LOWER LEFT: *X. Study*, by Heinrich Kuehn. Jan. 1911, 33:41. Gum; mezzotint photogravure. 18.7 x 13.8 cm. LOWER RIGHT: *XI. Winter Landscape*, by Heinrich Kuehn. Jan. 1911, 33:43. Gum; mezzotint photogravure. 11.8 x 16.4 cm.

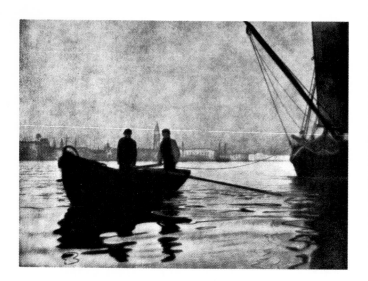

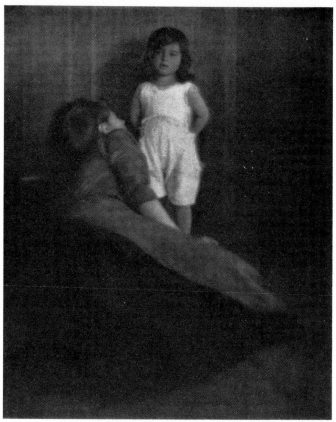

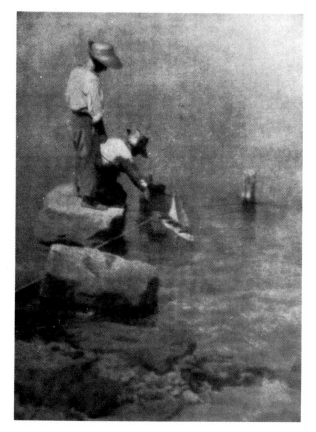

UPPER LEFT: *XII. Venice*, by Heinrich Kuehn. Jan. 1911, 33:53. Gum; duplex halftone. 19.6 x 14.8 cm. UPPER RIGHT: *XIII. Lotte and Her Nurse*, by Heinrich Kuehn. Jan. 1911, 33:55. Gum; duplex halftone. 18.3 x 14.6 cm. LOWER LEFT: *XIV.*

Sailing Boats, by Heinrich Kuehn. Jan. 1911, 33:57. Gum; duplex halftone. 20.3 x 14.3 cm. LOWER RIGHT: *XV. Landscape*, by Heinrich Kuehn. Jan. 1911, 33:59. Gum; duplex halftone. 19.3 x 14.6 cm.

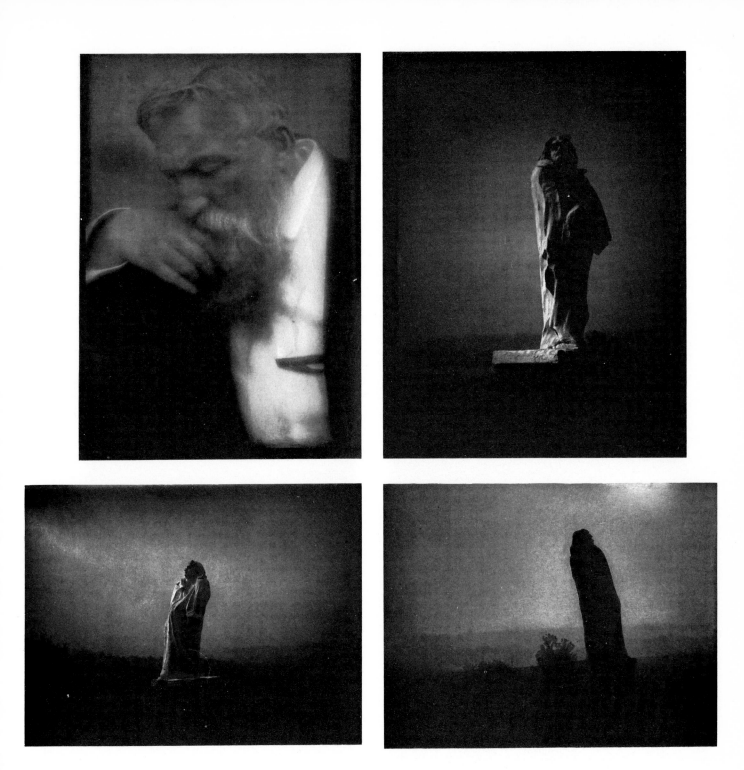

UPPER LEFT: *I. M. Auguste Rodin*, by Eduard J. Steichen. Apr./July 1911, 34/35:5. Original negative; photogravure. 23.9 x 16.5 cm. UPPER RIGHT: *II. Balzac—The Open Sky*, by Eduard J. Steichen. Apr./July 1911, 34/35:7. Original negative; photogravure. 20.3 x 15.6 cm. LOWER LEFT: *III. Balzac—Towards the Light, Midnight*, by Eduard J. Steichen. Apr./July 1911, 34/35:9. Original negative; photogravure. 15.7 x 20.2 cm. LOWER RIGHT: *IV. Balzac—The Silhouette, 4 a. m.*, by Eduard J. Steichen. Apr./July 1911, 34/35:11. Original negative; photogravure. 16.0 x 20.5 cm.

UPPER LEFT: *I. Photogravure of Drawing*, by Auguste Rodin. Apr./July 1911, 34/35:25. Photogravure. 18.5 x 13.6 cm. UPPER RIGHT: *II. Photogravure of Drawing*, by Auguste Rodin. Apr./ July 1911, 34/35:27. Photogravure. 19.4 x 15.7 cm. LOWER

LEFT: *III. Cambodian Dancer*, by Auguste Rodin. Apr./July 1911, 34/35:37. Colored collotype. 24.1 x 18.4 cm. LOWER RIGHT: *IV. Drawing*, by Auguste Rodin. Apr./July 1911, 34/ 35:39. Colored collotype. 26.8 x 18.5 cm.

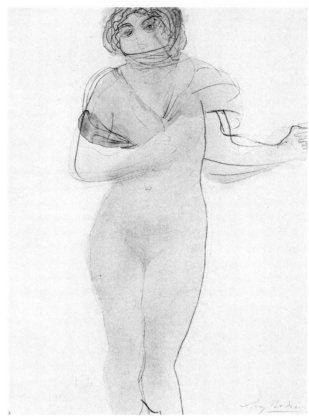

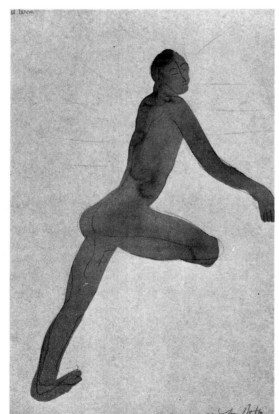

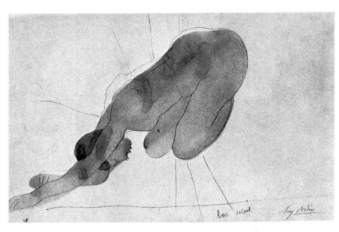

UPPER LEFT: *V. Drawing*, by Auguste Rodin. Apr./July 1911, 34/35:41. Colored collotype. 24.2 x 18.6 cm. UPPER RIGHT: *VI. Drawing*, by Auguste Rodin. Apr./July 1911, 34/35:43. Colored collotype. 26.1 x 18.4 cm. LOWER LEFT: *VII. Drawing (Sun Series)*, by Auguste Rodin. Apr./July 1911, 34/35:57. Colored collotype. 28.8 x 18.6 cm. LOWER RIGHT: *VIII. Drawing (Sun Series)*, by Auguste Rodin. Apr./July 1911, 34/35:59. Colored collotype. 18.4 x 28.8 cm.

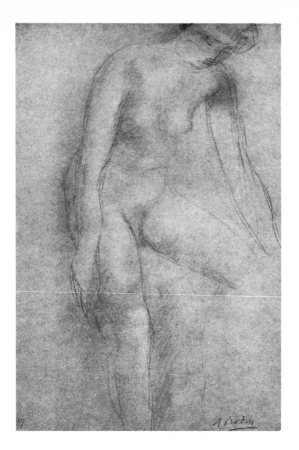

UPPER LEFT: *IX. Drawing*, by Auguste Rodin. Apr./July 1911, 34/35:61. Collotype. 25.8 x 17.0 cm. UPPER RIGHT: *I. The City of Ambition (1910)*, by Alfred Stieglitz. Oct. 1911, 36:5. Original negative; photogravure. 22.1 x 16.7 cm. LOWER LEFT: *II. The*

City Across the River (1910), by Alfred Stieglitz. Oct. 1911. 36:7. Original negative; photogravure. 19.9 x 15.8 cm. LOWER RIGHT: *III. The Ferry Boat (1910)*, by Alfred Stieglitz. Oct. 1911, 36:9. Original negative; photogravure. 20.8 x 16.1 cm.

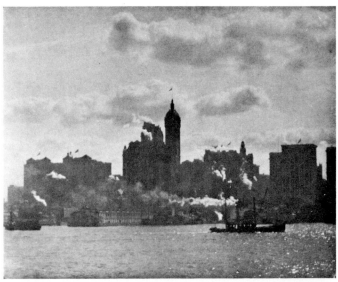

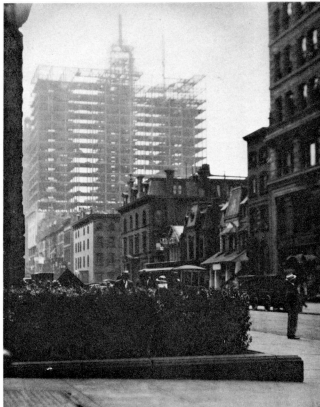

UPPER LEFT: *IV. The Mauretania (1910)*, by Alfred Stieglitz. Oct. 1911, 36:11. Original negative; photogravure. 20.8 x 16.2 cm. UPPER RIGHT: *V. Lower Manhattan (1910)*, by Alfred Stieglitz. Oct. 1911, 36:13. Original negative; photogravure. 15.9 x 19.7 cm. LOWER LEFT: *VI. Old and New New York* *(1910)*, by Alfred Stieglitz. Oct. 1911, 36:15. Original negative; photogravure. 20.2 x 15.7 cm. LOWER RIGHT: *VII. The Aeroplane (1910)*, by Alfred Stieglitz. Oct. 1911, 36:25. Original negative; photogravure. 14.3 x 17.4 cm.

UPPER LEFT: *VIII. A Dirigible (1910)*, by Alfred Stieglitz. Oct. 1911, 36:27. Original negative; photogravure. 17.7 x 17.9 cm. UPPER RIGHT: *IX. The Steerage (1907)*, by Alfred Stieglitz. Oct. 1911, 36:37. Original negative; photogravure. 19.6 x 15.7 cm. LOWER LEFT: *X. Excavating—New York (1911)*, by Alfred Stieglitz. Oct. 1911, 36:39. Original negative; photogravure. 12.6 x 15.6 cm. LOWER RIGHT: *XI. The Swimming Lesson (1906)*, by Alfred Stieglitz. Oct. 1911, 36:41. Original negative; photogravure. 14.7 x 22.9 cm.

UPPER LEFT: *XII. The Pool—Deal (1910)*, by Alfred Stieglitz. Oct. 1911, 36:43. Original negative; photogravure. 12.5 x 15.7 cm. UPPER RIGHT: *XIII. The Hand of Man (1902)*, by Alfred Stieglitz. Oct. 1911, 36:57. Original negative; photogravure. 15.8 x 21.4 cm. LOWER LEFT: *XIV. In the New York Central Yards (1903)*, by Alfred Stieglitz. Oct. 1911, 36:59. Original negative; photogravure. 19.3 x 15.8 cm. LOWER RIGHT: *XV. The Terminal (1892)*, by Alfred Stieglitz. Oct. 1911, 36:61. Original negative; photogravure. 12.0 x 15.8 cm.

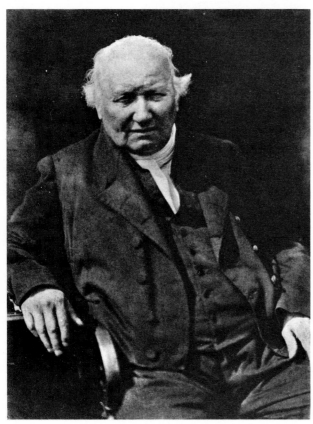

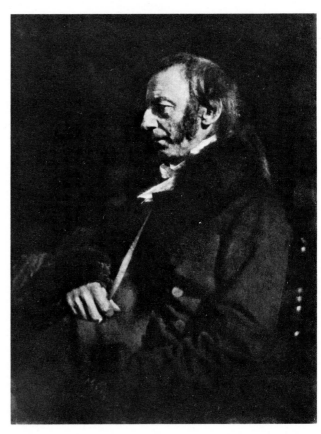

UPPER LEFT: *XVI. Spring Showers, New York (1900)*, by Alfred Stieglitz. Oct. 1911, 36:63. Original negative; photogravure. 22.9 x 9.1 cm. UPPER RIGHT: *I. Drawing*, by Pablo Picasso. Oct. 1911, 36:71. Halftone. 27.9 x 17.2 cm. LOWER LEFT: *I. Principal Haldane*, by David Octavius Hill [and Robert Adam-son]. Jan. 1912, 37:5. Original negative; photogravure. 21.5 x 15.9 cm. LOWER RIGHT: *II. The Marquis of Northampton*, by David Octavius Hill [and Robert Adamson]. Jan. 1912, 37:7. Original negative; photogravure. 10.0 x 14.9 cm.

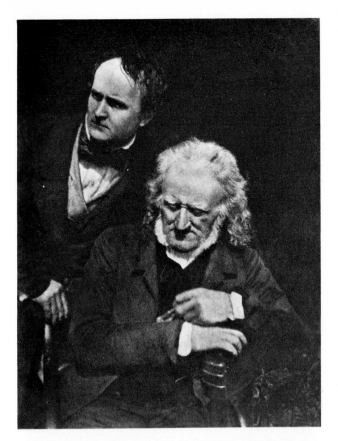

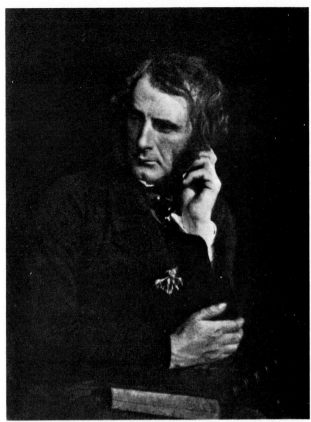

UPPER LEFT: *III. Handyside Ritchie and Wm. Henning*, by David Octavius Hill [and Robert Adamson]. Jan. 1912, 37:9. Original negative; photogravure. 21.4 x 15.8 cm. UPPER RIGHT: *IV. Sir Francis Grant, P. R. A.*, by David Octavius Hill [and Robert Adamson]. Jan. 1912, 37:11. Original negative; photogravure. 20.0 x 14.8 cm. LOWER LEFT: *V. Mrs. Anna Brownell*

Jameson, by David Octavius Hill [and Robert Adamson]. Jan. 1912, 37:13. Original negative; photogravure. 20.4 x 14.7 cm. LOWER RIGHT: *VI. Lady in Black*, by David Octavius Hill [and Robert Adamson]. Jan. 1912, 37:29. Original negative; photogravure. 20.8 x 15.7 cm.

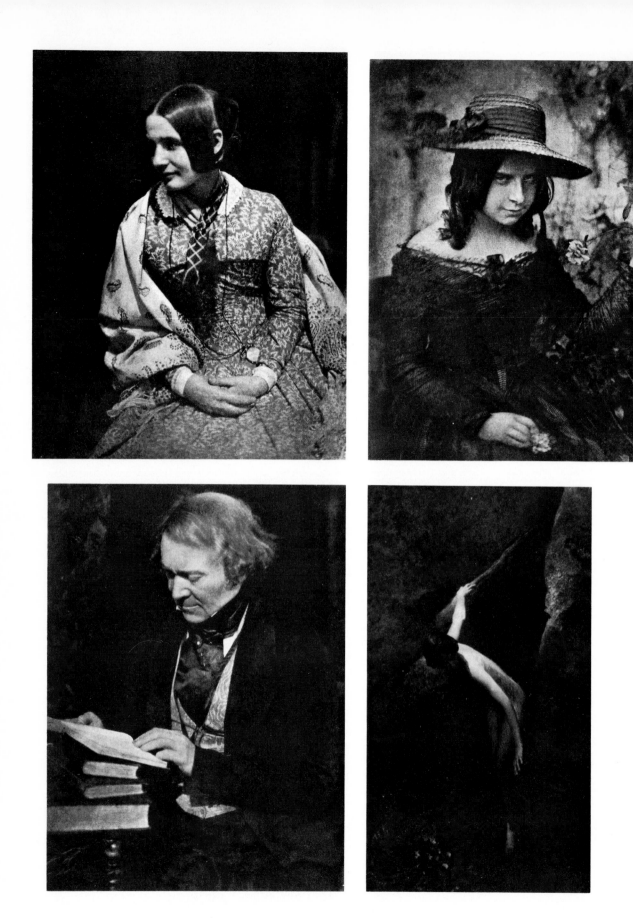

UPPER LEFT: *VII. Lady in Flowered Dress*, by David Octavius Hill [and Robert Adamson]. Jan. 1912, 37:31. Original negative; photogravure. 20.6 x 15.7 cm. UPPER RIGHT: *VIII. Girl in Straw Hat*, by David Octavius Hill [and Robert Adamson]. Jan. 1912, 37:33. Original negative; photogravure. 21.5 x 15.9

cm. LOWER LEFT: *IX. Mr. Rintoul, Editor "Spectator,"* by David Octavius Hill [and Robert Adamson]. Jan. 1912, 37:35. Original negative; photogravure. 20.3 x 14.9 cm. LOWER RIGHT: *I. The Cleft of the Rock*, by Annie W. Brigman. Apr. 1912, 38:5. Original negative; photogravure. 23.8 x 12.9 cm.

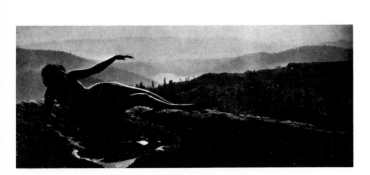

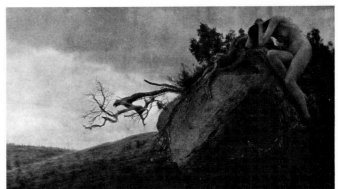

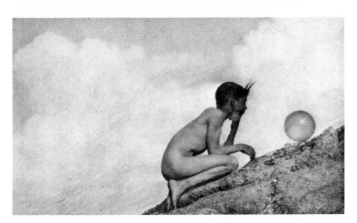

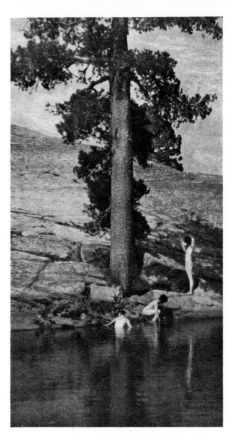

UPPER LEFT: *II. Dawn*, by Annie W. Brigman. Apr. 1912, 38:7. Original negative; photogravure. 10.5 x 24.3 cm. UPPER RIGHT: *III. Finis*, by Annie W. Brigman. Apr. 1912, 38:9. Original negative; photogravure. 13.5 x 23.9 cm. LOWER LEFT:

IV. The Wondrous Globe, by Annie W. Brigman. Apr. 1912, 38:11. Original negative; photogravure. 12.1 x 19.9 cm. LOWER RIGHT: *V. The Pool*, by Annie W. Brigman. Apr. 1912, 38:13. Original negative; photogravure. 23.6 x 12.4 cm.

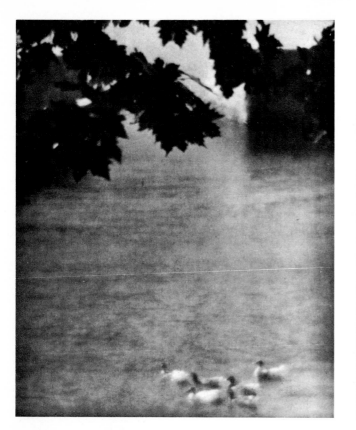

UPPER LEFT: *I. Ducks, Lake Como*, by Karl F. Struss. Apr. 1912, 38:25. Original negative; photogravure. 17.7 x 15.8 cm. UPPER RIGHT: *II. Sunday Morning Chester, Nova Scotia*, by Karl F. Struss. Apr. 1912, 38:27. Original negative; photogravure. 19.6 x 16.2 cm. LOWER LEFT: *III. The Outlook, Villa Carlotta,* by Karl F. Struss. Apr. 1912, 38:29. Original negative; photogravure. 19.4 x 15.9 cm. LOWER RIGHT: *IV. On the East River, New York*, by Karl F. Struss. Apr. 1912, 38:31. Original negative; photogravure. 19.9 x 16.0 cm.

UPPER LEFT: *V. Capri*, by Karl F. Struss. Apr. 1912, 38:49. Original negative; photogravure. 19.8 x 16.0 cm. UPPER RIGHT: *VI. The Landing Place, Villa Carlotta*, by Karl F. Struss. Apr. 1912, 38:51. Original negative; photogravure. 21.6 x 15.9 cm. LOWER LEFT: *VII. Over the House Tops, Missen*, by Karl F. Struss. Apr. 1912, 38:53. Original negative; photogravure. 23.0 x 12.5 cm. LOWER RIGHT: *VIII. The Cliffs, Sorrento*, by Karl F. Struss. Apr. 1912, 38:55. Original negative; photogravure. 20.8 x 15.7 cm.

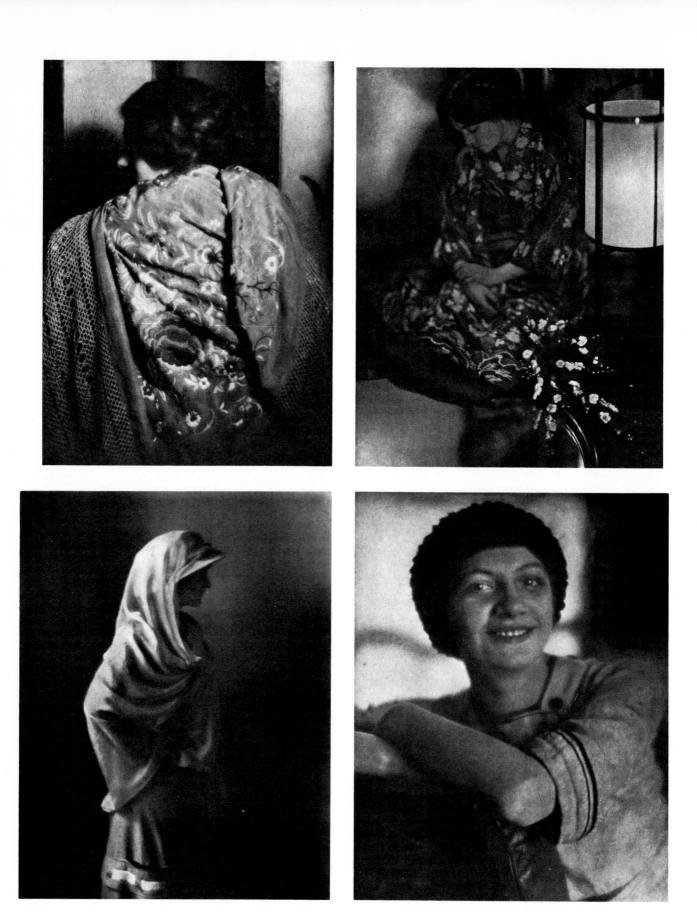

UPPER LEFT: *I. The Spanish Shawl*, by Paul B. Haviland. July 1912, 39:5. Original negative; photogravure. 22.2 x 15.9 cm. UPPER RIGHT: *II. The Japanese Lantern*, by Paul B. Haviland. July 1912, 39:7. Original negative; photogravure. 20.6 x 15.7 cm. LOWER LEFT: *III. Miss Doris Keane*, by Paul B. Haviland. July 1912, 39:9. Original negative; photogravure. 20.6 x 15.8 cm. LOWER RIGHT: *IV. Totote*, by Paul B. Haviland. July 1912, 39:11. Original negative; photogravure. 21.0 x 16.0 cm.

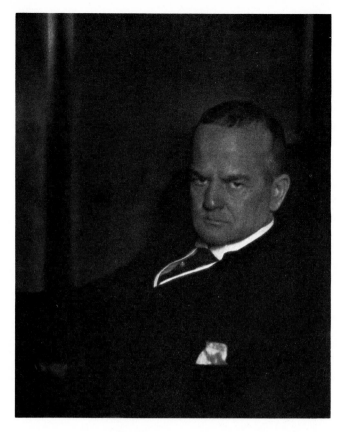

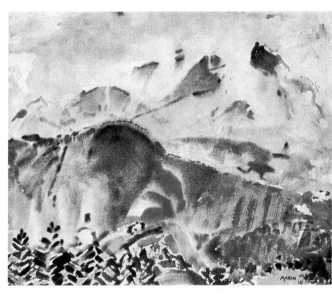

UPPER LEFT: *V. Mr. Christian Brinton*, by Paul B. Haviland. July 1912, 39:13. Original negative; photogravure. 20.8 x 16.0 cm. UPPER RIGHT: *VI. Passing Steamer*, by Paul B. Haviland. July 1912, 39:15. Original negative; photogravure. 16.7 x 17.6 cm. LOWER LEFT: *I. In the Tirol—No. 13*, by John Marin. July 1912, 39:27. Three-color halftone. 14.3 x 17.4 cm. LOWER RIGHT: *II. In the Tirol—No. 23*, by John Marin. July 1912, 39:29. Three-color halftone. 14.2 x 17.3 cm.

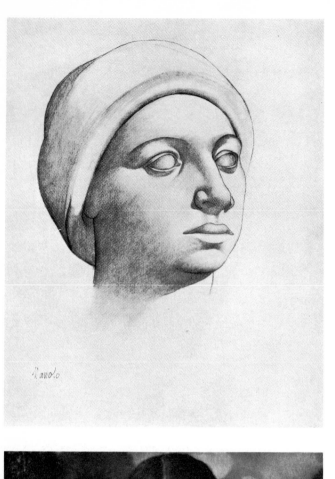

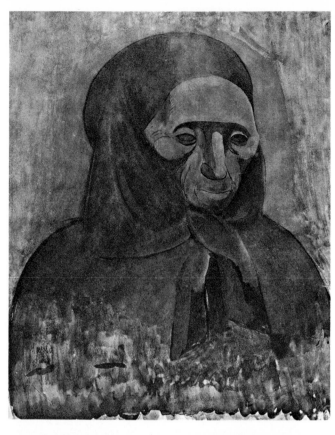

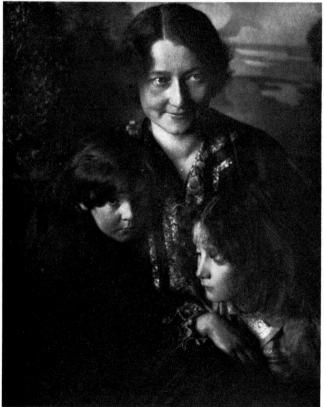

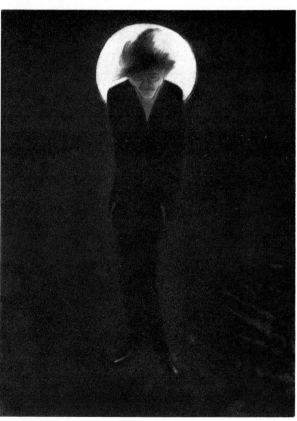

UPPER LEFT: *I. Totote*, by Manolo. July 1912, 39:41. Halftone. 24.6 x 19.5 cm. UPPER RIGHT: *II. Reproduction of a Drawing*, Manolo. July 1912, 39:43. Mezzotint photogravure. 19.7 x 15.6 cm. LOWER LEFT: *I. Portrait Group*, by H. Mortimer Lamb.

July 1912, 39:53. Original negative; photogravure. 20.0 x 15.8 cm. LOWER RIGHT: *II. L'Accoucheur d'Idées*, by M. De Zayas. July 1912, 39:55. Photogravure. 22.1 x 16.0 cm.

UPPER LEFT: Untitled [*Blue Nude—Souvenir de Biskra*], by Henri Matisse. Aug. 1912, SN:7. Halftone. 15.1 x 23.2 cm. UPPER RIGHT: *The Joy of Life*, by Henri Matisse. Aug. 1912, SN:9. Halftone. 15.2 x 21.0 cm. LOWER LEFT: Untitled [*Bathers* *with a Turtle*], by Henri Matisse. Aug. 1912, SN:11. Halftone. 15.1 x 18.7 cm. LOWER RIGHT: Untitled [*Still Life in Venetian Red*], by Henri Matisse. Aug. 1912, SN:13. Halftone. 15.0 x 18.1 cm.

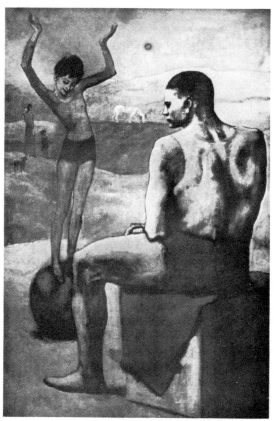

UPPER LEFT: *Hair-Dressing*, by Henri Matisse. Aug. 1912, SN:15. Halftone. 20.0 x 15.1 cm. UPPER RIGHT: *Sculpture*, by Henri Matisse. Aug. 1912, SN:17. Halftone. 11.2 x 15.0 cm. LOWER LEFT: *Sculpture*, by Henri Matisse. Aug. 1912, SN:19.

Halftone. 19.5 x 15.0 cm. LOWER RIGHT: *The Wandering Acrobats*, by Pablo Picasso. Aug. 1912, SN:31. Halftone. 19.5 x 12.5 cm.

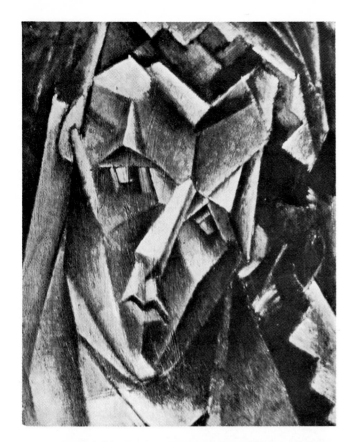

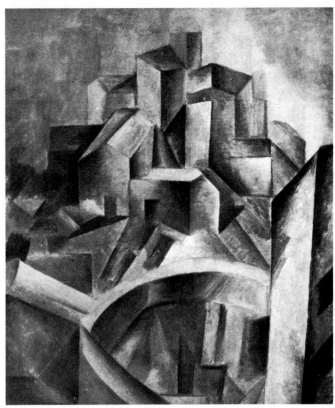

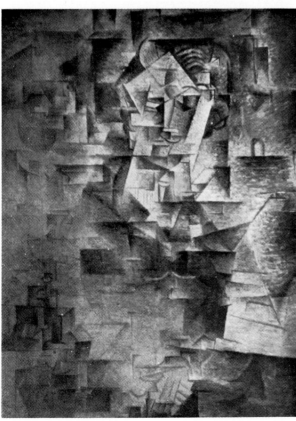

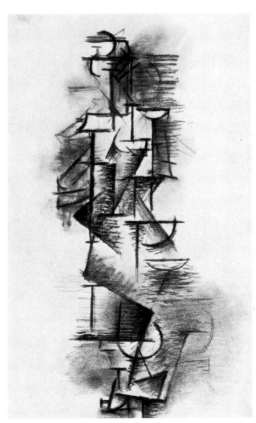

UPPER LEFT: Untitled, by Pablo Picasso. Aug. 1912, SN:33. Halftone. 19.3 x 15.0 cm. UPPER RIGHT: *Spanish Village*, by Pablo Picasso. Aug. 1912, SN:35. Halftone. 16.8 x 14.0 cm.

LOWER LEFT: *Portrait, M. Kahnweiler*, by Pablo Picasso. Aug. 1912, SN:37. Halftone. 21.5 x 15.5 cm. LOWER RIGHT: *Drawing*, by Pablo Picasso. Aug. 1912, SN:39. Halftone. 27.8 x 17.2 cm.

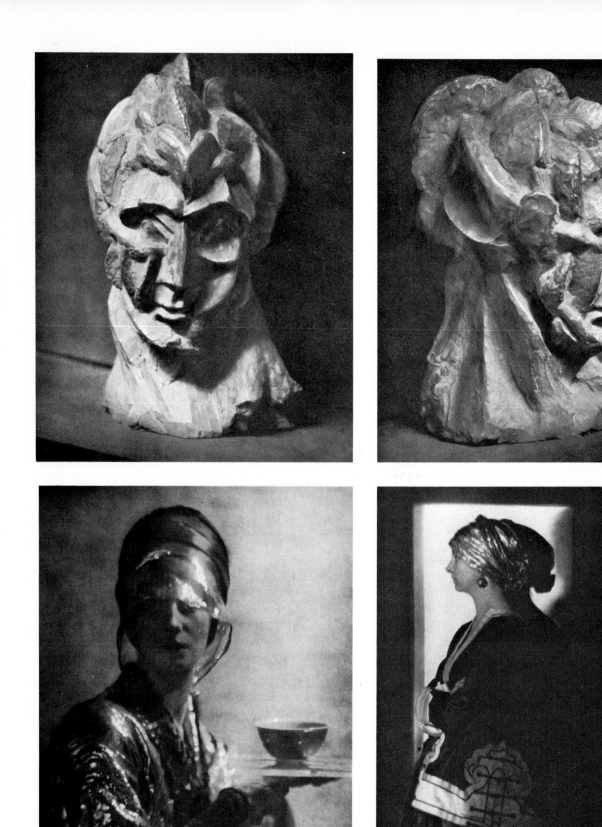

UPPER LEFT: *Sculpture*, by Pablo Picasso. Aug. 1912, SN:41. Halftone. 19.5 x 15.1 cm. UPPER RIGHT: *Sculpture*, by Pablo Picasso. Aug. 1912, SN:43. Halftone. 18.1 x 15.1 cm. LOWER LEFT: *I. The Cup*, by Ad. De Meyer. Oct. 1912, 40:5. Original negative; photogravure. 21.4 x 16.3 cm. LOWER RIGHT: *II. The Silver Cap*, by Ad. De Meyer. Oct. 1912, 40:7. Original negative; photogravure. 23.8 x 13.7 cm.

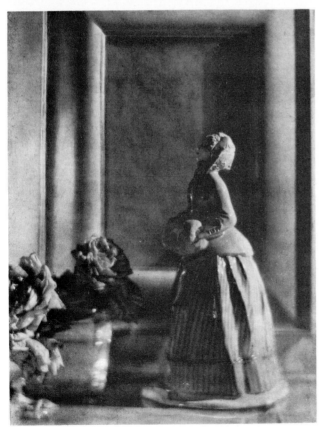

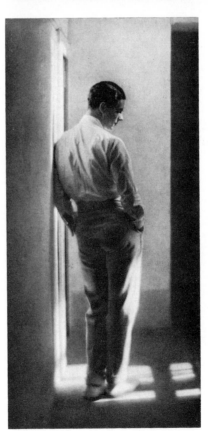

UPPER LEFT: *III. Marchesa Casati*, by Ad. De Meyer. Oct. 1912, 40:9. Original negative; photogravure. 21.7 x 16.2 cm. UPPER RIGHT: *IV. Miss J. Ranken*, by Ad. De Meyer. Oct. 1912, 40:11. Original negative; photogravure. 19.6 x 15.0 cm. LOWER LEFT:

V. The Nymphenburg Figure, by Ad. De Meyer. Oct. 1912, 40:13. Original negative; photogravure. 21.8 x 16.2 cm. LOWER RIGHT: *VI. Teddie*, by Ad. De Meyer. Oct. 1912, 40:15. Original negative; photogravure. 22.0 x 10.5 cm.

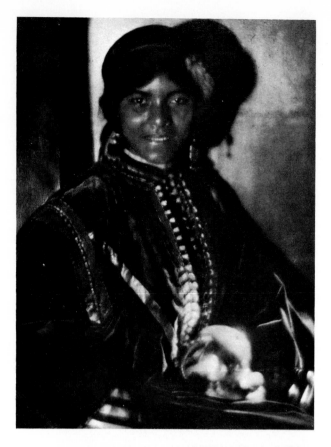

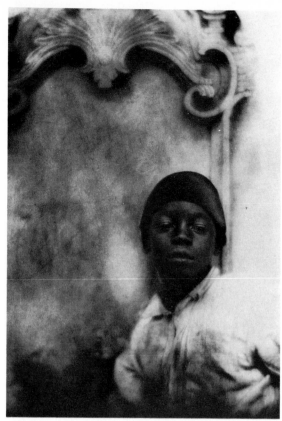

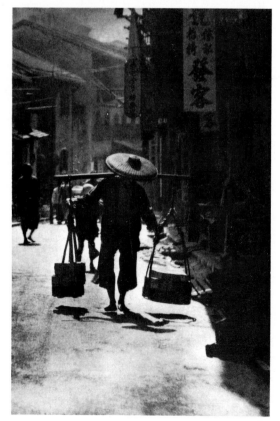

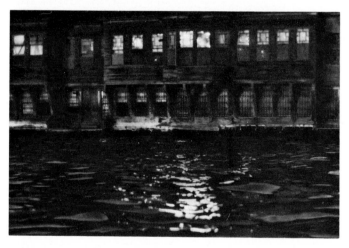

UPPER LEFT: *VII. Aïda, a Maid of Tangier*, by Ad. De Meyer. Oct. 1912, 40:29. Original negative; photogravure. 22.4 x 16.3 cm. UPPER RIGHT: *VIII. From the Shores of the Bosphorus*, by Ad. De Meyer. Oct. 1912, 40:31. Original negative; photogravure. 23.8 x 15.7 cm. LOWER LEFT: *IX. A Street in China*, by Ad. De Meyer. Oct. 1912, 40:33. Original negative; photogravure. 24.2 x 15.7 cm. LOWER RIGHT: *X. Windows on the Bosphorus*, by Ad. De Meyer. Oct. 1912, 40:35. Original negative; photogravure. 15.8 x 22.4 cm.

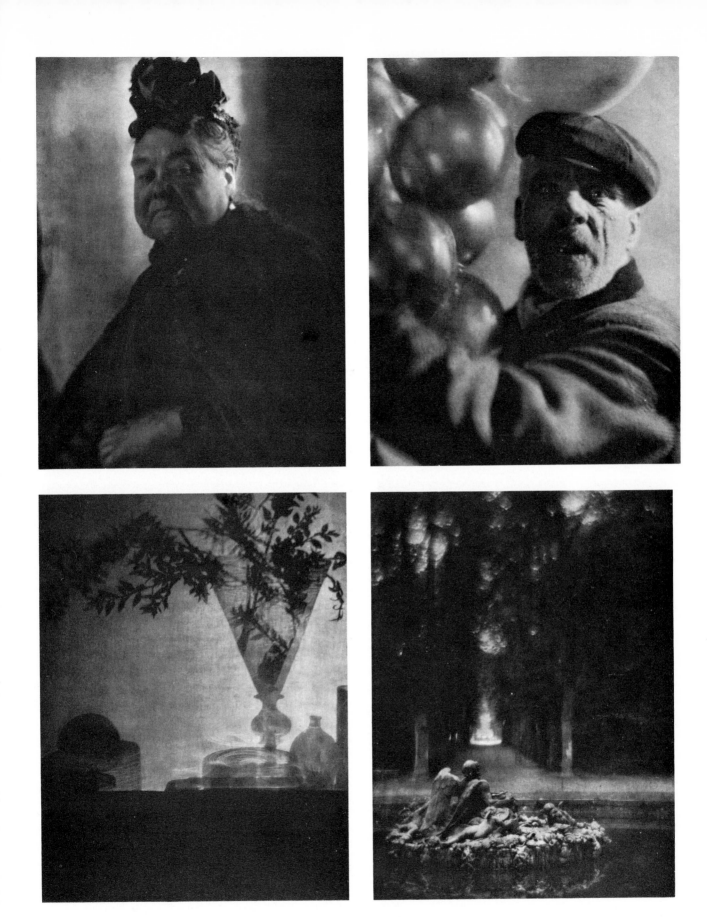

UPPER LEFT: *XI. Mrs. Wiggins of Belgrave Square*, by Ad. De Meyer. Oct. 1912, 40:45. Original negative; photogravure. 21.8 x 16.2 cm. UPPER RIGHT: *XII. The Balloon Man*, by Ad. De Meyer. Oct. 1912, 40:47. Original negative; photogravure. 21.8 x 16.7 cm. LOWER LEFT: *XIII. Glass and Shadows,* by Ad. De Meyer. Oct. 1912, 40:49. Original negative; photogravure. 22.1 x 16.5 cm. LOWER RIGHT: *XIV. The Fountain of Saturn, Versailles,* by Ad. De Meyer. Oct. 1912, 40:51. Original negative; photogravure. 21:5 x 16.0 cm.

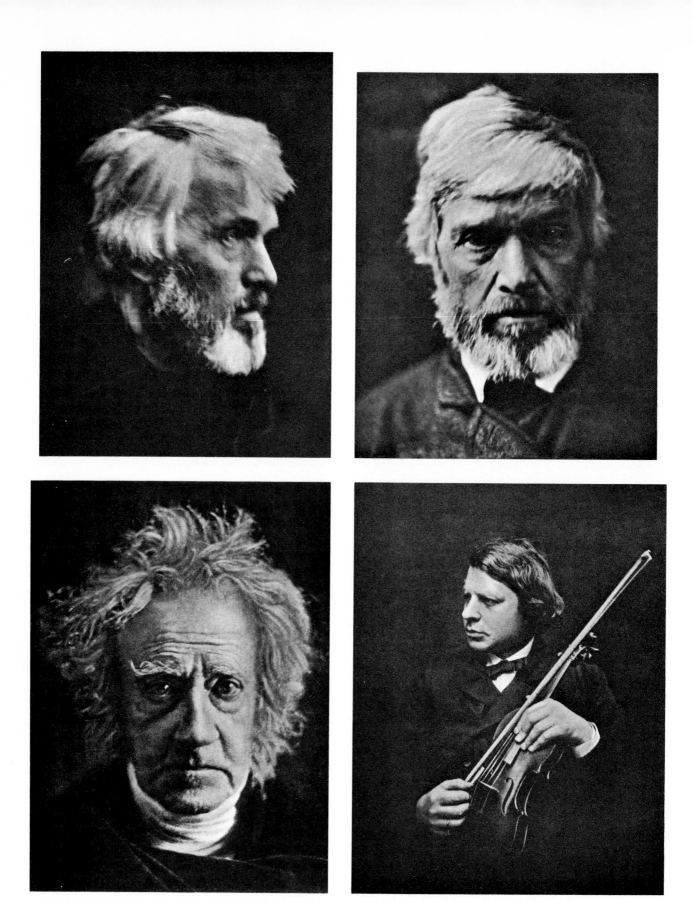

UPPER LEFT: *I. Carlyle*, by Julia Margaret Cameron. Jan. 1913, 41:5. Original negative; photogravure. 21.5 x 15.7 cm. UPPER RIGHT: *II. Carlyle*, by Julia Margaret Cameron. Jan. 1913, 41:7. Original negative; photogravure. 19.7 x 15.5 cm. LOWER LEFT:

III. Herschel, by Julia Margaret Cameron. Jan. 1913, .41:9. Original negative; photogravure. 21.3 x 15.6 cm. LOWER RIGHT: *IV. Joachim*, by Julia Margaret Cameron. Jan. 1913, 41:11. Original negative; photogravure. 20.3 x 15.4 cm.

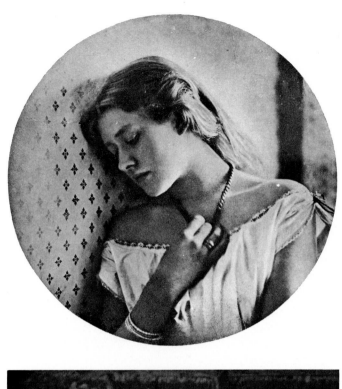

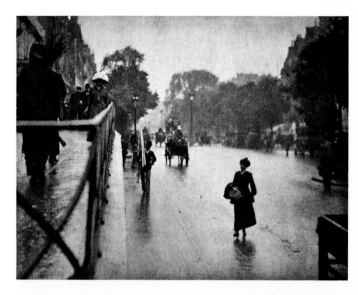

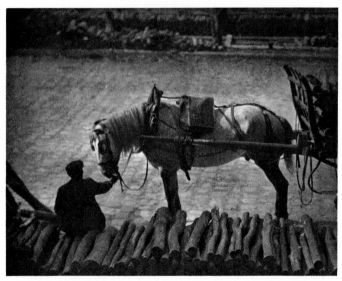

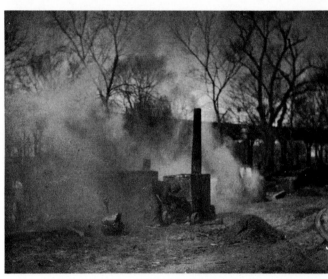

UPPER LEFT: *V. Ellen Terry, at the age of sixteen*, by Julia Margaret Cameron. Jan. 1913, 41:13. Original negative; photogravure. 15.5 cm. diam. UPPER RIGHT: *I. A Snapshot; Paris (1911)*, by Alfred Stieglitz. Jan. 1913, 41:33. Original negative; photogravure. 13.6 x 17.3 cm. LOWER LEFT: *II. A Snapshot;* *Paris (1911)*, by Alfred Stieglitz. Jan. 1913, 41:35. Original negative; photogravure. 13.6 x 16.8 cm. LOWER LEFT: *III. The Asphalt Paver; New York (1892)*, by Alfred Stieglitz. Jan. 1913, 41:37. Original negative; photogravure. 14.0 x 17.6 cm.

UPPER LEFT: *IV. Portrait—S. R. (1904)*, by Alfred Stieglitz. Jan. 1913, 41:39. Original negative; photogravure. 20.6 x 14.0 cm. UPPER RIGHT: *I. Vitality—Yvette Guilbert*, by Eduard J. Steichen. Apr./July 1913, 42/43:5 [pub. Nov. 1913]. Original negative; photogravure. 23.9 x 16.6 cm. LOWER LEFT: *II. Isadora Duncan*, by Eduard J. Steichen. Apr./July 1913, 42/43:7 [pub. Nov. 1913]. Original negative; photogravure. 16.6 x 20.4 cm. LOWER RIGHT: *III. Cyclamen—Mrs. Philip Lydig*, by Eduard J. Steichen. Apr./July 1913, 42/43:9 [pub. Nov. 1913]. Original negative; photogravure. 19.1 x 14.8 cm.

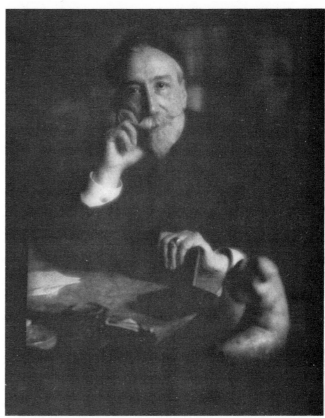

UPPER LEFT: *IV. Mary Learns to Walk*, by Eduard J. Steichen.
Apr./July 1913, 42/43:11 [pub. Nov. 1913]. Original negative;
photogravure. 20.8 x 16.0 cm. UPPER RIGHT: *V. Anatole France*,
by Eduard J. Steichen. Apr./July 1913, 42/43:29 [pub. Nov.
1913]. Original negative; photogravure. 20.4 x 15.9 cm. LOWER
LEFT: *VI. Henri Matisse*, by Eduard J. Steichen. Apr./July

1913, 42/43:31 [pub. Nov. 1913]. Original negative; photo-
gravure. 21.7 x 17.1 cm. LOWER RIGHT: *VII. The Man that
resembles Erasmus*, by Eduard J. Steichen. Apr./July 1913,
42/43:33 [pub. Nov. 1913]. Original negative; photogravure.
16.8 x 16.2 cm.

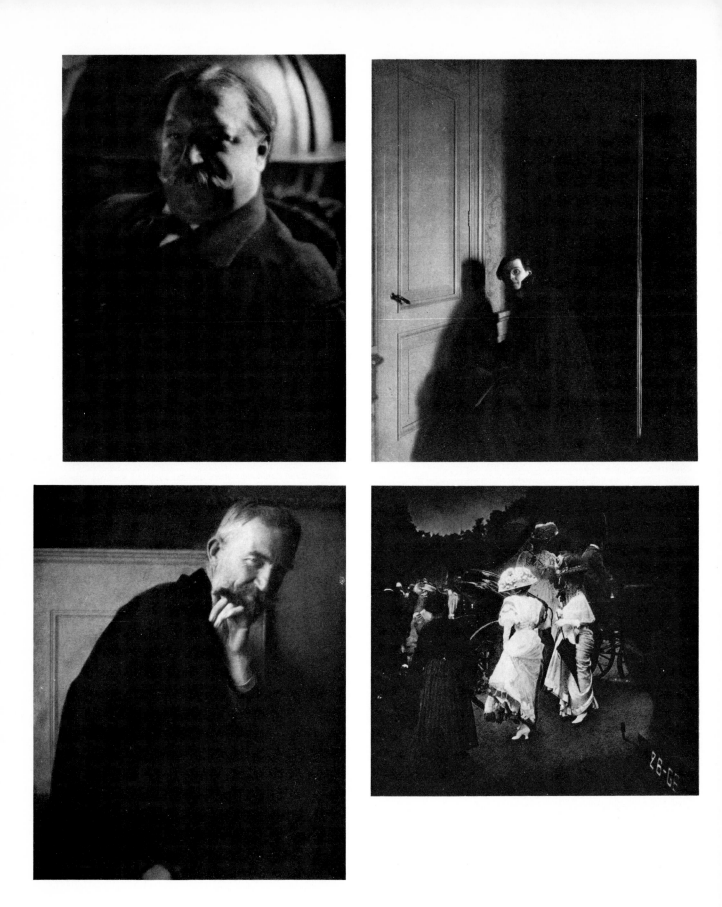

UPPER LEFT: *VIII. Henry W. Taft* [William Howard Taft], by Eduard J. Steichen. Apr./July 1913, 42/43:35 [pub. Nov. 1913]. Original negative; photogravure. 18.9 x 13.1 cm. UPPER RIGHT: *IX. E. Gordon Craig*, by Eduard J. Steichen. Apr./July 1913, 42/43:37 [pub. Nov. 1913]. Original negative; photogravure. 19.9 x 16.0 cm. LOWER LEFT: *X. The Photographers' Best* *Model—G. Bernard Shaw*, by Eduard J. Steichen. Apr./July 1913, 42/43:39 [pub. Nov. 1913]. Original negative; photogravure. 20.1 x 16.2 cm. LOWER RIGHT: *XI. Steeplechase Day, Paris; After the Races*, by Eduard J. Steichen. Apr./July 1913, 42/43:57 [pub. Nov. 1913]. Gum; duogravure. 16.9 x 15.7 cm.

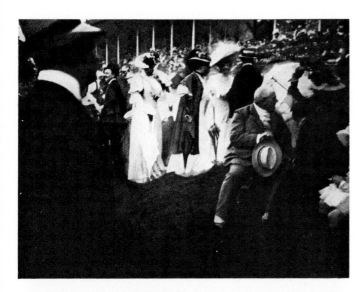

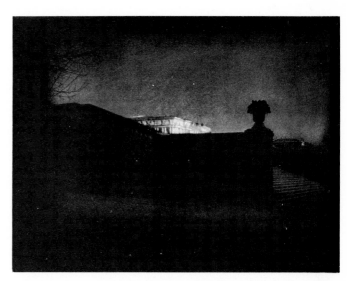

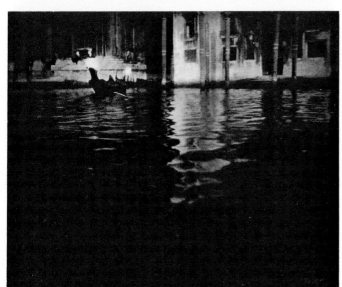

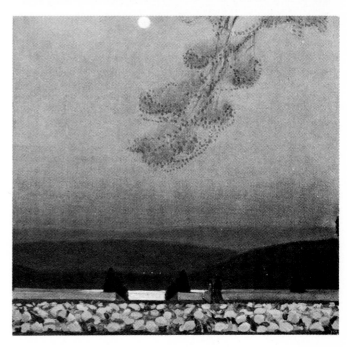

UPPER LEFT: *XII. Steeplechase Day, Paris; Grand Stand*, by Eduard J. Steichen. Apr./July 1913, 42/43:59 [pub. Nov. 1913]. Gum; duogravure. 15.6 x 19.9 cm. UPPER RIGHT: *XIII. Nocturne—Orangerie Staircase, Versailles*, by Eduard J. Steichen. Apr./July 1913, 42/43:61 [pub. Nov. 1913]. Gum; duogravure. 15.9 x 20.8 cm. LOWER LEFT: *XIV. Late Afternoon—Venice*, by Eduard J. Steichen. Apr./July 1913, 42/43:63 [pub. Nov. 1913]. Gum; duogravure. 15.5 x 18.6 cm. LOWER RIGHT: *XV. Nocturne —Hydrangea Terrace, Chateaux Ledoux*, by Eduard J. Steichen. Apr./July 1913, 42/43:85 [pub. Nov. 1913]. Three-color half-tone. 15.0 x 15.6 cm.

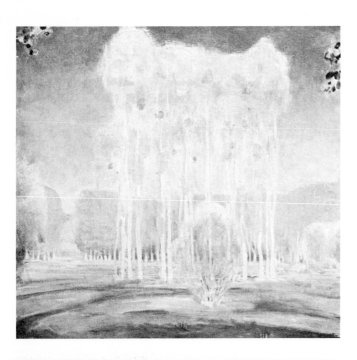

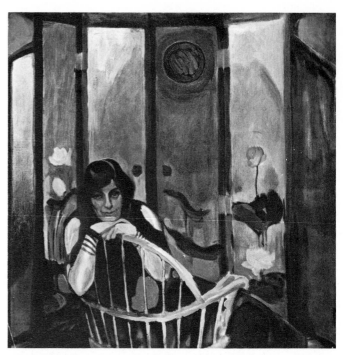

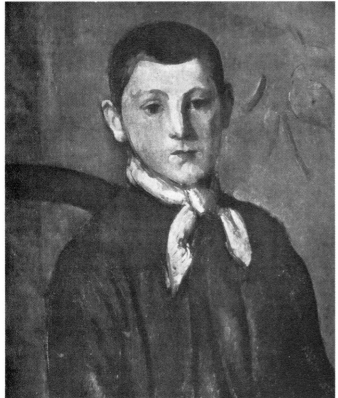

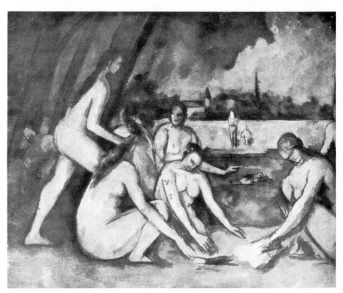

UPPER LEFT: *XVI. Autumnal Afternoon—The Poplars, Vou-*
langis, by Eduard J. Steichen. Apr./July 1913, 42/43:87 [pub.
Nov. 1913]. Three-color halftone. 15.2 x 15.8 cm. UPPER RIGHT:
XVII. The Lotus Screen: S. S. S., by Eduard J. Steichen. Apr./
July 1913, 42/43:89 [pub. Nov. 1913]. Three-color halftone.
16.8 x 16.2 cm. LOWER LEFT: *I. Portrait,* by Cézanne. June 1913,
SN:41. Halftone. 18.5 x 15.4 cm. LOWER RIGHT: *II. Nudes,* by
Cézanne. June 1913, SN:43. Halftone. 15.4 x 18.3 cm.

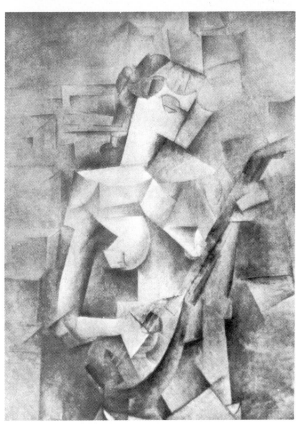

UPPER LEFT: *III. Still-Life*, by Cézanne. June 1913, SN:45. Halftone. 15.4 x 18.9 cm. UPPER RIGHT: *IV. Landscape*, by Van Gogh. June 1913, SN:47. Halftone. 19.2 x 15.4 cm. LOWER LEFT: *V. Portrait—Gertrude Stein*, by Picasso. June 1913, SN:49. Halftone. 17.5 x 14.2 cm. LOWER RIGHT: *VI. Woman with Mandolin*, by Picasso. June 1913, SN:51. Halftone. 20.6 x 14.9 cm.

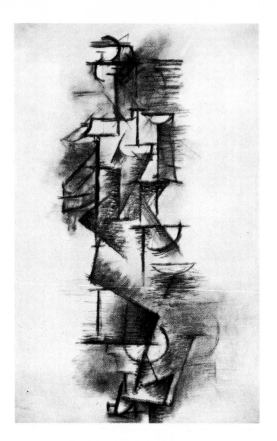

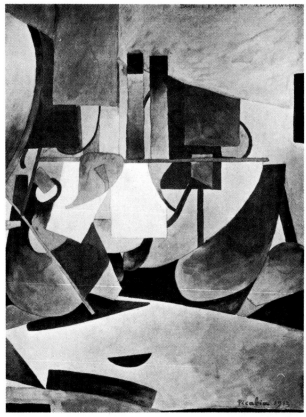

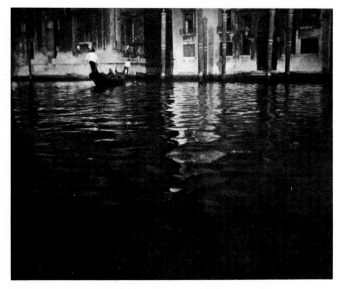

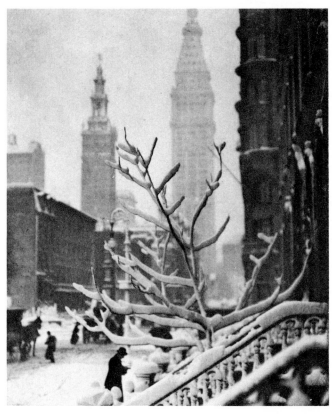

UPPER LEFT: *VII. Drawing*, by Picasso. June 1913, SN:53. Halftone. 17.2 x 27.8 cm. UPPER RIGHT: *VIII. Star-Dancer on Board a Transatlantic Steamer*, by Picabia. June 1913, SN:55. Halftone. 21.0 x 15.3 cm. LOWER LEFT: *I. Venice*, by Eduard J. Steichen. Oct. 1913, 44:5 [pub. Mar. 1914]. Original negative; photogravure. 16.5 x 19.9 cm. LOWER RIGHT: *II. Two Towers—New York*, by Alfred Stieglitz. Oct. 1913, 44:7 [pub. Mar. 1914]. Original negative; photogravure. 19.5 x 15.9 cm.

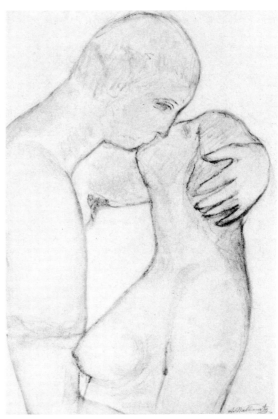

UPPER LEFT: *III. Dryads*, by Annie W. Brigman. Oct. 1913, 44:9 [pub. Mar. 1914]. Photogravure. 15.7 x 20.3 cm. UPPER RIGHT: *I. Music*, by A. Walkowitz. Oct. 1913, 44:29 [pub. Mar. 1914]. Collotype. 25.8 x 15.5 cm. LOWER LEFT: *II. Mother and Child*, by A. Walkowitz. Oct. 1913, 44:31 [pub. Mar. 1914]. Collotype. 24.6 x 15.6 cm. LOWER RIGHT: *III. Kiss*, by A. Walkowitz. Oct. 1913, 44:33 [pub. Mar. 1914]. Collotype. 23.5 x 15.9 cm.

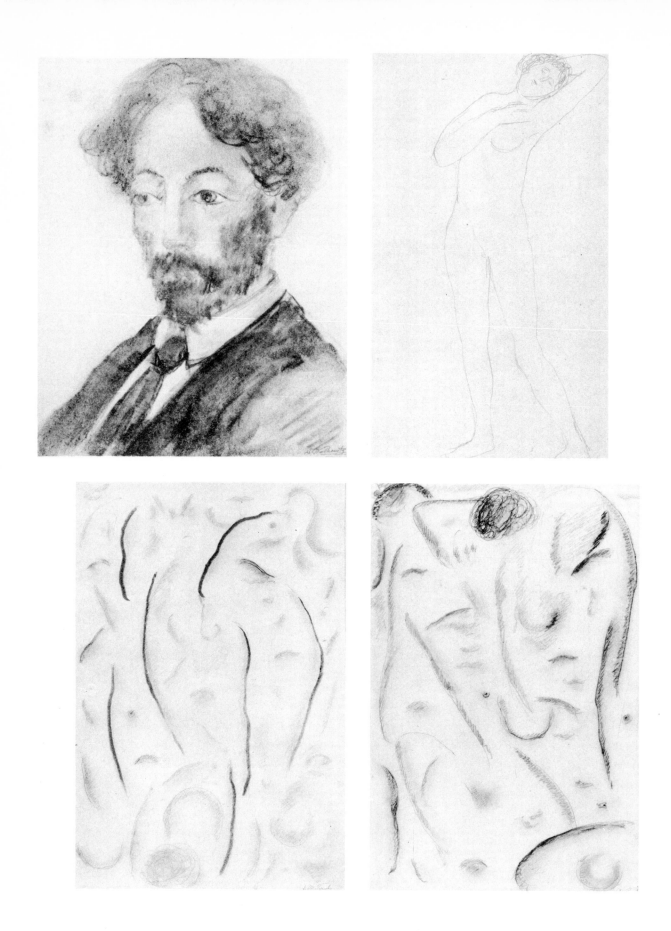

UPPER LEFT: *IV. Portrait*, by A. Walkowitz. Oct. 1913, 44:35 [pub. Mar. 1914]. Collotype. 20.1 x 15.6 cm. UPPER RIGHT: *V. Sigh*, by A. Walkowitz. Oct. 1913, 44:47 [pub. Mar. 1914]. Collotype. 22.2 x 13.1 cm. LOWER LEFT: *VI. From Life to Life,* *No. I*, by A. Walkowitz. Oct. 1913, 44:49 [pub. Mar. 1914]. Collotype. 23.1 x 15.5 cm. LOWER RIGHT: *VII. From Life to Life, No. II*, by A. Walkowitz. Oct. 1913, 44:51 [pub. Mar. 1914]. Collotype. 23.2 x 15.5 cm.

UPPER LEFT: *I. A Blind Musician—Granada*, by J. Craig Annan. Jan. 1914, 45:5 [pub. June 1914]. Photogravure. 20.1 x 11.9 cm. UPPER RIGHT: *II. A Gitana—Granada*, by J. Craig Annan. Jan. 1914, 45:7 [pub. June 1914]. Photogravure. 19.4 x 13.6 cm. LOWER LEFT: *III. A Carpenter's Shop—Toledo*, by J. Craig Annan. Jan. 1914, 45:9 [pub. June 1914]. Photogravure. 14.5 x 18.0 cm. LOWER RIGHT: *IV. Group on a Hill Road—Granada*, by J. Craig Annan. Jan. 1914, 45:11 [pub. June 1914]. Photogravure. 11.3 x 18.0 cm.

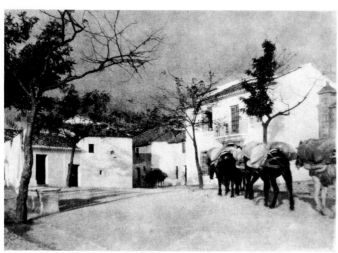

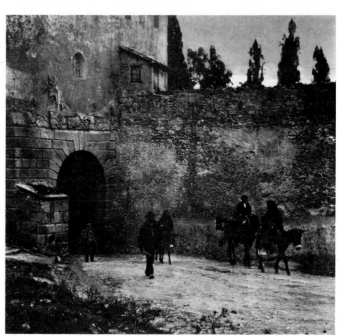

UPPER LEFT: *V. Bridge of St. Martin—Toledo*, by J. Craig Annan. Jan. 1914, 45:29 [pub. June 1914]. Photogravure. 12.7 x 18.0 cm. UPPER RIGHT: *VI. Old Church—Burgos*, by J. Craig Annan. Jan. 1914, 45:31 [pub. June 1914]. Photogravure. 18.1 x 14.7 cm. LOWER LEFT: *VII. A Square—Ronda*, by J. Craig Annan. Jan. 1914, 45:33 [pub. June 1914]. Photogravure. 13.6 x 18.8 cm. LOWER RIGHT: *VIII. A Gateway—Segovia*, by J. Craig Annan. Jan. 1914, 45:35 [pub. June 1914]. Photogravure. 14.4 x 15.1 cm.

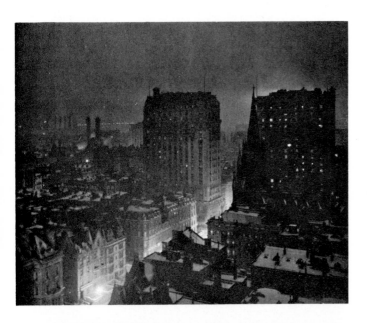

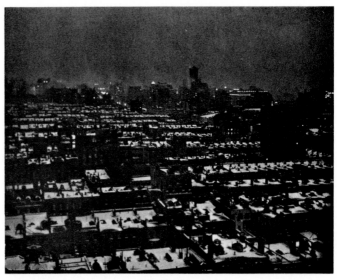

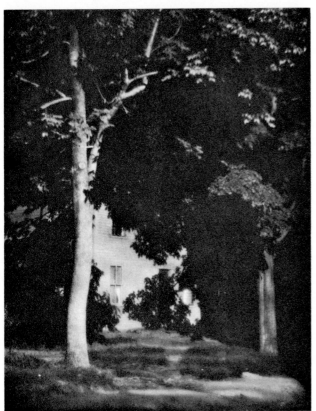

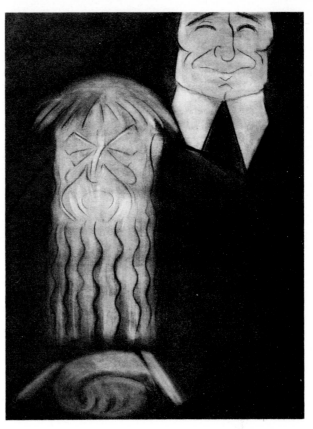

UPPER LEFT: *I. New York at Night*, by Paul B. Haviland. Apr. 1914, 46:5 [pub. Oct. 1914]. Original negative; photogravure. 15.6 x 18.0 cm. UPPER RIGHT: *II. New York at Night*, by Paul B. Haviland. Apr. 1914, 46:7 [pub. Oct. 1914]. Original negative; photogravure. 14.0 x 17.4 cm. LOWER LEFT: *III. Landscape*, by Frederick H. Pratt. Apr. 1914, 46:9 [pub. Oct. 1914]. Original negative; photogravure. 21.2 x 16.0 cm. LOWER RIGHT: *I. Rodin and Eduard J. Steichen*, by Marius De Zayas. Apr. 1914, 46:25 [pub. Oct. 1914]. Photogravure. 21.7 x 16.2 cm.

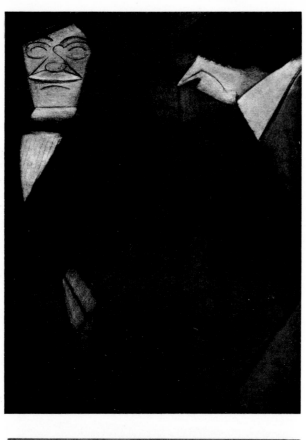

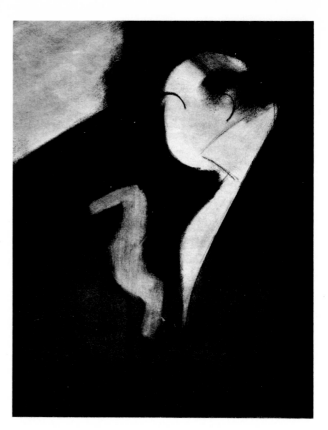

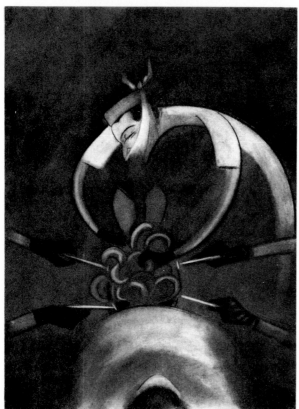

UPPER LEFT: *II. John Marin and Alfred Stieglitz*, by Marius De Zayas. Apr. 1914, 46:27 [pub. Oct. 1914]. Photogravure. 16.5 x 22.0 cm. UPPER RIGHT: *III. Charles Darnton*, by Marius De Zayas. Apr. 1914, 46:29 [pub. Oct. 1914]. Photogravure. 21.9 x 16.6 cm. LOWER LEFT: *IV. Dr. A. A. Berg*, by Marius De Zayas. Apr. 1914, 46:31 [pub. Oct. 1914]. Photogravure. 22.4 x 16.5 cm. LOWER RIGHT: *V. Alfred Stieglitz*, by Marius De Zayas. Apr. 1914, 46:37 [pub. Oct. 1914]. Photogravure. 23.4 x 17.7 cm.

UPPER LEFT: *VI. Mrs. Eugene Meyer, Jr.,* by Marius De Zayas. Apr. 1914, 46:39 [pub. Oct. 1914]. Photogravure. 24.3 x 18.0 cm. UPPER RIGHT: *VII. Two Friends,* by Marius De Zayas. Apr. 1914, 46:41 [pub. Oct. 1914]. Photogravure. 17.6 x 23.4 cm. LOWER LEFT: *VIII. Theodore Roosevelt,* by Marius De Zayas. Apr. 1914, 46:43 [pub. Oct. 1914]. Photogravure. 23.3 x 17.5 cm. LOWER RIGHT: *IX. Paul B. Haviland,* by Marius De Zayas. Apr. 1914, 46:45 [pub. Oct. 1914]. Photogravure. 23.4 x 17.5 cm.

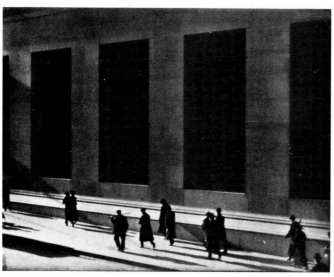

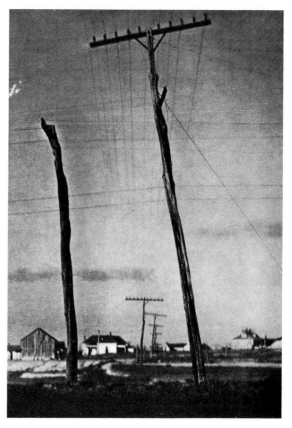

UPPER LEFT: *X. Francis Picabia*, by Marius De Zayas. Apr. 1914, 46:47 [pub. Oct. 1914]. Photogravure. 23.9 x 18.0 cm. UPPER RIGHT: *I. The Cat*, by Frank Eugene. Oct. 1916, 48:5. Photogravure. 22.1 x 17.2 cm. LOWER LEFT: *I. New York*, by Paul Strand. Oct. 1916, 48:25. Original negative; photogravure. 13.1 x 16.1 cm. LOWER RIGHT: *II. Telegraph Poles*, by Paul Strand. Oct. 1916, 48:27. Original negative; photogravure. 20.0 x 13.6 cm.

UPPER LEFT: *III. New York*, by Paul Strand. Oct. 1916, 48:29. Original negative; photogravure. 12.4 x 16.5 cm. UPPER RIGHT: *IV. New York*, by Paul Strand. Oct. 1916, 48:31. Original negative; photogravure. 13.0 x 16.9 cm. LOWER LEFT: *V. New York*, by Paul Strand. Oct. 1916, 48:33. Photogravure. 13.8 x 16.6 cm. LOWER RIGHT: *VI. New York*, by Paul Strand. Oct. 1916, 48:35. Original negative; photogravure. 21.7 x 10.7 cm.

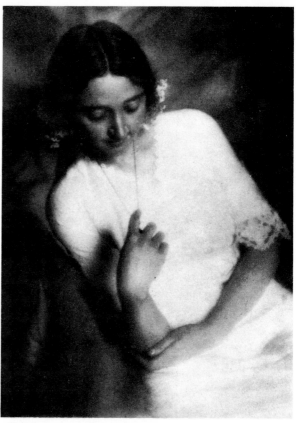

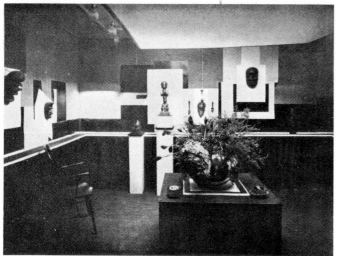

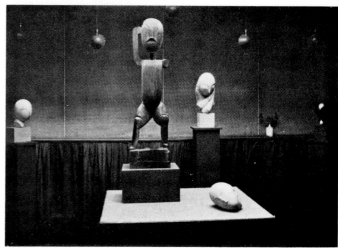

UPPER LEFT: *I. Winter*, by Arthur Allen Lewis. Oct. 1916, 48:49. Photogravure. 21.7 x 16.6 cm. UPPER RIGHT: *II. A Portrait*, by Francis Bruguière. Oct. 1916, 48:51. Photogravure. 16.6 x 11.6 cm. LOWER LEFT: *I. Negro Art Exhibition, Novem-ber, 1914*, by Alfred Stieglitz. Oct. 1916, 48:66. Halftone. 10.5 x 13.9 cm. LOWER RIGHT: *II. Brancusi Sculpture, March 1914*, by Alfred Stieglitz. Oct. 1916, 48:66. Halftone. 10.0 x 13.9 cm.

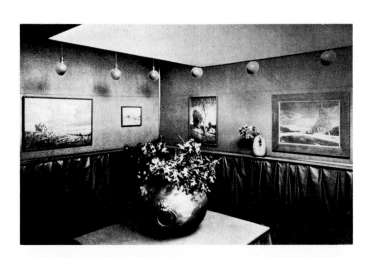

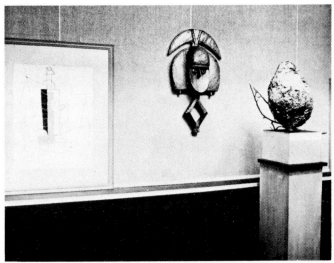

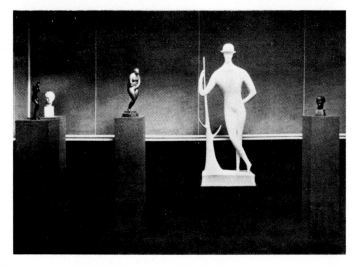

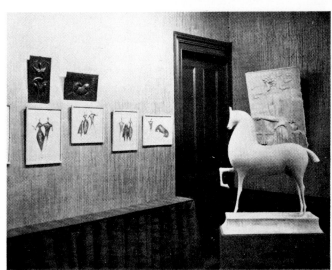

UPPER LEFT: *III. German and Viennese Photography, March, 1906*, by Alfred Stieglitz. Oct. 1916, 48:67. Halftone. 9.7 x 14.6 cm. UPPER RIGHT: *IV. Detail: Picasso—Braque Exhibition, January, 1915*, by Alfred Stieglitz. Oct. 1916, 48:67. Halftone. 10.9 x 14.0 cm. LOWER LEFT: *V. Nadelman Exhibition—2 Rooms, December, 1915*, by Alfred Stieglitz. Oct. 1916, 48:68. Halftone. 10.2 x 13.9 cm. LOWER RIGHT: *VI. Nadelman Exhibition—2 Rooms, December, 1915*, by Alfred Stieglitz. Oct. 1916, 48:68. Halftone. 10.8 x 13.9 cm.

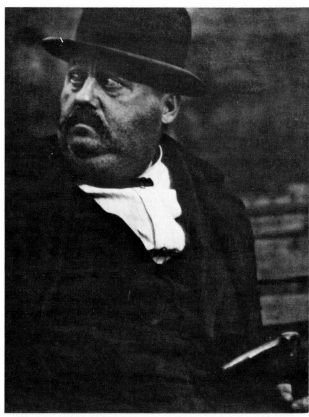

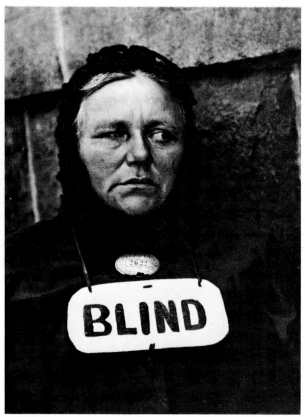

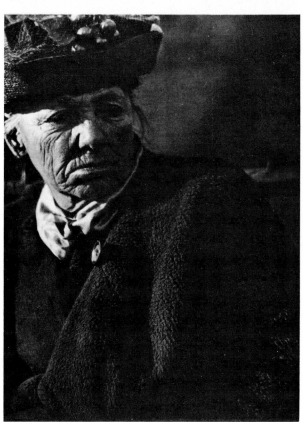

UPPER LEFT: *I. Photograph—New York*, by Paul Strand. June 1917, 49/50:9. Photogravure. 22.2 x 16.8 cm. UPPER RIGHT: *II. Photograph—New York*, by Paul Strand. June 1917, 49/50:11. Photogravure. 22.6 x 16.9 cm. LOWER LEFT: *III. Photograph—New York*, by Paul Strand. June 1917, 49/50:13. Photogravure. 22.2 x 16.4 cm. LOWER RIGHT: *IV. Photograph—New York*, by Paul Strand. June 1917, 49/50:15. Photogravure. 17.0 x 23.3 cm.

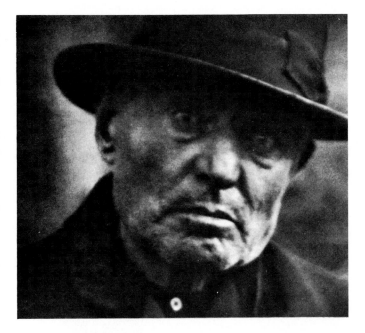

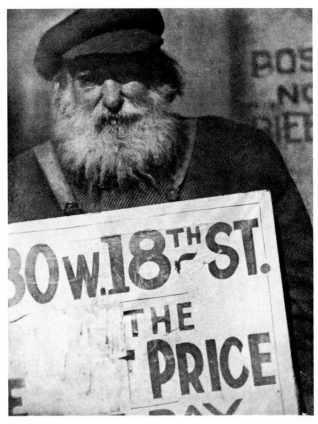

UPPER LEFT: *V. Photograph—New York*, by Paul Strand. June 1917, 49/50:17. Photogravure. 16.8 x 18.7 cm. UPPER RIGHT: *VI. Photograph—New York*, by Paul Strand. June 1917, 49/50:19. Photogravure. 22.9 x 16.8 cm. LOWER LEFT: *VII. Photo-graph—New York*, by Paul Strand. June 1917, 49/50:21. Photogravure. 24.0 x 16.7 cm. LOWER RIGHT: *VIII. Photograph—New York*, by Paul Strand. June 1917, 49/50:23. Photogravure. 21.7 x 16.7 cm.

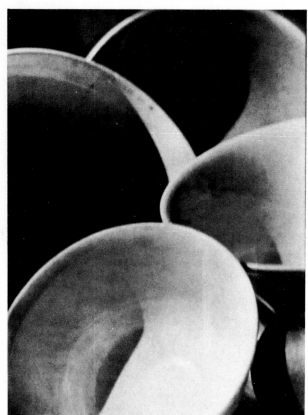

UPPER LEFT: *IX. Photograph*, by Paul Strand. June 1917, 49/ 50:25. Photogravure. 17.0 x 22.0 cm. UPPER RIGHT: *X. Photograph*, by Paul Strand. June 1917, 49/50:27. Photogravure. 24.2 x 16.2 cm. LOWER LEFT: *XI. Photograph*, by Paul Strand. June 1917, 49/50:29. Photogravure. 23.1 x 16.9 cm.

INDEX OF ARTISTS

WORKS WITHOUT ARTIST CREDIT. Two illustrations appeared in *Camera Work* which neither received an artist credit in *Camera Work* nor are attributed to an artist by the editor of this volume. These appear in the chronological index at Oct. 1905, 12:31 and 12:33.

Abbott, C. Yarnall
 I. Coryphée, A. Apr. 1905, 10:45
 II. Illustration for "Madame Butterfly." Apr. 1905, 10:47
 II. Sentinels. Jan. 1909, 25:27
Adamson, Prescott
 I. 'Midst Steam and Smoke. Jan. 1904, 5:37
Adamson, Robert
 See Hill, David Octavius
Annan, J. Craig
 I. Blind Musician—Granada, A. Jan. 1914, 45:5
 IV. Bolney Backwater. Oct. 1910, 32:11
 V. Bridge of St. Martin—Toledo. Jan. 1914, 45:29
 III. Carpenter's Shop—Toledo, A. Jan. 1914, 45:9
 VI. Dark Mountains, The. Oct. 1904, 8:15
 I. East & West. Oct. 1910, 32:5
 II. Etching Printer—William Strang, Esq., A. R. A., The. July 1907, 19:7
 I. Ex Libris. Apr. 1909, 26:29
 I. Franciscan, Venice, A. Oct. 1904, 8:5
 III. Frau Mathasius. Oct. 1904, 8:9
 VIII. Gateway—Segovia, A. Jan. 1914, 45:35
 II. Gitana—Granada, A. Jan. 1914, 45:7
 IV. Group on a Hill Road—Granada. Jan. 1914, 45:11
 III. Harlech Castle. Oct. 1910, 32:9.
 IV. Janet Burnet. July 1907, 19:11
 II. Man Sketching. Oct. 1910, 32:7
 VI. Old Church—Burgos. Jan. 1914, 45:31
 II. On a Dutch Shore. Oct. 1904, 8:7
 V. Ploughing Team. July 1907, 19:13
 III. Portrait of Mrs. C. July 1907, 19:9
 IV. Prof. John Young, of Glasgow University. Oct. 1904, 8:11
 V. Riva Schiavoni, Venice, The. Oct. 1904, 8:13
 VII. Square—Ronda, A. Jan. 1914, 45:33
 I. Stirling Castle. July 1907, 19:5
 V. White House, The. Oct. 1910, 32:13
Bane, E. M.
 Untitled. Apr. 1905, 10:53
Becher, Arthur E.
 II. Moonlight. Oct. 1903, 4:51

Botticelli, [Sandro]
 Untitled [*Primavera:* detail]. Oct. 1905, 12:35
 Spring. Apr. 1905, 10:31
Boudin, E.
 Old Basin of Dunkirk, The. July 1903, 3:19
Boughton, Alice
 I. Danish Girl. Apr. 1909, 26:5
 II. Dawn. Apr. 1909, 26:7
 IV. Nature. Apr. 1909, 26:11
 V. Nude. Apr. 1909, 26:13
 III. Sand and Wild Roses. Apr. 1909, 26:9
 VI. Seasons, The. Apr. 1909, 26:15
Brigman, Annie W.
 III. Brook, The. Jan. 1909, 25:9
 V. Bubble, The. Jan. 1909, 25:13
 I. Cleft of the Rock, The. Apr. 1912, 38:5
 II. Dawn. Apr. 1912, 38:7
 III. Dryads. Oct. 1913, 44:9
 II. Dying Cedar, The. Jan. 1909, 25:7
 III. Finis. Apr. 1912, 38:9
 V. Pool, The. Apr. 1912, 38:13
 I. Soul of the Blasted Pine. Jan. 1909, 25:5
 IV. Source, The. Jan. 1909, 25:11
 IV. Wondrous Globe, The. Apr. 1912, 38:11
Bruguière, Francis
 II. Portrait, A. Oct. 1916, 48:51
Cadby, Will A.
 II. Storm Light. Apr. 1904, 6:31
 I. Under the Pines. Apr. 1904, 6:29
Cameron, Julia Margaret
 I. Carlyle. Jan. 1913, 41:5
 II. Carlyle. Jan. 1913, 41:7
 V. Ellen Terry, at the age of sixteen. Jan. 1913, 41:13
 III. Herschel. Jan. 1913, 41:9
 IV. Joachim. Jan. 1913, 41:11
Cassatt, Mary
 Breakfast in Bed, The. July 1903, 3:19
Cézanne, [Paul]
 II. Nudes. June 1913, SN:43
 I. Portrait. June 1913, SN:41
 III. Still-Life. June 1913, SN:45
Coburn, Alvin Langdon
 III. After the Blizzard. July 1906, 15:9
 VI. Alfred Stieglitz, Esq. Jan. 1908, 21:15
 V. Bernard Shaw. Jan. 1908, 21:13
 V. Bridge—Ipswich, The. Apr. 1904, 6:13
 V. Bridge—London, The. July 1906, 15:13

II. Bridge—Sunlight, The. July 1906, 15:7
VII. Bridge, Venice, The. Jan. 1908, 21:33
IV. Decorative Study. July 1906, 15:11
III. Dragon, The. Apr. 1904, 6:9
III. Duck Pond, The. Jan. 1908, 21:9
XII. Fountain at Trevi, The. Jan. 1908, 21:43
I. Gables. Apr. 1904, 6:5
VI. House on the Hill. Apr. 1904, 6:16
IV. Mother and Child—A Study. Apr. 1904, 6:11
IX. New York. Jan. 1908, 21:37
VIII. Notre Dame. Jan. 1908, 21:35
I. On the Embankment. Oct. 1909, 28:55
II. Portrait Study, A. Apr. 1904, 6:7
II. Road to Algeciras. Jan. 1908, 21:7
IV. Rodin. Jan. 1908, 21:11
X. Rudder, The. Jan. 1908, 21:39
XI. Spider-webs. Jan. 1908, 21:41
Study—Miss R. Oct. 1904, 8:33
I. Toros, El. Jan. 1908, 21:5
I. Wier's Close—Edinburgh. July 1906, 15:5
IV. Winter Shadows. July 1903, 3:49
Craig, Gordon
 I. Ninth Movement. Oct. 1910, 32:37
Davison, George
 VI. Berkshire Teams and Teamsters. Apr. 1907, 18:15
 II. Harlech Castle. Apr. 1909, 26:31
 I. Houses Near Aix-les-Bains. Oct. 1909, 28:29
 II. In a Village under the South Downs. Apr. 1907, 18:7
 V. Long Arm, The. Apr. 1907, 18:13
 I. Onion Field—1890, The. Apr. 1907, 18:5
 III. Thames Locker, A. Apr. 1907, 18:9
 IV. Wyvenhoe on the Colne in Essex. Apr. 1907, 18:11
de Chavannes, [Pierre Cécile] Puvis
 Hiver, L'. Jan. 1903, 1:31
Demachy, Robert
 I. Behind the Scenes. July 1904, 7:29
 V. Behind the Scenes. Oct. 1906, 16:13
 V. Contrasts. Jan. 1904, 5:13
 III. Effort, L'. July 1905, 11:39
 I. In Brittany. Jan. 1904, 5:5
 II. Model, A. Oct. 1906, 16:7
 IV. On the Lake. Jan. 1904, 5:11
 III. Portrait—Mlle. D. Oct. 1906, 16:9
 IV. Seine at Clichy, The. Oct. 1906, 16:31
 III. Severity. Jan. 1904, 5:9
 II. Speed. July 1904, 7:31
 IV. Street in Lisieux. Oct. 1906, 16:11
 II. Street in Mentone. Jan. 1904, 5:7
 VI. Struggle. Jan. 1904, 5:16
 VI. Study. Oct. 1906, 16:15
 I. Toucques Valley. Oct. 1906, 16:5
De Meyer, Baron A[dolf] (Ad. De Meyer)
 VII. Aïda, a Maid of Tangier. Oct. 1912, 40:29
 XII. Balloon Man, The. Oct. 1912, 40:47
 I. Cup, The. Oct. 1912, 40:5
 XIV. Fountain of Saturn, Versailles, The. Oct. 1912, 40:51
 VIII. From the Shores of the Bosphorus. Oct. 1912, 40:31
 XIII. Glass and Shadows. Oct. 1912, 40:49
 VI. Guitar Player of Seville. Oct. 1908, 24:31
 III. Marchesa Casati. Oct. 1912, 40:9

IV. Miss J. Ranken. Oct. 1912, 40:11
V. Mrs. Brown Potter. Oct. 1908, 24:29
XI. Mrs. Wiggins of Belgrave Square. Oct. 1912, 40:45
V. Nymphenburg Figure, The. Oct. 1912, 40:13
II. Silver Cap, The. Oct. 1912, 40:7
I. Still Life. Oct. 1908, 24:5
II. Still Life. Oct. 1908, 24:7
III. Still Life. Oct. 1908, 24:9
IV. Still Life. Oct. 1908, 24:11
IX. Street in China, A. Oct. 1912, 40:33
VII. Study of a Gitana. Oct. 1908, 24:33
VI. Teddie. Oct. 1912, 40:15
X. Windows on the Bosphorus. Oct. 1912, 40:35
Devens, Mary
 II. Ferry, Concarneau, The. July 1904, 7:51
Dewing, Thomas W.
 In the Garden. Apr. 1905, 10:31
De Zayas, Marius (M. De Zayas)
 II. Accoucheur d'Idées, L'. July 1912, 39:55
 V. Alfred Stieglitz. Apr. 1914, 46:37
 I. Benjamin De Casseres. Jan. 1910, 29:41
 III. Charles Darnton. Apr. 1914, 46:29
 IV. Dr. A. A. Berg. Apr. 1914, 46:31
 X. Francis Picabia. Apr. 1914, 46:47
 II. John Marin and Alfred Stieglitz. Apr. 1914, 46:27
 II. Madame Hanako. Jan. 1910, 29:43
 IV. Mrs. Brown Potter. Jan. 1910, 29:47
 VI. Mrs. Eugene Meyer, Jr. Apr. 1914, 46:39
 IX. Paul B. Haviland. Apr. 1914, 46:45
 I. Rodin and Eduard J. Steichen. Apr. 1914, 46:25
 III. Ruth St. Denis. Jan. 1910, 29:45
 VIII. Theodore Roosevelt. Apr. 1914, 46:43
 VII. Two Friends. Apr. 1914, 46:41
Dugmore, A. Radclyffe
 II. Fish. Jan. 1907, 17:39
 Study in Natural History, A. Jan. 1903, 1:55
Dyer, William B.
 II. Allegro, L'. Apr. 1907, 18:55
 I. Spider, The. Apr. 1907, 18:53
Eugene, Frank
 I. Adam and Eve. Apr. 1910, 30:5
 X. Brigitta. Apr. 1910, 30:61
 I. Cat, The. Oct. 1916, 48:5
 II. Cigale, La. Jan. 1904, 5:39
 XIV. Direktor F. Goetz. July 1910, 31:63
 VII. Dr. Emanuel Lasker and His Brother. July 1910, 31:19
 VIII. Dr. Georg Hirth. July 1910, 31:17
 X. Frau Ludwig von Hohlwein. July 1910, 31:39
 II. Fritz v. Uhde. July 1910, 31:7
 I. H. R. H. Rupprecht, Prince of Bavaria. July 1910, 31:5
 VIII. Horse. Apr. 1910, 30:31
 XII. "Hortensia." July 1910, 31:59
 IX. Kimono—Frl. v. S. July 1910, 31:37
 II. Lady of Charlotte. Jan. 1909, 25:43
 VII. Man In Armor. Apr. 1910, 30:29
 IV. Master Frank Jefferson. Apr. 1910, 30:11
 IX. Minuet. Apr. 1910, 30:59
 VI. Mosaic. Apr. 1910, 30:15
 I. Mr. Alfred Stieglitz. Jan. 1909, 25:41

INDEX OF TITLES

UNTITLED WORKS. A number of illustrations appeared in *Camera Work* without titles. Complete information about them may be found in the chronological index at the following locations: July 1903, 3:35, 3:37; Oct. 1904, 8:29 (two illustrations), 8:30 (two illustrations), 8:31 (two illustrations); Apr. 1905, 10:29, 10:53; Oct. 1905, 12:31, 12:33 (two illustrations), 12:35, 12:37, 12:39; Aug. 1912, SN:7, SN:11, SN:13, SN:33.

INDEX OF SITTERS

Ashley, (Miss) Minnie
 Apr. 1905, 10:5

Balzac, Honoré de
 Apr./July 1911, 34/35:7
 Apr./July 1911, 34/35:9
 Apr./July 1911, 34/35:11
Bartholomé, Paul Albert
 Apr. 1903, 2:13
Beatty, John W., Jr.
 Jan. 1905, 9:13
Beatty, Katherine Elizabeth
 Jan. 1905, 9:13
Berg, (Dr.) A. A.
 Apr. 1914, 46:31
Besnard, Paul Albert
 Apr. 1903, 2:20
Brinton, Christian
 July 1912, 39:13
Burnet, Janet
 July 1907, 19:11

Carlyle, Thomas
 Jan. 1913, 41:5
 Jan. 1913, 41:7
Casati, (Marchesa) Luisa Amon
 Oct. 1912, 40:9
Chase, William Merritt
 Apr. 1906, 14:7
 Apr. 1906, SS:15
Coburn, Alvin Langdon
 Oct. 1904, 8:30
 Oct. 1904, 8:31
 July 1906, 15:15
 Oct. 1910, 32:45
Coburn, Fannie E.
 Oct. 1910, 32:45
Compton, Spencer Joshua Alwyne, Marquis of Northampton
 Jan. 1912, 37:7
Craig, Edward Gordon
 Apr./July 1913, 42/43:37

Darnton, Charles
 Apr. 1914, 46:29
De Casseres, Benjamin
 Jan. 1910, 29:41
Duncan, Isadora
 Apr./July 1913, 42/43:7

Duse, Eleonora
 Apr. 1906, SS:11

Everett, Mary
 July 1908, 23:17

Felix, Letitia
 July 1903, 3:7
France, Anatole
 Apr./July 1913, 42/43:29
Francis of Assisi, Saint
 Oct. 1905, 12:33
 Oct. 1905, 12:37

Geiger, Willi
 July 1910, 31:13
Goetz, F.
 July 1910, 31:63
Grant, Sir Francis
 Jan. 1912, 37:11
Guilbert, Yvette
 Apr./July 1913, 42/43:5

Haldane, Robert
 Jan. 1912, 37:5
Hanako, Madame
 Jan. 1910, 29:43
Hartmann, Sadakichi
 July 1904, 7:49
Haviland, Paul B.
 Apr. 1914, 46:45
Hengeler, (Prof.) Adolf
 July 1910, 31:9
Henning, William
 Jan. 1912, 37:9
Herschel, (Sir) John
 Jan. 1913, 41:9
Hirth, (Dr.) Georg
 July 1910, 31:17
Hohlwein, Frau Ludwig von
 July 1910, 31:39
Howe, Julia Ward
 Apr. 1907, 18:33

Irving, Sir Henry
 Apr. 1910, 30:13

Jameson, Anna Brownell
 July 1905, 11:15
 Jan. 1912, 37:13

Jefferson, Frank
 Apr. 1910, 30:11
Joachim, Joseph
 Jan. 1913, 41:11

Kahnweiler, Daniel-Henry
 Aug. 1912, SN:37
Käsebier, Gertrude S.
 Oct. 1904, 8:31
Keane, Doris
 July 1912, 39:9
Kühn, Fr. (mother of Heinrich Kühn)
 Jan. 1911, 33:5

Lasker, Berthold
 July 1910, 31:19
Lasker, Emanuel
 July 1910, 31:19
Lenbach, Franz von
 Apr. 1903, 2:17
Lockhart, John Gibson
 July 1905, 11:11
Lydig, Mrs. Philip
 Apr. 1905, 10:9
 Apr./July 1913, 42/43:9

Maeterlinck, (Count) Maurice
 Apr. 1906, SS:7
Mann, Mrs. Harrington
 July 1908, 23:45
Marin, John
 Apr. 1914, 46:27
Mathasius, Frau
 Oct. 1904, 8:9
Matisse, Henri
 Apr./July 1913, 42/43:31
Meyer, Mrs. Eugene, Jr.
 Apr. 1914, 46:39
Monro, (Dr.) Alexander Tertius
 July 1905, 11:5
Morgan, John Pierpont
 Apr. 1906, SS:9

North, Christopher
 See Wilson, John

Picabia, Francis
 Apr. 1914, 46:47
Potter, Mrs. Brown
 Oct. 1908, 24:29
 Jan. 1910, 29:47
Prospero, (Prince) Felipe
 Oct. 1905, 12:39

Ranken, (Miss) J.
 Oct. 1912, 40:11
Rigby, Anne Palgrave
 July 1905, 11:7
 Oct. 1909, 28:13

Rintoul, Robert Steven
 Jan. 1912, 37:35
Ritchie, Handyside
 Jan. 1912, 37:9
Rodin, Auguste
 Apr. 1903, 2:5
 July 1905, 11:35
 Apr. 1906, SS:25
 Jan. 1908, 21:11
 Apr./July 1911, 34/35:5
 Apr. 1914, 46:27
Roosevelt, Theodore
 Apr. 1914, 46:43
Rupprecht, Marie Luitpold Ferdinand, Crown Prince of
 Bavaria
 Apr. 1910, 30:7
Rupprecht, Princess (and family)
 July 1910, 31:5
Ruthven, (Lady) Mary
 Apr. 1905, 11:9

St. Denis, Ruth
 Jan. 1910, 29:45
Seitz, Adolf von
 July 1910, 31:15
Shaw, George Bernard
 Jan. 1908, 21:13
 Apr. 1908, 22:7
 Apr./July 1913, 42/43:39
Steichen, Eduard J.
 Apr. 1903, 2:9
 Oct. 1904, 8:30
 Apr. 1914, 46:25
Stein, Gertrude
 June 1913, SN:49
Stieglitz, Alfred
 Oct. 1904, 8:29
 Jan. 1908, 21:15
 Jan. 1909, 25:41
 Apr. 1914, 46:27
 Apr. 1914, 46:37
Strang, William
 July 1907, 19:7
Stuck, Franz von
 July 1910, 31:11

Taft, William Howard
 Apr./July 1913, 42/43:35
Terry, Ellen Alicia
 Jan. 1913, 41:13
Totote
 July 1912, 39:11
 July 1912, 39:41

Uhde, Fritz Karl Hermann von
 July 1910, 31:7

Watts, George Fredrick
 Apr. 1906, 14:5